THE MANUAL OF
OUTDOOR
PHOTOGRAPHY

THE MANUAL OF
OUTDOOR
PHOTOGRAPHY

Michael Freeman

ZIFF-DAVIS PUBLISHING COMPANY
NEW YORK

Contents

An Adkinson Parrish Book

Copyright © 1981 by Adkinson Parrish Limited

Published by
Ziff-Davis Publishing Company
One Park Avenue,
New York, NY 10016

ISBN 0-87165-112-2

First printing 1981

Library of Congress Catalog Card Number 80-54316

Designed and produced by Adkinson Parrish Limited, London

Managing Editor	Clare Howell
Design Manager	Christopher White
Editor	John Roberts
Designers	Mike Rose Robert Lamb
	Rose & Lamb Design Partnership
Illustrators	Richard Blakeley Phil Holmes
	Dave Pugh Rob Shone Ken Stott

Phototypeset by Servis Filmsetting Limited, Manchester

Colour illustrations originated by Siviter Smith Limited, Birmingham

Printed and bound in Spain by Printer industria gráfica sa.
Sant Vicenç dels Horts, Barcelona
DLB 22755 - 1980

Introduction

This is a manual in the strict sense of the word, a working book designed for the camera case rather than the bookshelf. It contains as much hard, practical information as has been possible to pack into a book this size, information tailored for the photographer who is out on location, actually taking pictures. It is not a teaching book for beginners, nor is it a gentle treatise on armchair photography. There are plenty of such books available, and they have their place. The reasons for this manual's existence, however, are much more practical: it carries the references, help and advice needed when using a camera – and only these things.

As a result, all temptations to discuss the more exalted aspects of photography, such as aesthetics and personal style, have been ruthlessly suppressed and the photographs have not been allowed to spread themselves to the size that would have suited them best. Many were in fact, taken for magazine covers or to be reproduced over double pages, but here they have just one function – information. This is not intended as criticism of larger format photographic books that overflow with images to entertain and impress. It is just that such books never do find themselves packed alongside cameras and film. They remain at home. To get the most out of this book, treat it as a piece of

photographic equipment as much as you would an exposure meter or a set of filters. Keep it in the pocket of your shoulder bag, and make it work for you.

The material included ranges from the straightforward information and tables to advice derived from experience, and takes in along the way some emergency measures for the times when equipment or technique have let you down. Some of it is fairly obvious, such as colour temperature scales, but even these are presented practically. One of the most important criteria in designing this book has been to deliver information in the fastest way possible. The close-up scales on pages 186–191 are an example. In principle, there is nothing outstandingly difficult in close-up calculations, but in practice they can be a real headache, particularly in an outdoor location when there may be little time. Here, in addition to the basic ways of working out lens extensions, a special scale makes it possible simply to aim the camera and read off the extra f-stops.

Some kinds of information are given a rather different emphasis from that in most books. How to handle natural light, for example, which begins the manual, may seem to receive a great deal of attention. From my own experience, however, being able to choose and use the

infinite varieties of daylight is the single most important factor in outdoor photography. It is the light by which most photographs are taken, yet many people take little trouble over it. Anticipating the weather or the angle of the sun can be the element of success in a photograph, and even daylight that may look unsatisfactory at first glance – such as an overcast sky – can often be put to good use.

Other things come only out of trial and error. Photographing by moonlight was a hard-won experience, and the sample night-time shots on pages 42–47 cost more rolls of film than I would be happy to admit. Nor is the quality of car headlights as photographic lighting standard published information, but they made possible at least one shot that I could not otherwise have taken. Finally, no camera manufacturer will give you the least encouragement or help to dismantle and repair their product, but what should you do when the shutter jams in front of an important shot? Surprisingly, there are repairs that you can reasonably expect to manage for yourself, if you take the right precautions.

Much of the book is, in fact, taken up with unusual situations – unusual lighting conditions, emergencies, breakdowns and the like. This is deliberate. Under average conditions, using a camera is extremely simple, and there is little to say about it. Good photography, however, is not usually concerned with the average, but with images that have original interest – interest that is due either to the subject or to the way it is interpreted. This brings in the question of automatic cameras.

Automatic systems, whether used for exposure control, flash units or focusing, are designed for average photography, and this actually makes them unhelpful in many situations. Their value is that they take care of distracting calculations and camera operation, so that they can free the photographer to concentrate on the image. The limitation that they all share is that they only react in a predetermined way, and that has been established in advance by the camera designer. The sad truth is that most people do use their cameras in predictable ways, and it is this that makes their photographs uninteresting.

In order to exercise full control, however – and that is essentially what this book is designed to help you do – you will usually need to override any automatic controls that your camera may have. When automatic systems remove choice, as they often do, they only limit the enormous, creative possibilities of photography.

MICHAEL FREEMAN

1. LIGHTING

Exposure

Of all the elements in photography, controlling the quality of light contributes most to success. The basic skill is to be able to record different light levels on the film as you wish. There are few lighting situations where just one exposure can be pronounced dogmatically correct, but knowing how to convert a particular brightness level into a specific tone in a photograph is essential.

Accurate exposure calls for a light meter, although in an emergency a rule-of-thumb guide, such as the examples on pages 16–17, can be good enough. Any meter measures all the light available to it, indiscriminately. It then indicates an exposure setting that will record the scene in front of it as a mid-tone. In other words, it averages the light. With a typical scene, this will almost certainly indicate a satisfactory ex-

posure, but anything out of the ordinary, such as a small white subject against a dark background, or a small dark one in a bright setting, will need special attention. A meter gives all subjects the same treatment, whether bright snow or a dark woodland interior – it simply shows how to record them as mid-tones. It cannot decide which parts of the scene are important, nor how the final image ought to look.

Latitude Sunlit scenes nearly always cover a greater brightness range than the film can handle, making careful exposure important. How far you can stray from the ideal exposure and still have an acceptable image depends on the *exposure latitude* of the film. Latitude is, in effect, a safety margin for mistakes. Negative materials have more latitude than transparency

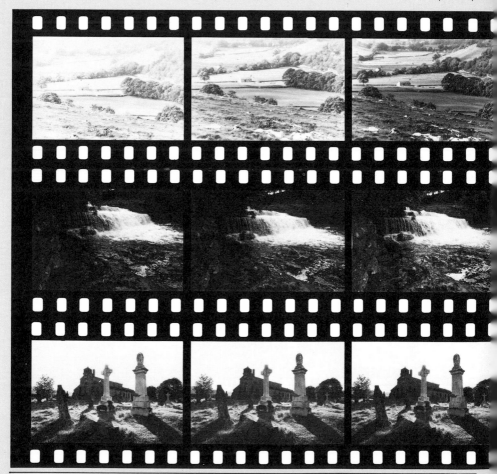

film, faster emulsions more than slower ones, and black-and-white more than colour. If for any reason the exposure is extremely uncertain, a high-speed black-and-white film, such as Tri-X or HP5, would be the safest choice.

Bracketing Most professional photographers, particularly when faced with a difficult lighting situation, bracket exposures around the most likely setting, usually in half-stop increments. Although, on the face of it, bracketing may seem wasteful, it is perfectly justified when the shot is important or has been costly to set up. It is a hedge against uncertainty and an insurance against mistakes. Remember when bracketing that under-exposure will tend to give better results than over-exposure with negative films, whilst the reverse is true for transparencies.

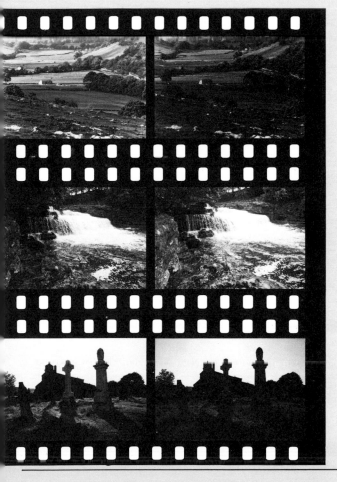

Average scene When the brightness level is predictable and the contrast range is moderate, bracketing half a stop over the indicated exposure and half a stop under is usually sufficient. In this strip of five exposures, the far left and far right frames, each one full stop different from the metered reading, are clearly incorrect.

Metering problems When there are serious doubts about the exposure, bracketing is a valuable insurance. In this scene, it was important that the foaming water should include a hint of detail, neither grey or featureless white. The contrast between the water and the dark rocks made a precise exposure calculation difficult, but bracketing assured success.

Backlighting Most backlit scenes are open to a wide variety of tonal interpretation, and any of several exposures may be acceptable. All five of these exposures at half stop differences could be printed successfully, from a bright flared image at left to a virtual silhouette at right. In this case, bracketing is used to provide a choice of image rather than insure against incorrect exposure.

Exposure meters

There are three basic types of exposure meter: through-the-lens, hand-held and spot meters. All contain light-sensitive cells that respond to the quantity of light falling on them. The ways in which they can be used, however, vary considerably.

Most modern cameras either have exposure meters built into them or, as with view cameras, can be adapted to take readings. As a result, through-the-lens (TTL) metering is the most widely used method. Its outstanding advantage is that the exposure reading is taken from the actual image about to be recorded on film, whatever the angle of view of the lens and whatever filters are being used. It is ideally suited to 'average' scenes, where the light levels of the main subject are not very different from those from the rest of the image. Unusual lighting conditions, however, give rise to problems, and when the background is dominant and much brighter or darker than the main subject, allowances have to be made. The mechanisms of TTL metering can be highly sophisticated, and most systems are weighted to allow for the way in which most photographers compose images. The display in the viewfinder is commonly either a moving needle, glowing red LEDs (light-emitting diodes) or the less energy-consuming LCDs (liquid crystal displays).

Hand-held meters are more versatile than TTL metering, but are slower to use. Most can be set to take either reflected light readings (measuring the light coming directly from the subject), or incident readings (measuring the general level of light falling on the subject). The best meters have the facility to take attachments for different purposes, such as matching the angle of view of a particular camera lens. Modern digital meters can also incorporate microprocessors to make standard lighting calculations. In general, hand-held meters are best when there is plenty of time for shooting, or as a check and back-up for the camera's TTL system.

Spot meters are also, in a sense, hand-held meters, but are designed to take very precise reflected light readings. They use an optical system, and show the exposure reading from an accurately calibrated central disc that covers a very narrow angle of view. Because they measure such a small angle, they are easy to misuse, but with practice can give readings in practically any situation, however difficult.

Hand-held When set for reflected light readings, most hand-held meters have an acceptance angle of 30°, rather less than that of a 'standard' camera lens. Some can be fitted with long-focus attachments to reduce the angle to 15°, 10° or 7.5°, to coincide with the angle of view of long-focus lenses. For incident light readings, a white translucent dome is fitted.

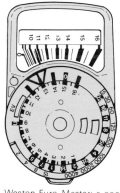

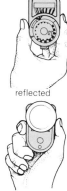

reflected

incident

Weston Euro-Master: a good general purpose hand-held meter

Minolta Flash Meter III: coping with both continuous light and flash, giving the reading as a digital display

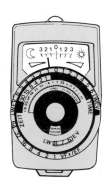

Gossen Profisix: capable of measuring light from very low to very high levels

Through-the-lens meter

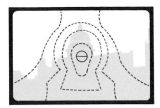

Spot meter

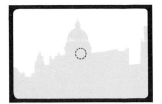

Through-the-lens Some camera TTL systems can be set to give either a straightforward average reading or a reading from a selected central area – virtually a spot reading. Most of them, however, only weight the reading to conform with a 'typical' photograph, with the main subject central and the horizon line two thirds up the frame. They are biased towards the lower part of the picture so that a bright sky does not upset the reading. The weighting shown here, from the Leica R3, is common. Be sure that you are familiar with the weighting system in the camera you are using – it may be slightly different.

Spot meter The spot meter lens is aimed at the subject and the small engraved circle visible through the eyepiece shows the exact area being measured, usually over an angle of just 1°. A trigger or button activates the reading, which can usually be held by means of a memory lock.

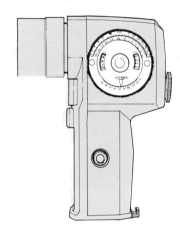

Types of cell

There are two types of light sensitive cell used in exposure meters: those that generate a measurable electric current according to the amount of light falling on them (selenium cells) and those that modify a small current passing through the cell from a battery. Selenium cells, which are becoming less common, are thus 'self-powered' and need no batteries. As a result, they rarely fail, and work well in situations where batteries would drain quickly, such as low temperatures. Their efficiency depends on their size, however, and readings in dim light are difficult to make and are unreliable. Battery-powered

cadmium sulfide cells (CdS) are much smaller and are very sensitive, even in such poor illumination as moonlight. In bright light, these cells 'remember' the reading, and should be allowed to rest for a few minutes before using in dim light. Other battery-powered cells have recently been introduced, silicon and gallium cells, which are even more sensitive, taking an effective reading 1,000 times quicker than the CdS cell. Worn batteries are the most frequent cause of failure with battery-powered cells, and many cameras now have a battery testing mechanism to counteract this danger.

Light readings

There are three ways of taking an exposure reading: *reflected light readings* measure the quantity of light reflected from subjects, and therefore depend as much on the surface of the subject as on the lighting; *incident light readings* measure the light falling on the scene, and are therefore independent of the subject; and *substitute readings* measure the light reflected from a surface that takes the place of the subject.

TTL meters and spot meters can only be used for reflected light readings or substitute readings. Hand-held meters are more versatile and can be used for all three types of reading. Which method you use depends not only on the equipment you have to hand, but also on the subject, how accessible it is, and the way it is lit. Direct, reflected light readings with either the camera's TTL system or a hand-held meter are ideal for uncomplicated lighting situations where there are no great tonal differences. When the scene contains bright highlights and deep shadows next to each other, however, an average reading from the camera position may not give the correct exposure for important parts of the subject. Then, in order to use a reflected light meter, two readings have to be taken – one

Average reading

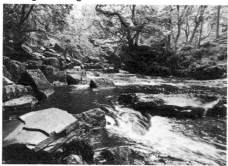

High-low reading

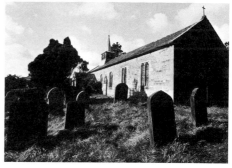

TTL meters

An average scene such as this has a limited range of contrast, without extremes. Simply rely on the overall reading. Most TTL systems are weighted to the centre or lower centre of the frame, which in this case is representative of the whole. Precautions would also be unnecessary when using an automatic camera.

The sunlit and shadowed parts of this church and cemetery are both important, yet the scene has a high contrast level. Move in close with the camera to take two separate TTL readings, one from the brightly lit wall, the other from the dark wall. Select an aperture and shutter combination midway between the two.

Hand-held meters
reflected
For a reflected light reading, use a hand-held meter exactly as the camera's TTL meter. Under an open sky, however, shield the top of the meter with your hand to prevent it from responding to the sun or clouds.
incident
For an incident reading, hold the meter (with its translucent dome fitted) in the same light as the subject and aim it at the camera. In the scene above, the reading can be taken from the camera position.

Use a reflected light hand-held meter in the same way as the TTL meter, approaching the church close enough to take two readings – highlight and shadow.

A high-low incident reading can be taken from the camera position by first holding the meter in the sunlight, and then shading it. Set the camera midway between the two readings.

Spot meters
As a spot meter measures over an angle of only 1°, it is not really suitable for average readings. Aim it at several parts of the scene and take the mean setting.

A spot meter can take high-low readings very easily. Aim at the two areas marked on the photograph.

from the brightly lit part, the other from the shadowed area – and the exposure set halfway between. Doing this usually means approaching closer to the subject than the shooting position, which may not always be convenient or possible, and here a spot meter comes into its own. If you have a long-focus lens, you can use it with the TTL meter. Simply take a reading with a long-focus lens pointed at the part of the scene you want to meter.

When the main subject occupies a small part of the picture frame, and is either much lighter or much darker than the background, then a key reading is the only answer. Here, the most important tone in the scene is identified – say, the sunlit portion of a face – and the reading

taken from it. With a hand-held meter adjusted for incident readings, the meter is held in the same light as the key subject and pointed towards the camera. The light falling on the subject is measured, not the light reflected from it. With TTL meters, key readings can either be taken close to, or from a convenient surface that acts as a substitute for the subject – the most accurate substitute is a grey card that is exactly average in tone (see pages 14–15), but many photographers find it easier to use the back of their hand, making adjustments based on experience to allow for their skin tone being darker or lighter than average. Even a plain white card can be used, lightening the exposure by three stops from the indicated reading.

Key reading	Substitute reading
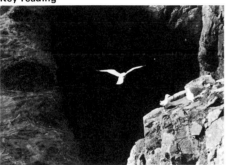	
In this high contrast scene, the exposure setting should be made for the seagulls alone, ignoring the shadow areas. With a TTL meter, either approach close enough to take a reading from this desired area or, as in the case of this inaccessible cliff, fit a long-focus lens to take the reading (thus using the camera as a spot meter). Some TTL systems have a useful spot reading facility.	When a subject is inaccessible and is difficult to meter by normal methods, take the reading from an 18 per cent grey tone, as printed on the next pages. This aircraft is moving rapidly against a light background, which would over-influence a TTL reading. Hold the 18 per cent grey tone in the same light as the subject, aim the camera at it, and take the reading.
The broad coverage of most hand-held meters makes them unsuitable for key readings, unless they have a telephoto attachment.	Use the hand-held meter in the same way as the TTL meter.
By holding an incident meter in the same light as the key subject, a satisfactory measurement can be taken. In this case, the meter should be in bright sunlight.	Not applicable.
This is the type of photograph for which a spot meter is ideally suited. Here, a reading can be made directly from the rock on which the birds are perching. A reading from the seagulls themselves would cause under-exposure as their plumage is much lighter than an average surface.	Use a spot meter in the same way as above.

18 per cent grey for substitute readings

The grey shading on these two pages has been carefully printed to give an average tone – reflecting 18 per cent of the light falling on it. Use it to make a substitute light reading in the following way.

Hold the book open at these pages so that they receive the same lighting as the subject. Aim the camera so that both pages fill the screen and take a through-the-lens reading. Alternatively, point a hand-held meter towards them, being careful not to cast a shadow that would affect the reading. If you have more than one meter, regularly compare readings from this grey tone to make sure that they are still accurate.

Daylight exposure guide

If for any reason you are unable to make an accurate meter reading (because of failed batteries or a broken meter, for example), use the exposure setting for whichever of the examples on these pages most resembles the scene in front of you. They are all common, middle-of-the-day situations. For more unusual lighting conditions, see pages 42–47. You can also use these settings as a rough comparison for your meter readings. If your meter consistently gives exposure readings more than one stop different from these examples, check it.

The settings are given for three basic film speeds – ASA 64, 125 and 400. If the film you are using has a different speed, the adjustment is easy to make – ASA ratings are on a linear scale, so that ASA 32 is half the speed of ASA 64, and therefore one stop slower. The scale right shows ASA speeds in steps of one-third of a stop. Going down the scale, every third figure is one stop faster.

As a last resort, use this neat, simple formula as a basis for bracketing:

For typical, frontally lit subjects in sunlight,

$$\text{Exposure} = \frac{1}{\text{ASA rating}} \text{ second at f16.}$$

For example, with Plus-X or FP4, shoot at 1/125 sec at f16.

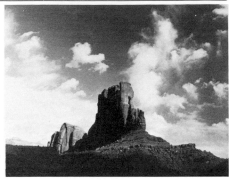

Bright sun Hard shadows with high contrast.
ASA 64: 1/250 sec at f8
ASA 125: 1/250 sec at f11
ASA 400: 1/500 sec at f14

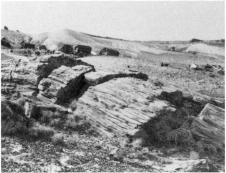

Hazy sun Weak but definite shadows. Distant views lack contrast.
ASA 64: 1/250 sec at f5.6
ASA 125: 1/250 sec at f8
ASA 400: 1/500 sec at f10

Overcast No shadow edges. The sky is lighter than the ground.
ASA 64: 1/125 sec at f5.6
ASA 125: 1/250 sec at f5.6
ASA 400: 1/250 sec at f10

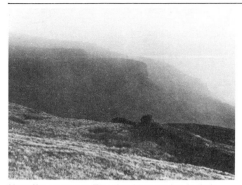

Heavily overcast The visual impression is dark.
No shadows.
ASA 64: 1/60 sec at f4
ASA 125: 1/60 sec at f5.6
ASA 400: 1/125 sec at f7

Fog and mist Light levels are unpredictable. This
example shows moderate sea mist with a clear sky.
ASA 64: 1/125 sec at f6.8
ASA 125: 1/250 sec at f6.8
ASA 400: 1/250 sec at f11

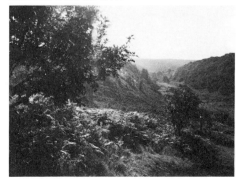

Backlighting Contrast very high. This example
shows low but bright sun in a clear sky.
ASA 64: 1/250 sec at f11 to hold sky
ASA 125: 1/500 sec at f11 to hold sky
ASA 400: 1/1,000 sec at f14 to hold sky

ASA	Film makes Colour (daylight)	Black-and-white
25	Kodachrome 25	Agfapan 25
32		Kodak Panatomic-X
40		
50	Agfachrome 50L, Agfacolor CT18	Ilford Pan F
64	Kodachrome 64, Ektachrome 64	
80	Agfacolor 80S, Agfa CNS2	
100	Fujicolor 100, Sakurachrome R100, 3M Color Slide, Agfacolor CT21, Kodacolor II, Kodak Vericolor II, Fujicolor FII, Sakuracolor II	3M 100, Agfapan 100
125		Kodak Plus-X, Ilford FP4, Agfa Isopan
160		
200	Ektachrome 200	
250		
320		
400	Ektachrome 400, Kodacolor 400, Agfacolor CNS400, Fujicolor 400, Sakuracolor 400, 3M 400	Kodak Tri-X, Ilford HP5, Agfapan 400, Fuji Neopan 400
500		
650		
800		
1000		Kodak Recording Film 2475

The apertures given in these examples are precise
and will not, therefore, always correspond to the
numerical scale of settings marked on the lens'
aperture adjustment ring. f14, for example, is
equivalent to f16 opened up one third of a stop. For
the full range of fractions see the table on page 119.

17

The zone system

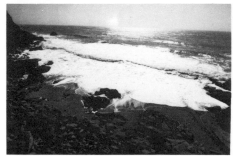

An important help in judging both correct exposure and contrast in a scene, Ansel Adams' Zone System assigns all tonal values to a simple scale of ten, each tone differing by exactly one f-stop from its neighbour. Zone 0 is solid black, Zone IX pure white, and Zone V average (the same as the 18 per cent grey reproduced on pages 14–15). By fitting key areas in the scene to the appropriate zones (follow the zone description below), the range of contrast can be easily discovered. An average subject covers about seven zones (thus also seven stops). This is also the capability of Polaroid Type 52 and most Grade 2 papers, and indicates a brightness range of 64:1. Average negative films can usefully record detail up to a range of 128:1, and colour reversal films up to 32:1 (or six stops/zones). Beyond this range, a loss of detail has to be accepted or steps taken to reduce contrast. See pages 54–55 and 84–85.

Zone III, textured shadow, is generally regarded as an important tone to preserve and most photographers will set their shutter speed and aperture to obtain correct exposure in this zone. A quick analysis of the scene using the Zone System will indicate which areas, if any, will be outside the film's brightness range. Use the zone scale at the left of this page by holding it up to the scene in front of you, or by laying it against prints.

The photographs on these pages have zones assigned to give an idea of the range of tones in variously lit scenes.

What each zone represents
0	Solid black
I	Nearly black – no detail
II	First hint of texture
III	Textured shadow
IV	Average shadow value
V	Middle grey – 18 per cent
VI	Average Caucasian skin
VII	Light surfaces, such as skin highlights or concrete
VIII	Brightest textured value
IX	Pure white

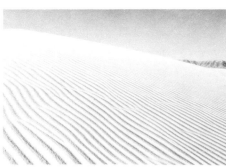

I

II

III

IV

V

VI

VII

VIII

IX

Low brightness level

Very high contrast 512:1 / 10 stops. Incident reading at ASA 125: 1/250 sec at f16. Strong sunlight and highly reflective surroundings give the highest brightness. Silhouettes give more contrast than films can record.

Very high contrast 512:1 / 10 stops. Incident reading at ASA 125: 1/4 sec at f2. Disregarding the street lights which contain no important detail, this dawn city scene still has a typically wide range of tones.

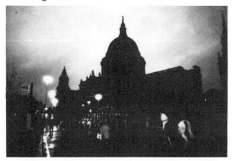

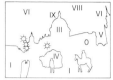

High contrast 128:1 / 8 stops. Incident reading at ASA 125: 1/250 sec at f11. Here, the high contrast caused by backlighting is increased further by the reflective differences between the dark rock and light sand.

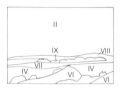

High contrast 128:1 / 8 stops. Incident reading at ASA 125: 1/15 sec at f5.6. Viewed just before sunset, this scene has an unexpectedly high contrast range, mainly because of the depth of the shadows.

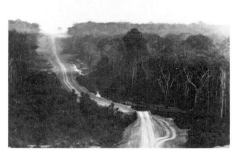

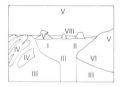

Medium contrast 56:1 / 7 stops. Incident reading at ASA 125: 1/250 sec at f8. Diffuse light from a hazy sun combined with subjects of average reflectance gives medium contrast, within the range of most films or papers.

Medium contrast 32:1 / 6 stops. Incident reading at ASA 125: 1/8 sec at f5.6. This overcast early morning view contains a greater range of contrast than might be expected. At first glance, the subject appears flat, but there are some deep shadows.

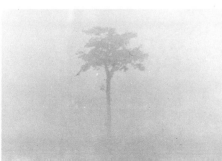

Low contrast 8:1 / 4 stops. Incident reading at ASA 125: 1/250 sec at f11. Provided the sun is behind the camera, extremely reflective surfaces fill in shadows and reduce contrast.

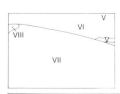

Low contrast 4:1 / 3 stops. Incident reading at ASA 125: 1/2 sec at f5.6. Fog and mist reduce contrast more than any other natural condition. There is considerable choice of exposure, depending on subjective interpretation.

19

Colour temperature

Any substance, when heated, eventually glows red, then orange, yellow, white, and ultimately blue. Colour temperature is a measure of this, in Kelvins, which are similar to degrees centigrade. The sun at midday is the yardstick for 'white' illumination – 5,500K. Closer to the horizon, the thicker layer of atmosphere causes a scattering of the light, allowing only the longer, reddish wavelengths to pass, and the colour temperature at sunrise or sunset can be as low as 2,000K. At the other end of the scale, the reflected light from a blue midday sky can be as high as 12,000K (or even higher in mountains), giving a decided blue imbalance in the shadows.

These colour differences can be corrected back to 'white' by using colour correction filters of varying strengths. Yellowish filters (81 and 85) lower colour temperature, bluish filters (82 and 80) raise it. To simplify calculations, the *mired scale* is an alternative measure, and is equal to 1 million/Kelvins. Each filter has a mired shift value, positive or negative, which indicates how much it will alter colour temperature. On the table on this page, draw a straight line from the existing colour temperature to the one you want to achieve. Where the line crosses the central scale, use the filter indicated.

In many situations, however, you may prefer to record the sunlight as it appears and make no correction. A fully 'corrected' sunset, for example, would look very unusual.

Measuring colour temperature If precise calculations are required, colour temperature can be measured with a special meter. Most colour temperature meters compare the intensity of blue and red components in light, and can measure over a range from about 2,000K to 30,000K. Some models can also compare the green and red components, and can be used with fluorescent lighting.

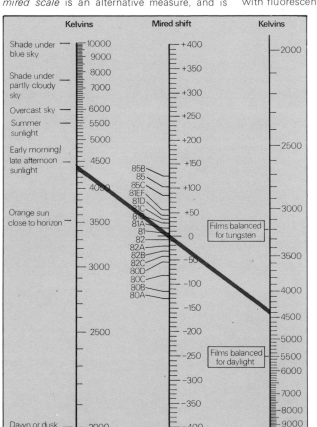

Daylight colour correction guide To convert the light from the common unbalanced sources listed below to 'mean noon daylight' – 5,500K – use the suggested colour balancing filters.

Shade under clear blue sky (10,000K)	85C
Shade under a partly cloudy sky (7,500K)	81EF
Overcast sky (6,000K)	81A
Orange sun close to horizon (3,500K)	82C +80D

Colour balancing filter table The table on the left can be used to calculate the mired shift value or the coding of filters for balancing any daylight source to the film you are using. Hold a straight edge from the colour temperature of the daylight at the left to the colour temperature the film is balanced for on the right (usually 5,500K or 3,200K) and read off the mired value and the required filter from the central scale.

Extreme daylight colour temperatures The sunset (above right) and the clear blue sky (below right) are common sources of unbalanced light. Note that it is the light reflected from the sky rather than the sun itself which is at greatest variance from the norm of 5,500K.

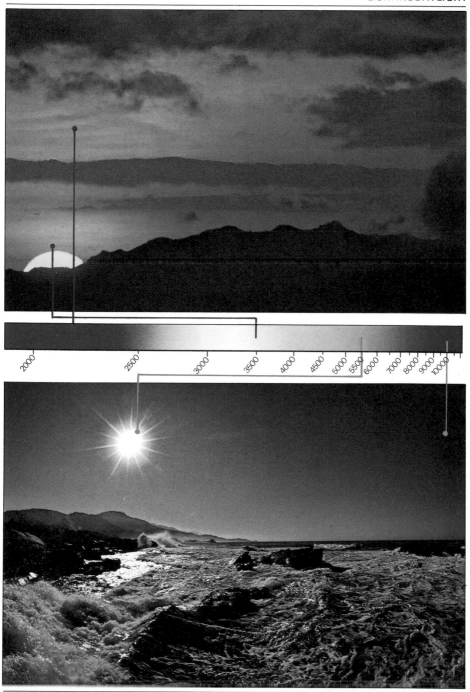

2000 2500 3000 3500 4000 4500 5000 5500 6000 7000 8000 9000 10000

Time of day

The position of the sun in the sky and the extent to which it is diffused by clouds or haze are the two factors that control the quality of natural light. Ignoring cloud cover for the time being, it is the height of the sun above the horizon that determines brightness and colour temperature, as well as more subtle qualities such as the texture and contrast of illuminated surfaces. The height of the sun depends on the time of day, season of the year, and geographical latitude.

Brightness When the sun is high above the horizon, its light passes through a lesser thickness of atmosphere than when it is low, and as a result is more intense. On a normally bright, clear summer day in middle latitudes, the highest incident light reading is in the region of 300 candles per square foot (c/ft^2), which would call for an exposure of 1/125 sec at f16 on ASA 125 film. At lower elevations, the intensity is less, as shown in the diagrams on these pages. Cloud cover also reduces the intensity, by up to four or five stops on a heavily overcast day (an incident reading of around 13 c/ft^2).

Colour temperature Differences in colour temperature, from the deep blue of a clear sky to the oranges and reds of sunrise and sunset, are caused by scattering. Air, dust and water vapour molecules all scatter the sun's radiation and, as the shorter, blue, wavelengths are scattered more easily, reflected light from the sky appears blue.

Scattering also causes the direct light from the sun to appear yellow, orange or red when close to the horizon by taking out the blue wavelengths, leaving the longer, redder, wavelengths. The more atmosphere that sunlight has to penetrate, the redder its direct light appears. At the point of sunrise or sunset, the sun's rays cut through the atmosphere at a very shallow angle, and so suffer the most scattering. Larger particles scatter all wavelengths equally, so that on very hazy days the sky appears whitish. The same is true of clouds.

Other qualities How much textural detail is revealed in a surface depends on the angle of light striking it. Direct sunlight just grazing a surface shows up the most texture so that, with most landscapes, a low sun gives the richest impression of detail. Diffused light reveals delicate texture poorly. Contrast is greater with direct, rather than diffused, sunlight and is most pronounced in the middle of the day, when shadows are found underneath objects. With a low sun, shadows are better illuminated by light reflected from the sky, and the level of contrast is reduced.

The quality of lighting is vital in achieving consistently good photography. Although natural light cannot really be controlled, understanding the interplay of such factors as the angle of the sun, reflected light from the sky and weather makes two things possible – the anticipation of lighting conditions and making the best use of any given time of day.

Sunlight through the day
This sequence of photographs shows the passage of the sun in late summer over a Mediterranean island. This is the simplest range of lighting conditions – with an uncomplicated subject and the sun in a clear sky.

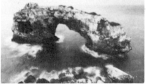
Pre-dawn

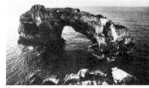
Sunrise

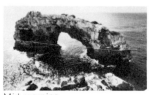
Mid morning

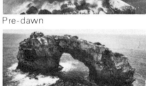
Noon

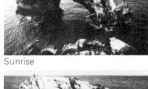
Mid afternoon

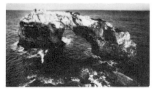
Late afternoon

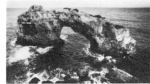
Sunset

Dusk

Summer

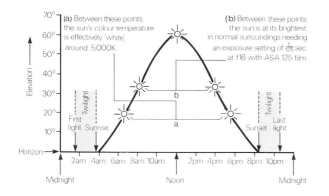

The position of the sun
Predicting the movement of the sun across the sky can give the basic information required for all outdoor photography. These graphs show the position of the sun during the course of the day for the seasons in western Europe and the northern United States. There are, of course, variations from year to year, between latitudes and from west to east across a time-zone. The graphs take no account of daylight-saving time.

The definition of twilight is largely subjective – here, the limit is visible light. With a cloudy sky, therefore, twilight is shorter than shown.

Spring or autumn

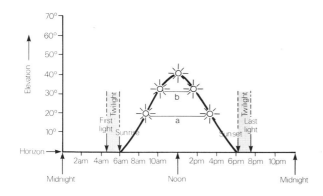

At the spring or autumn equinox, the earth is at the mid-point in its orbit around the sun – between summer and winter, depending on the hemisphere.

Winter

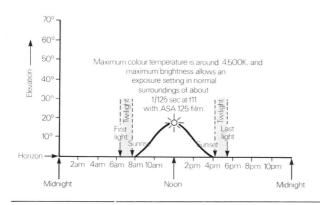

In middle to high latitudes, the winter sun is lower, even at midday, than many people imagine. Closer to the poles, the sun is even lower in winter and higher in summer. Nearer to the equator, on the other hand, there is much less difference in the sun's position in the different seasons.

Low sun

The early morning and late evening are the most valuable times of day for still photography. In the space of an hour or two, depending on the latitude, many different lighting situations are possible. Between a position roughly 30° above the horizon and sunrise or sunset, brightness and colour temperature change rapidly, shadows are long and move noticeably. Low raking sunlight is particularly good for showing the texture of a landscape, and when the shadows are nearly horizontal, subjects are often picked out dramatically against dark backgrounds. Picture possibilities are even further increased by exploiting different shooting angles relative to the sun. Shooting into the sun can make use of silhouettes; cross-lighting, with the sun to one side, gives strong local contrast and texture; and when the sun is behind the camera, it can often give rich, saturated colours. The chief drawback with low sun is when clouds are present. Precisely because the light is varied and unpredictable under these conditions, there is always a strong risk of the light rapidly becoming unsuitable for a carefully planned picture.

Intrinsically, there is no difference between sunrise and sunset, and they are usually impossible to tell apart in photographs. In some locations, however, local conditions lead to great differences between these two times of day. For instance, early morning mist forms over marshy areas if the nights are cool, completely altering the appearance of the sunrise, or daytime industrial pollution over some cities (Athens is a famous example) creates hazy, red sunsets that may have more character than the clearer sunrises.

Choosing between sunrise and sunset as a time to shoot often depends on the position of the subject and the viewpoint. Working this out in advance is not always easy. As a general rule, in middle latitudes the summer sun rises slightly to the north of east and sets to the north of west (to the south of east and the south of west in the southern hemipshere), while in winter it rises to the south of east and sets to the south of west. Only in the tropics does the sun rise and set almost vertically. Shooting at dawn means rising early, and predicting the exact point of sunrise can be difficult. In the northern hemisphere first light is always to the north of sunrise, and in fairly high latitudes the dawn light moves quite a distance to the right before the sun appears. Again, these directions are reversed in the southern hemisphere. In the late afternoon, it is easier to predict the sun's path simply by watching its angle of descent over a couple of hours. The light in the period before sunset usually seems less red at the time than it appears on the film, because the eye adapts to the slow change in colour temperature.

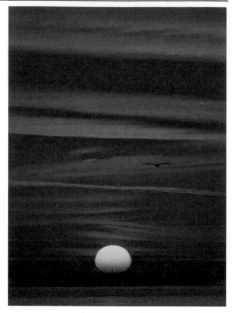

A setting or rising sun A fairly wide range of exposures is acceptable when the sun itself is the key subject – bracket over at least three stops. Generally, under-exposure is more acceptable than over-exposure, which loses the colour of the sun's disc.

Possibly the most over-used photographic cliché of all, a setting sun can nevertheless be given some new interest with dramatic clouds and a silhouetted shape such as this pelican. ASA 64: 1/250 sec at f5.6.

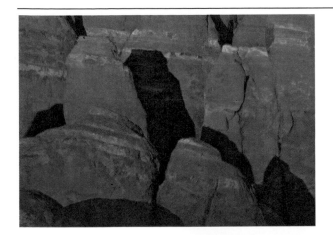

Cross-lighting When the sun is to one side of the camera, shadows are long and definite, emphasizing shapes. With some subjects, such as these blunted sandstone pinnacles, the arrangement of shadows can be used to create a graphic effect. Local contrast, as here, is high. ASA 64: 1/125 sec at f5.6.

The sun behind the camera Facing directly away from a low sun, the lighting is warm and frontal, giving rich, saturated colours. Without strong shadows, the contrast is low. Half a stop under-exposure further increases colour saturation and exploits the lighting fully. ASA 64: 1/30 sec at f5.6.

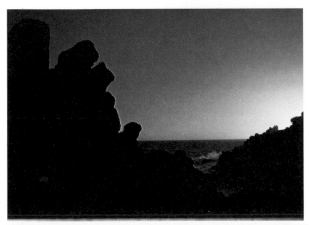

Silhouettes In the direction of sunset or sunrise, contrast is extremely high, and good use can be made of the outline of the subject. With a scene like this, set the exposure for the sky, not the foreground. An averaged exposure would give a pale skyline without showing any useful detail in the rocks. ASA 64: 1/60 sec at f4.

High sun

In most circumstances, the sun reaches its greatest intensity when it is 36° above the horizon. Higher than this there is hardly any increase in brightness, except where there are highly reflective surfaces such as snow or sand, and the colour temperature remains a fairly constant 5,500K 'white'. In the middle of summer, in middle latitudes, the sun reaches this point about four or five hours after sunrise and four or five hours before sunset, so that from mid morning to mid afternoon on a clear day the only change in the lighting is due to the position of the sun and the angle of shadows. You can check the elevation of the sun by using a 35mm camera with its standard 50mm or 55mm lens – hold it vertically so that the horizon is at the bottom of the frame. When the sun is at the top edge, its elevation is about 36–40°. Never look directly at the sun, however, even through a viewfinder, without using a protective filter. The recommended filter is a piece of fully developed (that is, black) black-and-white negative film. Photographic filters give no visual protection.

On bright days, a high sun gives stark lighting, almost lunar in quality. For many subjects, and portraits in particular, the contrast and the pooling of shadows make it an awkward, unflattering time of day for photography. Few subjects benefit from what amounts to a strong overhead spotlight, but there are many times

Portraits In high mountains, the midday summer sun gives both high contrast and high light levels. Portraits are usually more successful in the shade. Here the subject's wide hat shaded his face. Reflected sunlight from the ground reduced the contrast slightly, giving a rather unusual effect typical of a very high sun. ASA 64: 1/250 sec at f8

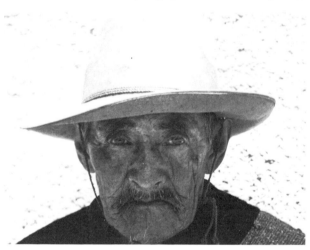

Silhouettes Choosing a camera position that catches the sun's reflection behind a subject gives very effective, graphic silhouettes. A wide range of exposures is acceptable and it is worth bracketing, using the direct meter reading to indicate the darkest exposure. ASA 64: 1/250 sec at f16.

when these conditions are unavoidable and there is no time to wait for better light. If a shot has to be taken under a harsh, direct sun, look for a composition that makes use of strong shapes and contrasting tones – by exaggerating the hard lighting and deep shadows, strong graphic pictures are possible. A deep red filter for black-and-white film and a polarizing filter for colour will further enhance contrast. Portraits are more of a problem, and in the absence of haze or light cloud to diffuse the sunlight, a shaded setting is usually the best answer. Sometimes, you can position the person you are photographing right at the edge of the shade so that the ground in front reflects light up into the face – the effect is not conventional, but usually effective.

One essential precaution to take with photography in the shade is to balance the colour temperature when using colour film. Shadows in the middle of the day are lit by reflected light from the sky, and if the air is clear, this is an intense blue, sometimes more than 10,000K. Because the eye adapts to moderate colour differences, it usually seems to be less blue than it really is. Use one of the light balancing filters recommended on pages 20–21.

Shooting against the sun at this time of day produces very high contrast indeed, as well as high light levels. Aiming upwards from a low position makes it possible to silhouette subjects. A special case, which can give dramatic pictures, is when a subject is silhouetted against the reflection of sunlight in water. To be really effective, this calls for the special circumstances when a long-focus lens and a fairly high camera viewpoint are appropriate.

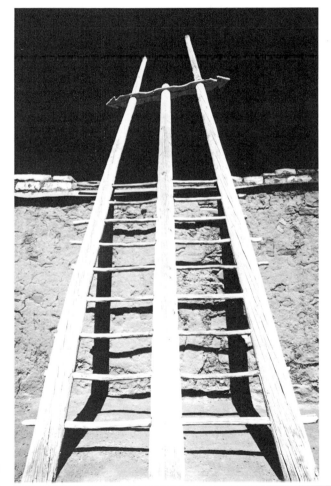

Strong shapes The normally unattractive hard shadows from a high sun can be put to work by choosing a subject that has an inherently strong shape or a very definite contrast in its surface. This ladder in an Indian village in Mexico appears more striking for the harsh lighting, deliberately accentuated with a polarizing filter.
ASA 64 with polarizing filter: 1/125 sec at f6.4.

Night and twilight

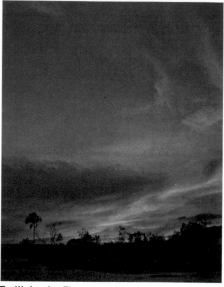

Reflected twilight One of the special qualities of twilight is a large, evenly toned sky. This is particularly effective with reflective surfaces such as water – here a river. With the sun below the horizon, the reflection is even, giving a simple, clean image. ASA 64: 1/15 sec at f8.

Twilight sky The most strikingly lit cloud formations occur when the sun is below the horizon. Depending on the weather conditions, the sun's rays may light the underside of clouds as here. The lighting at this time of day is usually unpredictable. ASA 64: 1/30 sec at f3.5.

Although extremely low light levels pose obvious difficulties, photography after sunset or before sunrise can produce unusual and interesting results. Moonlight, or the last traces of daylight, can be a useful alternative for some static subjects (mainly buildings and landscapes) that might otherwise look uninteresting in sunlight.

Twilight The easiest way of using the weak daylight when the sun is below the horizon is to silhouette subjects against the brightest parts of the sky. Using this technique, photography is possible even when the twilight is very weak, although it depends on the subject having an interesting or recognizable outline. Shooting subjects actually lit by twilight needs longer exposures, as the contrast is much lower. Used carefully, twilight can give the impression of night whilst still holding some detail and shapes. To preserve a night-time appearance, shots should be deliberately under-exposed, to the point where the basic outlines of the subject are just visible. Alternatively, full exposure can be given to the shot to obtain a mysterious or surreal type of effect.

Judging a precise exposure by twilight is inevitably hit or miss, partly because the light levels are low and partly because long exposures cause *reciprocity failure*. With exposures longer than a few minutes, it takes extremely long extra exposure, sometimes up to an hour or two, to have any significant effect on the film. By this time, with colour film, the colour shifts are difficult to predict. To keep exposures under about five minutes, use a fast film and fast lens whenever possible. (See also pages 66–67 for colour film and pages 84–85 for black-and-white.)

Use the metering techniques for available light situations described on pages 40–41, but remember that there is less latitude when twilight is the only source of illumination and there are no bright points of artificial light to lift the scene and define small areas of detail. As the light level is either rising or falling quickly, constantly monitor it with a CdS or other sensitive meter. In all cases, bracket exposures widely.

If stars appear in the shot, they will record as pinpoints only with exposures of less than about

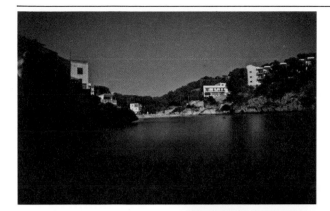

By moonlight Exposed on ASA 400 colour film for four minutes at f3.5, this Mediterranean bay by the light of a full moon appears almost the same as it would by sunlight – with hard shadows, high contrast and a blue sky. As moonlight is no more than a weak reflection of sunlight, this is natural, yet it seems surprising because of the eye's deficient night-time colour vision. With many films, but not this ASA 400 Ektachrome, reciprocity failure at long exposures causes colour shifts.

The moon The main problem with photographing the moon against a dark sky is accurately judging the exposure. The solution is bracketing – here four exposures were made, from 1/30 to 1/250 sec at f5.6 on ASA 64 film. 1/125 sec was most satisfactory.

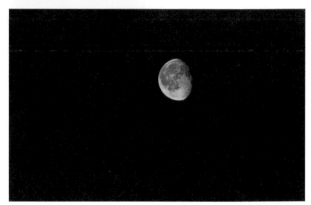

one minute with a standard lens. Longer than this and they will appear as short streaks. Watch out also for aircraft and satellites – cover the lens with your hand while they pass through the field of view.

Moonlight As illumination, the moon acts as a slightly smaller and much dimmer version of the sun. Because moonlight is simply reflected sunlight and the colour of the moon itself is neutral, there is no actual difference in colour from daylight. However, reciprocity failure introduces a colour shift in all colour films. Also, for largely psychological reasons, most people expect moonlit scenes to be slightly bluish and may be disconcerted by a photograph that shows other 'unreal' colours by moonlight.

Moonlight is about 400,000 times weaker than sunlight. As an average subject in bright sunlight needs an exposure of around 1/1,000 sec at f5.6 on ASA 125 film, the same subject under a full moon in a clear sky would need 400,000 times more exposure – around seven minutes at f5.6 or, with a moderately fast lens, one minute at f2. On top of this, you might have to increase the exposure by two or even four times

to allow for reciprocity failure. However, shorter exposures might be acceptable if you want the scene to appear dark. Be careful with exposures of more than an hour – the rotation of the earth will cause shadows to blur as the moon appears to move across the sky.

Photographing the moon Taking photographs of the moon rather than by its light is fairly straightforward. It can usually be managed with quite high shutter speeds, and reciprocity failure is not usually a problem. Exactly how bright the moon is at any given time and place depends on its elevation, its phase, and how clear the air is. As a starting point, a bright, clear full moon usually needs an exposure of f8 with ASA 125 film. Even with a 1,000mm lens, the moon's disc is still quite small in the frame of a 35mm camera, and a direct TTL meter reading is unreliable. If, on the other hand, the moon is lighting up a reasonable amount of light cloud, then follow the meter reading. The moon appears to move at a rate equal to its own diameter every two minutes. With a 400mm lens on a 35mm camera, this will cause blurring if the exposure is longer than one second.

Clouds, haze and fog

In the same way that studio lighting attachments modify lights, clouds and other atmospheric conditions alter the quality of sunlight by diffusing it and by acting as reflectors. The amount of diffusion depends on the thickness of the cloud cover and its height. A thin, high layer of cloud takes the edge off the harshness of direct sunlight while still preserving definite shadows. For portraiture in particular, it is a very useful weather condition. At the other extreme, a dense, low cloud diffuses the light over the whole sky – on a strongly overcast day it is impossible to tell the position of the sun, and shadows are virtually non-existent. Cloud cover can reduce brightness levels by up to four stops (see the diagram below).

Clouds also act as reflectors, filling in shadows and reducing contrast. The effect is moderate with a light scattering of fair weather cumulus, but with thick, continuous cloud cover it is very pronounced. While cloud reduces local contrast, the contrast between the ground and sky is increased, to the point where there may be a five or six stop difference between the two. Overcast conditions also give stronger colour saturation than direct sunlight – grass and vegetation appear a lusher green under a cloudy sky than in direct sunlight.

Atmospheric haze enhances aerial perspective by weakening the image of distant subjects. This often has the effect of simplifying landscapes by reducing the compositional elements to a few distinct planes. Film is more sensitive to the ultraviolet component in haze than is the eye, and so automatically exaggerates this effect. To enhance it deliberately with black-and-white film, use a blue filter (see pages 82–83). More extreme isolation of subjects occurs with fog, mist and very low cloud; individual trees or buildings, for instance, can appear to stand out clearly from their backgrounds.

Clouds can be used as an important element in a composition, provided that they have definite shapes (for example, cumulus or cirrus) or strong tonal differences (for example, thunderheads). To emphasize clouds, keep the horizon low in the picture frame and, if there is blue sky showing, use a polarizing filter (or a red filter with black-and-white film). Backlit clouds, if dense, have a high contrast range. Use a neutral graduated filter to bring the tonal value of the clouds in an overcast sky within the range of the film. The same filter can be used to make a stormy sky seem more threatening. Brown or orange graduated filters can sometimes be successful in enhancing the warmth of a sunset, but often give a false-looking effect.

High, thin cloud	Cloudy bright	Moderately overcast	Strongly overcast
Decrease in light level minus 1 stop	minus 2 stops	minus 3 stops	minus 4 stops

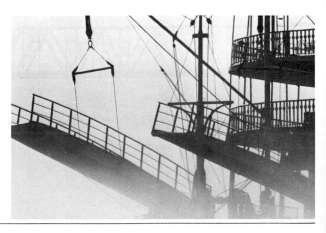

Approximating the visual appearance of a cloudy sky, each of the four skies above differs from its neighbour by one f-stop. The brightest is one stop darker than clear sunshine, the next two stops darker and so on. In changing conditions, compare the strip with the sky regularly and alter exposure settings accordingly.

Mist and fog These conditions simplify shapes, enhance the sense of distance, and reduce tonal values to a very narrow range. Interesting shapes, such as the deck and gangway of this Mississippi steamboat, make good subjects. Light levels vary greatly so bracket exposures. ASA 64: 1/125 sec at f2.8.

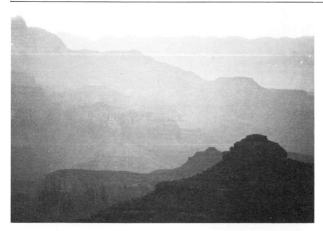

Haze Over great distances, as in this evening view of the Grand Canyon, haze causes pronounced ultraviolet scattering. This is most obvious towards the brightest part of the sky and tends to separate landscapes into distinct planes. Ultraviolet scattering records as blue on colour film.
ASA 64: 1/125 sec at f5.6.

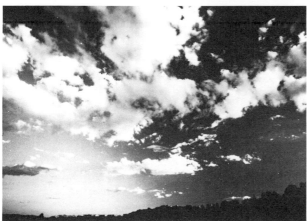

Clouds as subjects Clouds can in themselves be sufficiently interesting to be the main subject, although at least part of the horizon is usually needed to add substance to the picture. A wide-angle lens (here 20mm used on a 35mm camera) gives good coverage of the sky, and a polarizing filter helps increase contrast and colour saturation.
ASA 64 with polarizing filter: 1/60 sec at f4.

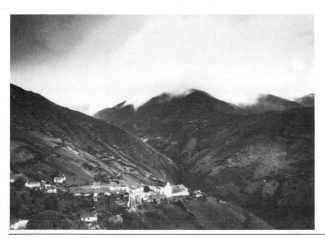

Clouds related to landscape Low clouds, particularly in hilly or mountainous country, can be treated as an integral part of the shot. A graduated filter will darken them even further, bringing them into the same tonal range as the land. A small identifiable subject, such as this Andean village, gives scale.
ASA 64: 1/60 sec at f5.6.

Bad weather

Storms, rain, snow and other kinds of bad weather need not inhibit photography, given certain basic precautions to protect the equipment. Precisely because these conditions are usually avoided by photographers, they have the advantage of appearing relatively fresh and different as settings. Moreover, most storms are inherently dramatic. Bad weather is usually active (falling rain, strong winds, fast-moving clouds), calling for rapid camera work. This favours small camera formats and fast film. Lighting conditions may change quickly, so be prepared to take advantage of a new situation at short notice, and bracket exposures. Rain and falling snow rarely appear as dominant in still photographs as they do in real life – the feeling of motion is often lost. Backlighting is best, although not always possible to achieve, and streetlights can be very effective for this, especially when they are just out of frame. At slow shutter speeds (1/4 sec and over), rain appears indistinct, and to capture individual snowflakes, use a speed of at least 1/125 sec.

To photograph lightning, aim the camera on a tripod in the direction of the previous flash as most lightning displays and electrical storms occur in sequences in the same general location, moving in the direction of the wind. Leave the shutter open – the lightning flash will then take its own picture. This only works when the overall light level is low enough for exposures of at least several seconds. Photographing lightning in daytime needs lucky timing and a large quantity of film.

Care of equipment For most bad weather situations, including rain, snow, the middle of cloud, and dust-storms, keep all equipment sealed until use. Treat all airborne moisture and particles as potentially damaging. Water is corrosive, seawater even more so, dust and grit are abrasive and penetrating.

When shooting, the best protection for most cameras is a transparent plastic bag, sealed, with a hole cut for the lens. Secure the bag around the front of the lens with a rubber band, and fit an ultraviolet filter to protect the front element. Prolonged use in rain will cause condensation on the inside of the bag, particularly in warm weather, so shoot quickly and return the camera to drier conditions. As an extra precaution, add a small sachet of silica gel desiccant to the bag. If the adverse conditions are more or less permanent, such as in the Arctic, tropical rainforest, or desert, more elaborate and considered preparation is necessary (see pages 206–207). Alternatively, use a waterproof camera, such as the Nikonos or Minolta Weathermatic.

In the event of an accident, or inadequate protection, see pages 152–153 for emergency procedures.

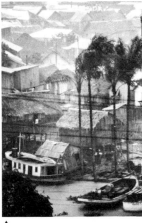

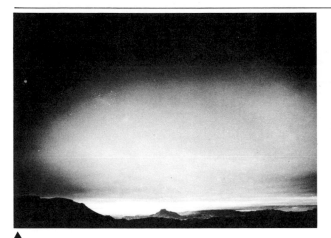

▲
Stormy skies Here, the thin strip of brighter weather in a Texan desert storm was emphasized by placing the horizon low in the frame to give weight to the overcast sky. Under-exposure added to the dramatic effect.
ASA 64: 1/125 sec at f6.4.

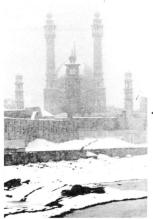

◀ **Rainbows** These pose no special photographic problems other than requiring a quick reaction. The essential ingredients are sunlight and rain, and as the refracted colours depend on the angle between the sun and the observer, the rainbow moves as you move, making it possible to alter the composition by changing your position. To record a full arc, a wide-angle lens is normally needed, but for a detailed view of the colours, use a medium long-focus lens, as in this shot.
ASA 64: 1/250 sec at f5.6.

▲
Rain Heavy rain, as in this tropical storm in Brazil, lowers contrast and can give an impressionistic result. The speed of the falling rain always blurs the individual drops, and the sense of a downpour is difficult to convey without the help of some other element, such as the strong winds in this scene.
ASA 64: 1/125 sec at f2.8.

◀ **Falling snow** In many ways, falling snow has the same effect as rain on the image – blurring outlines, reducing contrast and increasing aerial perspective. But individual flakes ramain distinct at normal shutter speeds, provided there is no strong wind, and the darkened sky of a snowstorm can be handled quite well with an averaging light meter.
ASA 64: 1/80 sec at 12.8.

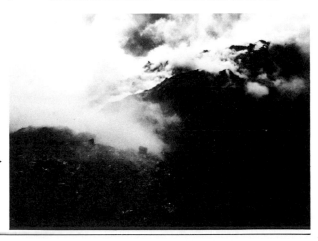

Volcanoes Extremely bad ▶ conditions, such as these sulphur dioxide clouds in the crater of a Central American volcano, can be treated similarly to other forms of bad weather. Under-exposure will enhance the drama.
ASA 64: 1/125 sec at f5.6.

Geographical location

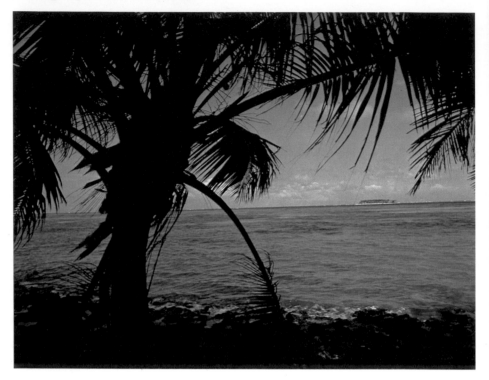

There are special lighting conditions at the extremes of latitude – close to the equator and in the polar regions – and in mountains. The elevation of the sun is the major factor in high or low latitudes, while the thinner atmosphere at altitude needs special precautions for ultraviolet scattering and high contrast.

Tropical light The overhead midday sun on or near the equator is rarely satisfactory for photography. In open spaces there may be virtually no shadows at all, making landscapes appear dull and formless. In forests and around buildings, on the other hand, the problem becomes one of too much contrast. Shadows are deep and highlights strong, creating a high local contrast range that is usually beyond the range of the film. Trees and vegetation commonly have a chiaroscuro pattern of small highlights and shadows that confuse images.

If photographs have to be taken at midday, calculate exposure for either the sunlight or the shadows, and if it is possible to move the subject completely into one or the other, so much the better. Light levels are difficult to estimate, because the elevation of the sun and the heat both create an impression of greater brightness than exists. As explained on page 26, there is very little increase in the sun's intensity once it is higher than 36°, yet psychologically it seems that there is more light. As a result, underexposure is a common fault unless the exposure meter's reading is followed rigorously.

The deliberate over-exposure and underdevelopment of film lowers contrast (see pages 66–67 and pages 84–85), and this may be a useful way of coping with the high contrast range, provided that you have access to a laboratory that will do altered processing.

Distant views with a long-focus lens may appear blurred due to heat shimmer. The only practical solution is to shoot early in the day, before the ground has had time to heat up. Ultraviolet scattering is high in humid tropical regions—use a strong ultraviolet filter on long-focus lenses and, with black-and-white film, an orange or red filter.

Early morning and late afternoon are better times of day for most photography, but because the sun rises and sets vertically, dusk and dawn are very short in the tropics.

Polar light In high latitudes, the sun is never very high, so a low lighting angle and low colour

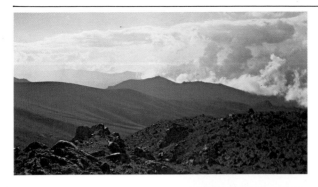

◀ **High altitude** High contrast and ultraviolet scattering over distances are the features of mountain areas in sunlight. Both are accentuated by shooting towards the sun, as in this Andean scene at 15,000 feet (4,500 metres). ASA 64: 1/125 sec at f16.

High latitudes Close to the Arctic and Antarctic circles, the sun remains very low. Noon in mid winter in Leningrad (latitude 60°, the same as Anchorage, Alaska) has the appearance of a sunset. ASA 64: 1/60 sec at f6.
▼

◀ **Tropics** The high contrast at midday between sunlight and shadow is typical of the tropics. It is nearly always better to expose for the sunlight, and use shadowed areas as silhouettes or frames. ASA 64: 1/250 sec at f11.

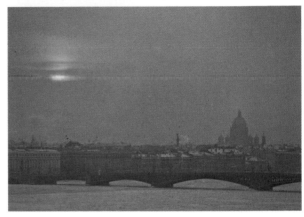

The tropical and polar sun Compare these sun graphs with those on page 23. Tropical twilight is very short, and both sunrise and sunset are rapid, whereas the Arctic sun changes very little through the day.
▼

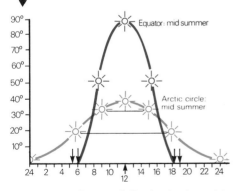

temperature is normal. On the Arctic and Antarctic circles, the maximum elevation of the sun on midsummer's day is 38°. As a result, on clear days the light is generally very favourable, much the same as shooting early or late in the day in middle latitudes. During the summer, there is no real darkness. The sun sets, if at all, in the north in the Arctic, and in the south in the Antarctic. During winter, on the other hand,

light levels are constantly low, and for at least part of the season there is no light at all.

The chief exposure problem in high latitudes is snow. Follow the exposure method outlined on pages 36–37, deciding first on the tonal value that the snow should have in the final photograph. With a low sun behind the camera, contrast levels are often low, and a fairly high-contrast film such as Kodachrome is useful.

High altitudes With increasing altitude, the atmosphere is thinner. For photography, this has two major effects. The first is a significant increase in ultraviolet radiation: there is less thickness of atmosphere to screen the ultraviolet wavelengths from the sun. The characteristic bluish haze can be partly eliminated by using strong ultraviolet or polarizing filters, and is less pronounced when shooting with the sun behind the camera or to one side than when shooting towards the sun. It is also less noticeable very early or late in the day. The second effect is an increase in local contrast. With fewer particles in the air, there is less scattering of reflected light into shadow areas, and the skylight is a much deeper blue – almost black at very high altitudes.

Reflective surroundings

In most locations, the environment adds very little to the lighting, but snow, light sand, sea and lakes make a noticeable difference. To a greater or lesser extent, all act as reflectors, throwing light back up into shadows, and increasing the overall brightness. With the sun behind the camera, this added reflection actually lowers the contrast range, although shots into the sun can have strong contrast.

Exposure problems usually occur because of errors of judgement. The extra brilliance of snow, in particular, upsets many people's ability to estimate exposure. Sunglasses, particularly photochromic ones, compound this problem. As a general rule, reflective surroundings increase the brightness level by about one stop, so that an average subject that might need an exposure of 1/250 sec at f11 on ASA 125 film in direct sunlight and normal surroundings, would need an exposure of 1/250 sec at f16 if surrounded by snow. Always use a lens shade to reduce the danger of flare.

To record texture and tones in snow, foaming waves and light sand, the most important step is to decide what tonal value they should have in the final print or transparency. For the most accurate results, use the Zone System scale on page 18. Sunlit snow and foaming waves generally look best when they are almost white, showing a hint of overall texture. On the Zone System scale, this is Zone VIII, which is three stops brighter than 18 per cent. If they appear any brighter than this, the texture will be lost and they will reproduce as a featureless white. The safest way of judging the exposure under these conditions is to take a close reading of just the sunlit area, and then increase the exposure by three stops. Alternatively, take an incident light reading, and follow that. Sand should appear less bright than snow, except for gypsum dunes such as White Sands, New Mexico. Zone VII would appear right for average sand – an increase in exposure of two stops over the reflected light reading.

The best lighting for these subjects is usually low, raking sunlight. This shows contours well, gives good contrast between sunlit and shadowed slopes, and reveals small differences of texture. Snow that is completely in shadow is difficult to photograph, and normally looks muddy. In colour, the shadows on snow very accurately reflect the colour temperature of the light reflected from the sky. In the middle of the day, under a clear sky, they appear blue.

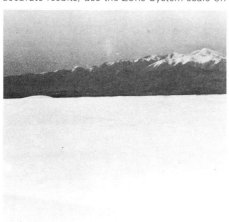

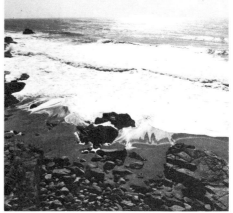

Low contrast Without direct sunlight, or with the sun behind the camera, the strong reflections from snow or sand tend to even out differences in contrast. The tonal range in this twilight view of White Sands. New Mexico with a snow-capped mountain in the distance, is extremely low, covering only three stops.
ASA 64: 1/30 sec at f2.8.

High contrast Quite different in appearance from the scene at left. the foam on this beach reflects morning sunlight to create very high contrast – a range of 10 stops. The high contrast is due to the backlighting and the dark tone of the rocks.
ASA 125: 1/250 sec at f16.

Sand dunes Dunes are particularly reflective, and have some of the qualities of snow or salt flats. To reproduce the tone accurately, the exposure was set at two stops lighter than the TTL reading.
ASA 64: 1/125 sec at f11.

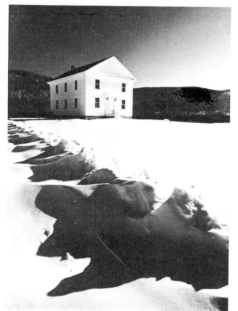

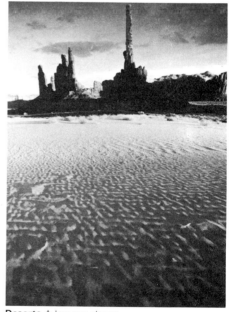

Snow One of the important qualities of snow is the sparkle of individual crystals. To capture this, shoot partly towards the sun. An incident light reading is the most reliable, but bracket for safety.
ASA 64: 1/125 sec at f14.

Deserts A low sun shows texture well. To cover the textural range of sand, from individual grains to the shape of dunes, use a wide-angle lens from a low position.
ASA 64 with polarizing filter: 1/60 sec at f8.

Available light

Available light is a catch-all term for non-photographic, artificial light sources. It is, in a sense, 'found' lighting and, being designed for visual illumination, is frequently unsatisfactory for colour film. The main types of available lighting found in outdoor night-time situations are tungsten, fluorescent, mercury vapour and sodium vapour. Because these are often photographed by twilight rather than in complete darkness, residual daylight is included here as an additional light source.

The colour balance of available light sources is their most important characteristic for photography. Several of them pose considerable problems because of their colour deficiencies, but in outdoor photography there is less of a crucial need to correct colours than there is in indoor photography. Exterior illumination from one artificial source rarely covers the whole of a picture and the limited colour cast may not be objectionable. Furthermore, if the actual lamps are included in the shot, they will normally record as a much paler colour by being over-exposed.

Tungsten The colour temperature of tungsten lamps depends on their rating – domestic lamps are much redder than photographic studio lights and are generally in the region of 2,500K to 2,900K. This is becoming a less common form of lighting for large-scale exteriors as it is more expensive in electricity than discharge lamps. It is still normal for domestic interiors, however, and is occasionally found as street-lighting in older urban areas. It is also used for light shows. Tungsten-rated film gives a truer rendering than daylight stock, and complete colour balancing is easily done by selecting the appropriate filter (see pages 20–21). Nevertheless, the reddish cast on unfiltered daylight film is often quite acceptable in street scenes.

Fluorescent Fluorescent lighting is now the most common type of artificial lighting. The purpose of the fluorescent coating on the inside of the tube is to spread the wavelength emission over a large part of the spectrum. Nevertheless, most fluorescent tubes are deficient in red, and if photographed without filters appear green. Because fluorescent lighting is so common, the filtration for all major makes is precisely known (see the table on these pages). However, unless you know the type of tube and its age, exact filtration is impossible without testing. When faced with an unknown fluorescent source, use a CC 30 Magenta filter with daylight film as a starting point.

Mercury vapour Frequently found as the major external illumination for industrial plant, and in some sports stadiums, these lamps do not emit a continuous spectrum, even though they may appear to the eye to be more or less white. They are strongly deficient in red, some more

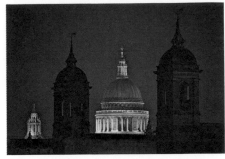
Sodium vapour

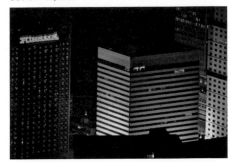
Fluorescent

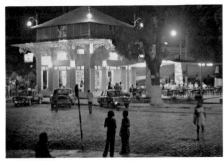
Mercury vapour

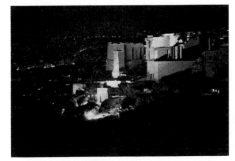
Tungsten, about 3,000K

than others, and if unfiltered appear blue-green on colour film. Without testing, there is no way of determining the exact filtration, as their light does not fit on the scale of colour temperature. Try a CC 20 Red or CC 40 Red filter with daylight film, possibly bracketing filtration around these. With some makes of mercury vapour lamp, it may be impossible to correct the colour imbalance completely.

Sodium vapour Commonly used as highway lighting in many cities, these lamps both appear and photograph yellow-orange. As with mercury vapour, sodium vapour lamps have a discontinuous spectrum, but are deficient in blue. Try a CC 20 Blue or CC 40 Blue filter with

daylight film, bracketing filtration and perhaps adding a CC 10 Magenta filter for one or two exposures.

Residual daylight A slight trace of daylight, after sunset or before sunrise, is very useful in addition to artificial available light to give overall form, particularly with distant views of towns and cities. The colour temperature of twilight varies from red to blue depending on the atmospheric haze and how far the sun is below the horizon, but if it does not dominate the shot, it is nearly always visually acceptable without filtration. Because the light level is low, you may need to correct reciprocity failure with filters (see pages 66–67 and 84–85).

Fluorescent lighting: filters and exposure increase

Type of lamp	Daylight	White	Warm white	Warm white delux	Cool white	Cool white delux
Daylight-balanced film	40M+30Y 1 stop	20C+30M 1 stop	40C+40M 1⅓ stops	60C+30M 1⅔ stops	30M ⅔ stop	30C+20M 1 stop
Tungsten-balanced film	85B+30M +10Y 1 stop	40M+40Y 1 stop	30M+20Y 1 stop	10Y ⅓ stop	50M+60Y 1⅓ stop	10M+30Y ⅔ stop

Mixed lights This evening shot combines, in different proportions, each type of available light, including residual daylight. The green street lighting in the centre is mercury vapour,

the bright row of public buildings are lit by sodium vapour lamps, and most of the shops use fluorescent lights. The small square beyond the clock tower is illuminated by tungsten lamps,

which also make up the scattered display lights. As with any overall view of city lights, there is no major source of illumination.

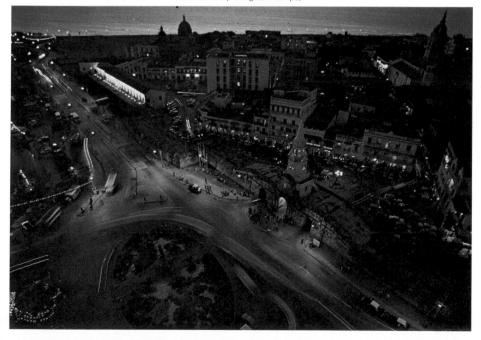

Available light techniques

The special difficulties of shooting in available light – low light levels, uneven illumination, high contrast and awkward colour balances – demand very specific techniques. To an extent, these difficulties are exaggerated versions of those found under more normal circumstances, and many of the low light techniques are dealt with more fully elsewhere: camera handling on pages 100 to 107, supports on pages 108 to 111 and focusing on pages 112 to 115. These two pages concentrate on some of the most important procedures as they apply to available light shooting.

Night lenses Lenses specially designed for night conditions normally have two special features: great light gathering power and good correction for flare. Light gathering is measured by maximum aperture, which is the way that most lenses are designated – an f2 Nikkor, for example. The fastest 35mm SLR lenses are around f1.2, although faster lenses are possible with simpler camera mechanics. Special correction for optical aberrations is important because many available light situations include naked lamps in the picture frame, and these typically cause flare, degrading the image.

Good correction calls for an aspherical front lens – one whose surface is an irregular curve. These are expensive to produce. Among the more normal designs, wide-angle lenses have some advantages at night. They are less prone than long-focus lenses to flare from, for example, streetlights and, because of their low magnification, they are much easier to hold steady at slow shutter speeds. Also, there will be less subject movement in the frame with wide-angle shots, and therefore less blurring (see pages 120–121).

Camera handling and supports Working in dim light invariably involves the use of slow shutter speeds. Many of the camera handling techniques illustrated on pages 100 to 107 are designed to reduce camera shake. Often, available light conditions are such that hand-held photography is not reliable, and for very slow shutter speeds you will need either to carry a conventional support, such as a tripod, or to make use of any platform you can find – the top of a low wall or a lamp-post, for example.

With deliberate practice, you can improve your ability with a hand-held camera at slow shutter speeds, and it is useful to know your

Low light with light sources in shot A night lens was used for this shot of a small harbour town. The lights of the town were an important part of the shot's interest, but it was important to keep the resulting flare to a minimum. The night lens's wide aperture (f1.2) and aspherical lens surface permitted a hand-held shot and controlled the flare to an acceptable level.

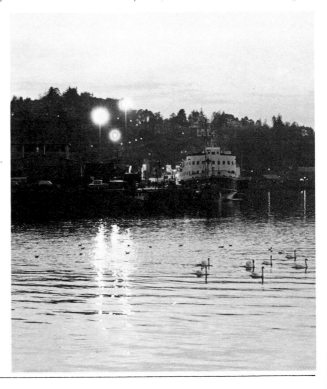

limits for any particular lens. For example, you may be able to avoid camera shake with a standard 50mm lens on a 35mm camera at speeds down to 1/15 sec, and with a 20mm lens down to 1/4 sec. When working close to these limits, take several exposures of each subject to improve the likelihood that one photograph will be in sharp focus.

Focusing Specific low light focusing techniques are described on pages 114–115. Once again, the problem is less severe with wide-angle lenses, which have greater depth of field and therefore need less critical focusing.

Exposure readings Valid exposure measurements are not always possible from the camera position, particularly when the subject is small and brightly lit in a large surrounding area of darkness – a person standing in a lighted doorway on a poorly lit street, for example. The typical situations on the following pages are a better guide to exposure under these conditions than metering. However, when using an exposure meter in dim light, consider the following:

1. Use a highly sensitive meter (with CdS, silicon or gallium cells) rather than a self-powered selenium cell meter.
2. With a TTL meter without light emitting diodes (LEDs), carry a small torch to make the viewfinder reading visible.
3. If your meter does not give readings for exposures longer than one or two seconds, change the ASA rating on the dial temporarily. For example, if you are using an ASA 25 film, and your TTL meter still shows under-exposure at maximum aperture and a 'B' setting on the shutter speed selector (two seconds), double the rating until you get a reading. If you need to set the meter at ASA 200 before a 'correct' exposure reading appears – an increase of three stops from the original two second setting – increase the exposure time accordingly, to 16 seconds in this case. Always remember to reset the ASA rating afterwards. At these long exposures, there will usually be reciprocity failure (see pages 66–67 and 84–85).

Film High-speed films have obvious advantages, although the coarse grain may not be suitable for all subjects, and with a tripod and a static subject a slow, fine grained film may be a better choice. From the descriptions of colour films on pages 54 to 59 and black-and-white on pages 76 to 79, choose the one that best suits the subject and working conditions.

Up-rating film (push-processing) may make the essential difference between camera shake and an acceptable image. Check the likely effects on pages 66 to 67 and 84 to 85.

TTL metering in poor light With some cameras, a small torch can be used to illuminate the TTL display. Shine it on the small window on the viewfinder housing that normally provides sufficient daylight for the display to be clearly visible.

ASA adjustment to obtain a reading If the TTL meter is still not giving you a reading at the slowest shutter speed, double the ASA rating on the camera's film speed dial until a satisfactory reading has been obtained. Then increase the exposure by the same number of stops. Remember to return the ASA dial to the correct setting.

Exposure guide 1

Many available light situations are difficult to meter. Contrast levels are often high, and an average of the shadow and highlight readings may be of little use if the main subject is either strongly or weakly lit. Many meters, particularly those with selenium cells, may not even register at low light levels. Small, brightly lit subjects at night are notoriously difficult to expose correctly – the surrounding blackness strongly upsets the reading.

For all these awkward picture-taking conditions, the best guide to exposure is ex-perience. The examples on the next six pages are drawn from practical assignments – all were widely bracketed and the most successful exposures are given here. Although the particular situation that you face is unlikely to be exactly the same, one of them should be sufficiently similar to be a starting point. When in doubt, bracket exposures widely, and if you are using colour film and are faced with the possibility of reciprocity failure (see page 28) and strange light sources, also bracket filtration in the way suggested.

Tungsten-lit interiors viewed from outside If the window area occupies a small part of the picture, an overall meter reading will indicate over-exposure. Instead, expose only for the interior. Here, the redness of 2,900K lamps on daylight film does not look as objectionable as it would if the interior filled the entire frame.
Daylight film, ASA 64: 1/4 sec at f2.8.

Bright tungsten lighting Very bright downtown theatre and night-club districts (in this case, Las Vegas) frequently allow hand-held shooting. If the display lighting is an important part of the shot, expose for that rather than the illumination at street level. Daylight film is satisfactory, and preferable to tungsten if neon lights are prominent.
Daylight film, ASA 64: 1/30 sec at f3.5.

Tungsten street lighting
Tungsten streetlamps spaced at intervals along a sidewalk give uneven, pooled lighting. The best compromise exposure for an overall shot is half or one stop more than needed for the most brightly lit parts.
Daylight film. ASA 64: 1 sec at f3.5.

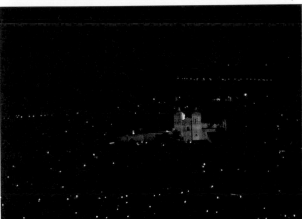

Distant view of a town
Without the benefit of twilight, a town in the distance appears as an unrecognizable collection of points of light unless there is a definite, well lit feature, such as this cathedral. Calculate exposure at about one stop more than needed for such key subjects.
Daylight film, ASA 64: 6 secs at f5.6.

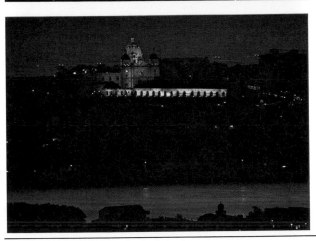

Twilight urban views Residual daylight gives the basic form to an overall shot that street lighting cannot. The artificial lights are best treated as subsidiary effects and to preserve the impression of night the exposure should be set at least one or two stops lower than the twilight reading indicates.
Daylight film, ASA 64: 1 sec at f5.6.

Floodlit buildings 1 The floodlighting on a large building, monument or fountain is usually uneven. To compensate for this, use an exposure that is one or two stops more than that needed for the most strongly lit areas. No filter was used for these sodium vapour lamps. Daylight film, ASA 64:1/2 sec at f3.5.

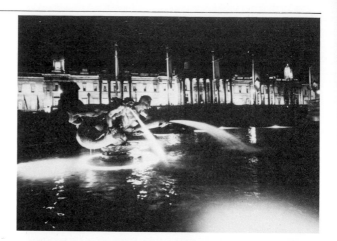

Floodlit buildings 2 When a floodlit building appears isolated in an area of darkness, disregard an average reading and set the exposure for the building alone. Floodlit buildings tend to have substantially similar levels of illumination. Daylight film, ASA 64: 1/2 sec at f4.

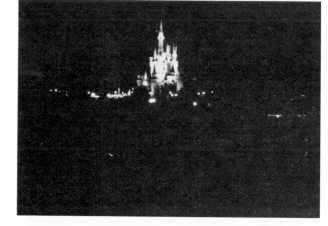

Overall cityscape The higher light levels and greater number of floodlit buildings make cities easier to photograph at night than towns. Nevertheless, for an overall view, a little residual daylight helps. This shot of Hong Kong was taken about three-quarters of an hour after sunset. Choose a high viewpoint where possible. Daylight film, ASA 64: 12 secs at f2.8.

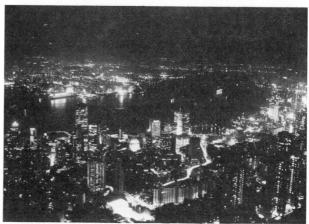

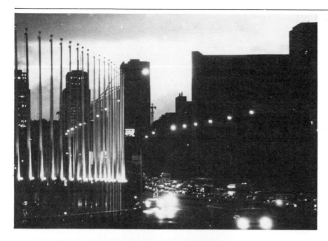

City traffic 1 One approach to traffic at night is to wait until the stream is halted, either because of congestion or traffic lights, and to shoot along the length of the road so that any cars that are moving show very little relative motion in the viewfinder. Individual cars and headlights then show clearly, with little blur. Daylight film, ASA 64: 1/15 sec at f5.6.

City traffic 2 An alternative approach to that at the top of the page is to make deliberate use of the streaking of car headlights and tail lights on a time exposure. The longer the exposure, the more striking this effect. Daylight film. ASA 64: 20 secs at f32.

Modern office buildings The interior lights in large, heavily windowed office blocks can make interesting patterns. Although usually fluorescent, they are nevertheless subsidiary illumination in a shot like this. A wide range of exposures is acceptable. Daylight film, ASA 64: 1/15 sec at f14.

Mixed vapour lighting When
yellow sodium vapour and blue-
green mercury vapour lamps
appear in the same scene, as
here, no filter can correct both. In
this case, a compromise filtration
of CC40 Red plus CC20 Yellow
was used, to correct the mercury
vapour partly. The extra colour
this gave to the clouds was
judged acceptable for evening.
Daylight film, ASA 64: 1 sec
at f6.8.

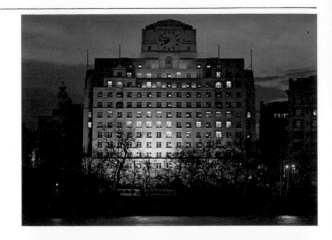

Neon displays Although
fluorescent lighting appears green
on colour film, in displays the
tubes are strongly coloured and
there is little point in using a
corrective filter. Fluorescent light
pulsates, so keep shutter speeds
slow – in any case no faster than
1/60 sec – in order to cover
several flickers.
Daylight film, ASA 64: 1/8 sec
at f5.6.

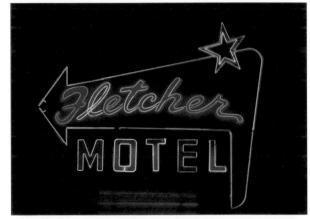

Car headlights In an
emergency, or for a special effect,
car headlights can be used as
lighting. Colour balance is usually
closer to 3,200K photographic
lamps than to domestic tungsten
lighting. Light intensity varies
between cars, and of course
depends on the distance to the
subject, obeying the inverse
square law (twice the distance
equals one quarter the
illumination). As a guide,
measure the light at 10 feet. At
20 feet open up two stops and at
40 feet a further two stops.
Daylight film, ASA 64: 1/4 sec
at f2.

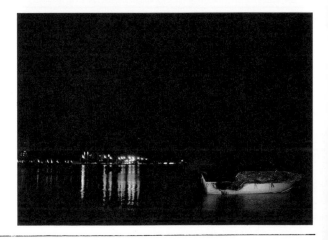

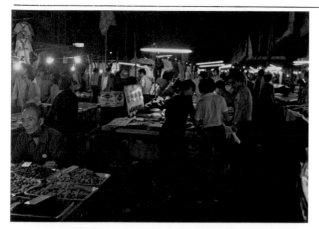

Mixed fluorescent and tungsten Unevenly lit, and with naked lamps in the picture frame, this street market had the added difficulty of mixed lighting, one reddish (tungsten), the other green (fluorescent). Filters for one would worsen the other, so none was used. Daylight film gave a compromise colour balance.
Daylight film, up-rated a half stop to ASA 600: 1/30 sec at f1.4.

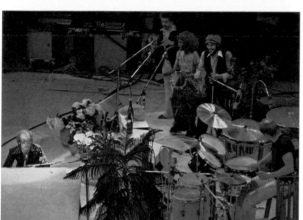

Rock concerts Because of movement on stage and quite low light levels, outdoor rock concerts must be shot on highly rated film, even if this involves push-processing (see pages 66–67). Heavy graininess is inevitable. Coloured tungsten spotlights predominate, but at the climax of a number higher powered plain spotlights are often used, allowing faster shutter speeds, as here.
Type B film, up-rated two stops to ASA 500: 1/60 sec at f5.6.

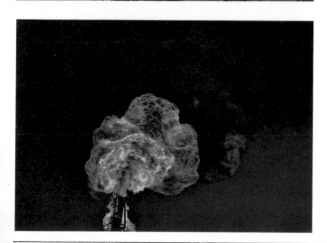

Flames When flames are the subject, set the exposure as the direct reading (TTL) indicates. Otherwise, over-exposure, which is tempting, will result in weaker colours. Daylight film gives a more intense red than tungsten-balanced film. Use as fast a shutter speed as possible to catch the movement of the flames.
Daylight film, ASA 64: 1/250 sec at f2.8.

Portable flash

Electronic flash units can be either manual or automatic. With manual units, the light output is fixed, and a calculator dial on the housing shows the aperture to use with any given film speed and subject distance. Automatic flash units incorporate a light-sensitive cell to measure the quantity of light reflected from the subject and circuitry that can quench the flash duration once a pre-set level of brightness is reached. A more sophisticated type of automatic flash is the integrated unit, designed to be used with a specific camera model. Extra contacts link the unit to the shutter speed and viewfinder information display to ensure consistent results, and with some models the flash output can be measured and controlled by the camera's TTL system. The more automated the unit, the fewer precautions need to be taken for accuracy and consistency. Equally though, there is less opportunity to vary the effect and use of the flash. Most automatic units have a manual setting, which delivers the maximum flash output at each firing.

Synchronization Between-the-lens shutters can be used at any speed with flash. Focal plane shutters are less flexible, and their fastest shutter speed for flash synchronization is around 1/60

sec–1/100 sec. Higher speeds cut part of the film off from the flash exposure. Maximum sync speed is normally designated 'X' on the camera's selector dial. Most portable flash units have a mounting that fits into the hot shoe of the camera. This automatically provides electrical contact. For cameras without built-in hot shoes, there is often some provision for fitting an adaptor. Otherwise, a co-axial sync lead is connected to the camera's 'X' sync terminal. An extension lead allows the flash to be fired at a distance from the camera.

Testing the unit The first step with any unit is to check the flash output. It may not always be as specified. More importantly, guide numbers given by manufacturers are always calculated for average indoor use, where reflective surroundings add to the brightness level. There are three standard measures of the power of a flash unit: joules (watt seconds), BCPS (Beam Candlepower-Seconds) and guide numbers. The first is a measure of electrical input to the head from the capacitor, and is really only relevant in studio work. BCPS is a bench-mark for comparing flash units and does not vary with film speed. The guide number is a practical method of calculating exposure. It is determined by the BCPS and the speed of the film you are using. Once calculated (see the table below), tape a note of both the BCPS and guide number

Checking the BCPS
Most manufacturers publish the BCPS of their units. The most accurate method of working it out independently is with a flash meter, some of which have a separate calibration for this purpose. If not, make a guide number test, and use the table for an approximate indication.

Checking the guide number
Guide numbers are recommended by manufacturers for general indoor use, in reflective surroundings. They are nearly always too optimistic for outdoor use. Make a test, outdoors and at night, using either a flash meter or a series of bracketed exposures on film. Use the unit at full power, or on the manual setting if an automatic unit, with the film that you normally use. Colour transparency film has the least latitude, and so is good for testing. The test subject should be average (say, a person), and at a known distance from the flash. At 10 feet (3.16m), for instance, with ASA 64 film, bracket widely around f8, noting each exposure. After processing, assess the film and choose the f number that gave the best result. Multiply this by the distance to give the guide number. If, in this example, the best exposure was at f8, then the guide number would be $(f)8 \times 10(ft) = 80$.

Portable flash units Electronic flash units now have very sophisticated performance: both efficient and controllable, given the limitations of portable flash as a source of illumination.

Manual flash unit The camera aperture must be adjusted to suit the fixed flash output.

Automatic flash unit With a sensor to measure the light reflected from the subject, the duration of the flash is controlled automatically. Here, a rotating head allows the use of bounced flash.

Recycling battery unit Here, the Norman 200B, with a very high level of flash output and rapid recharging ability.

on the flash unit housing for future reference.
Calculating exposure With automatic units, there is normally no need to make exposure calculations. Simply test the unit beforehand to make sure that it is consistently accurate. If the unit is manual, with a fixed flash output, then the most accurate exposure calculation can be made with a flash meter. Modern portable battery-operated flash meters are light and reliable, particularly if they use integrated circuits. If you do not have one, divide the guide number for the speed of film you are using by the distance to the subject. In other words, retrace the same steps taken to calculate the guide number in the first place.

Most units indicate that they are ready before they have accumulated a full charge. Wait at least five seconds after the ready-light glows. If you trigger the unit immediately, the output will be approximately 80 per cent of the full charge.
Positioning the flash Portable flash units are designed to be fired mainly from the camera position. This is convenient, but gives flat lighting, and in portraiture is often responsible for 'red-eye – red reflections from the subject's retinas. An alternative is to hold the flash high and to one side with your left hand, or to fit a longer extension lead and have a friend or assistant aim it from several feet to the side. Even this will not eliminate hard shadows. For a

softer, more diffused light, fit a translucent panel over the flash tube. In an emergency, use a white handkerchief, increasing the exposure by one stop to compensate for the light loss.

Bounce flash, where the flash is deliberately aimed at a ceiling, wall or other reflective surface to give a very diffused light, is rarely possible outdoors. Even if there is a convenient surface, much of the light will be lost, and this may be difficult to calculate. If the sensor on an automatic unit can be aimed at the subject independently of the flash head, the light loss will automatically be compensated for. Alternatively, use a flash meter to calculate the exposure or, as a very rough guide, increase the exposure between two and four stops, bracketing widely.

Another possibility is to position a second flash unit well to one side of the subject, to fill in shadows. So as not to introduce secondary shadows, the output of this second unit should be at most half that of the main flash. It can be triggered by an extension lead connected with the main flash to a small sync junction, or by means of a photo-cell slave unit.
Open flash With large night-time subjects, such as buildings, fix the camera on a tripod and lock the shutter open. Then walk around the subject, firing the flash by hand. Always make sure that at least the flash unit, and preferably yourself, is concealed from the camera position.

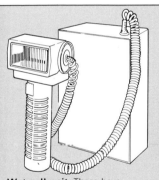

Wet cell unit These have increased power and durability. The flash head can be directed as desired.

Guide numbers for electronic flash

ASA film speed	BCPS output of electronic flash unit									
	350	500	700	1000	1400	2000	2800	4000	5600	8000
20	18	22	26	32	35	45	55	65	75	90
25	20	24	30	35	40	50	60	70	85	100
32	24	28	32	40	50	55	65	80	95	110
40	26	32	35	45	55	65	75	90	110	130
50	30	35	40	50	60	70	85	100	120	140
64	32	40	45	55	65	80	95	110	130	160
80	35	45	55	65	75	90	110	130	150	180
100	40	50	60	70	85	100	120	140	170	200
125	45	55	65	80	95	110	130	160	190	220
160	55	65	75	90	110	130	150	180	210	250
200	60	70	85	100	120	140	170	200	240	280
250	65	80	95	110	130	160	190	220	260	320
320	75	90	110	130	150	180	210	250	300	360
400	85	100	120	140	170	200	240	280	340	400
500	95	110	130	160	190	220	260	320	370	450
650	110	130	150	180	210	260	300	360	430	510
800	120	140	170	200	240	280	330	400	470	560
1000	130	160	190	220	260	320	380	450	530	630
1250	150	180	210	250	300	350	420	500	600	700
1600	170	200	240	280	340	400	480	560	670	800

Fill-in flash

Backlit subjects inevitably have a high contrast range, and an exposure setting that will record all detail in the subject will usually leave the background washed out. Conversely, if the background is correctly exposed, the subject may be virtually in silhouette. So, when it is important to balance subject and background, a portable flash unit can be used to fill in shadows.

The great danger with fill-in flash is the temptation to use too powerful a setting, so that the flash illumination dominates. This always looks unnatural, and rarely pleasing. For fill-in, the flash intensity must be at most half that of daylight. The simplest approach is to decide in advance the ratio of flash-to-daylight intensity. 1:2 is the maximum before the flash fill-in becomes overpowering, and the most useful range is between 1:2 and 1:8. The ratio can be balanced either by adjusting the flash output or the camera's shutter speed and aperture, or a combination of both. Remember that altering the shutter speed adjusts only the daylight

exposure, not the flash exposure. Which method you use will depend largely on the equipment. The limitations are:

With a manual unit, unless there is a power reduction selector, the only ways of reducing output are either to move the flash further away from the subject, or to cover over the flash tube. A set of neutral density filters cut to size is the most precise way, otherwise use a white handkerchief. Unfolded it will cut the light by about one stop, folded in half by about two stops, and so on. See pages 60–61 for a full list of neutral density filter strengths.

With a between-the-lens shutter, any shutter and aperture combination can be selected, so that the aperture can be increased or decreased to control the flash exposure without altering the daylight exposure.

With a focal plane shutter, only shutter speeds longer than about 1/80 sec can be used. This gives hardly any control at all, as these speeds are too slow for most moving subjects.

Handkerchief Flash intensity can be reduced by folding a white handkerchief over the tube.

Neutral density filter An N D filter shaped to cover the flash tube has a more precisely controlled effect.

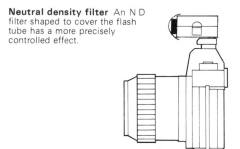

Procedure

1 If the flash is to be used strictly as fill-in, then the daylight reading must be the basic setting. Take the reading from the bright background, not the shadow areas of the subject, which will be lit by the flash. For example, this may be f16 at 1/60 sec.

2 Decide on the flash: daylight intensity. This is a subjective judgement and is easier to make with experience. At first, bracket ratios.

3 Reduce the flash exposure from its nominal setting for the subject by the most convenient method of the ones listed above. The chosen flash: daylight ratio determines the reduction, as follows:

Ratio	1:2	1:3	1:4	1:6	1:8
Reduce flash exposure by	1 stop	1½ stops	2 stops	2½ stops	3 stops

For instance, if the subject is 10 feet away and the flash unit's guide number is 80, then the nominal aperture for a full exposure would be f8 (guide number divided by distance). Now, if the chosen ratio is 1:2, the exposure should be one stop darker. Altering the aperture to f11 is one answer, but this may not suit the daylight setting. If the daylight exposure were f16 at 1/60 sec, then the following choices would be available: with a between-the-lens shutter, change the camera setting to f11 at 1/125 sec; with a focal plane shutter, do not alter the aperture, but place a neutral density ND0.3 filter (or handkerchief) over the flash. Alternatively, move the flash back so that it is about 14 feet from the subject. The flash unit should be set at manual, or the sensor taped over.

Varying the fill-in ratio This portrait was lit from behind the subject, and fill-in flash was needed. The best exposure setting for the background was f8 at 1/125 sec. Without flash, the girl's face is dark.

Here, a portable flash unit was used from the camera position, but at one quarter of the power that would be needed if it were the only source of illumination. The effect is a slight lightening of the face.

Increasing the flash output to one half of its nominal setting gave a more definite fill-in. There are slight highlights on the upper cheeks, but these are scarcely noticeable.

With the flash used at full-power, the balance was definitely artificial, and facial highlights became prominent.

Neutral density filters were placed over the flash tube for this series of photographs as described opposite in order to control the intensity of the flash.

Location lighting

With elaborately set up shots in an outdoor location, it may be necessary to control the sunlight or introduce artificial lighting in order to create a desired effect. Location lighting may be as simple as providing fill-in sunlight with a white reflector, or as complex as running a battery of flash heads from a portable generator.

Controlling sunlight Large reflectors are the simplest method of filling in shadowed areas. Sheets of expanded polystyrene (styrofoam) are convenient, being light but rigid. They can be used white or covered with crumpled silver foil or silvered plastic for a stronger fill-in. Direct sunlight can be modified by hanging a large sheet of translucent cloth such as net or scrim (seamless paper is too fragile) on a light wooden frame. For overhead use, this can be supported on lighting stands. Alternatively, sunlight can be blocked entirely from a shot by means of a black-out – a sheet of black cloth hung between two poles.

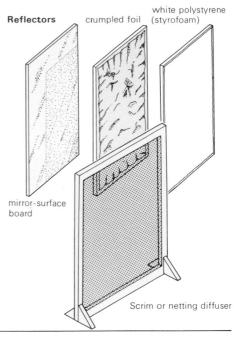

Reflectors crumpled foil white polystyrene (styrofoam)

mirror-surface board

Scrim or netting diffuser

Portable lighting Portability is usually important for location lighting, saving time and labour. If the shot can be lit with battery-powered lights, so much the better. For portable flash units, see the checklist on page 48. An alternative is to use battery-portable tungsten lamps designed for TV and motion picture use. These typically supply 30 volts to 150, 250 or 350 watt bulbs. Make sure that lighting and film are colour balanced, particularly when using supplementary tungsten lighting in daylight. To achieve colour balance, cover the lamp with a blue gelatin dichroic filter. Heat resistant blue gelatin is available in full strength (-131 mired, the equivalent of 80A), half-strength (-67 mired, the equivalent of 78B) and quarter-strength (-32, the equivalent of 82B).

An inevitable problem with battery-portable lights is that, because of their small size, the effect of the lighting is frequently hard, with unwanted areas of brightness known as 'hot spots'. This can sometimes be corrected by aiming the lights indirectly so that the subject is illuminated by the outer area of light or 'spill'. The best control, however, is to use a diffuser.

For more powerful lighting, virtually any studio flash or tungsten lights can be used, but setting them up can be a lengthy process. Either a mains power supply must be found or a portable generator must be carried.

Battery-powered tungsten lamp

Twin lamps and stands in carrying case

Power supply If power for lights is to be drawn from a local power point, check both the maximum power you will require and the location of the power supply well in advance. For small power requirements, domestic outlets in a nearby house may be sufficient. The load can be spread by using outlets in different parts of a building, and even more power is available at the point where the electricity supply comes into the building. To avoid frustrating hold-ups, you should also check the following in advance:
– the lengths of cable needed
– that you have adequate fusing
– the location of the power supply's main switch, in case of emergency
– that you have the correct plug and outlet fittings.

If there is no accessible mains supply, take a portable generator. A small petrol (gasoline) engine generator is usually sufficient for even quite ambitious location lighting. For example, a 3kW (3,000 watt) generator will power a 5,000 Joule flash power pack, and a 2kW generator will power a 1,000 Joule pack.

The voltage drop that results as the length of cable increases is another factor to take into account. It will lower the colour temperature of tungsten lamps, and you should thus keep the distance between the power outlet and the lights to a minimum. The capacity of a cable is reduced by heat, so never use a cable that is partly wound on its drum as this will cause inductance heating. Finally, make sure that the cables can carry the amperage needed. The calculations are as follows: amps equal watts divided by volts; and watts equal amps times volts, so that with a 1,000 watt lamp the amperage is 9.1 on 110/120 volts and 4.6 on 220/240 volts. Add the wattages together to find the total load if one cable has to carry the supply for several lights.

Portable generator

Location effects In addition to lighting, weather effects may be needed on location. *Fog* is produced by a fog generator, which emits small drops of oil heated to quite high temperatures by a burner. There is some fire risk, and the oily smoke can be harmful to cameras and other equipment. An alternative, for small quantities of ground mist, is to place dry ice chips (frozen carbon dioxide) in pails of hot water. Artificial fog disperses quickly in the slightest breeze. *Wind* can be created by a studio wind machine. *Rain* is difficult to produce convincingly, and needs a mains water supply with good pressure. The established method is to run perforated pipes over the scene, connecting them to the water supply. The higher the pipes, the greater the pressure needed.

Wind machine

Fogmaker

Rain-making frame

2. FILM
Colour film

Colour film is more susceptible to both poor storage conditions and processing errors than black-and-white, and so needs considerable care and attention at all stages. For consistent results, stick to a very few makes and types of film rather than frequently changing brands. Store film under reliable conditions before use, and use, if possible, a single processing laboratory that you are confident in. Despite home-processing kits, few individual photographers can equal the consistency of a good lab. Colour processing is a specialized business, best left to the professionals.

Colour balance To maintain a good, consistent colour balance, buy quantities of the same batch number of film. The colour balance between different batches of film from the same manufacturer can vary considerably.

Some film manufacturers produce two versions of the same type of film: one designated 'professional', and the other for general, amateur use. The main difference is that the professional film is at its best when it leaves the factory, and

the photographer is expected to use it immediately or store it at a low temperature to prevent ageing, while 'amateur' film is designed to be held by a photographic supplier for up to three months and then be at its best. In theory, professional film is made to more accurate standards, but amateur film holds its colour balance better.

Processing variations can also cause colour differences. Find a processing laboratory that gives you consistent results and stick to it.

Storage Film ages faster in high temperatures, high humidity, or worse still, both together. In addition, film that has been exposed but is still unprocessed is more susceptible to deterioration than fresh, unexposed film. As a general rule, keep all unprocessed film cool and dry, and process it as soon as possible.

The ideal temperature conditions for storage over a short period of time are below 16°C (60°F) at a relative humidity of 40 to 60 per cent. Lower temperatures are even better, but only if the film is sealed in moisture-proof containers,

Batch numbers As well as the suggested expiry date on the film pack (film will anyway last much longer if properly stored), the manufacturer's batch number will be given. For assignments where consistent colour between rolls is required, make sure you use films from the same batch. The variations can be considerable.

Altering contrast with colour film
Contrast can be controlled at practically every stage of photography, from taking the picture to processing. For black-and-white film see pages 84–85

To decrease contrast
1. Choose a low-contrast film (pages 56–59)
2. Use fill-in lighting (pages 50–53)
3. Shade off direct sunlight (pages 52–53)
4. Wait for the daylight conditions to change
5. Over-expose and under-develop the film (pages 66–67)
6. Pre-expose the film (pages 94–95)
7. Use a fog or diffusing filter (pages 62–63)
8. Use a graduated filter to darken light areas
9. Deliberately introduce flare
10. Have weak contrast masks made, to sandwich with a transparency or combine with a negative in the printing
11. Retouch

To increase contrast
1. Choose a high-contrast film (pages 56–59)
2. Add lights to imitate direct sunlight (pages 52–53)
3. Wait for daylight conditions to change
4. Under-expose and over-develop the film (pages 66–67)
5. Shade the lens as efficiently as possible (pages 118–119)
6. Use a graduated filter to darken the dark areas
7. Make a copy negative or transparency, which will automatically have higher contrast
8. Retouch

as cold increases the relative humidity. 4°C (40°F) in a refrigerator is good for general storage or −18°C (0°F) in a freezer will halt any ageing. When removing film from a cold store, allow it to warm up gently at room temperature before opening the pack, or condensation will form on the surface of the film. In any case, do not open cans or boxes of film before you are ready to use them – they have been packed at the factory in low humidity conditions.

When travelling, film is best kept in a container that is at least partially insulated – a polystyrene (styrofoam) lined picnic box is ideal. In humid conditions, include a desiccant with opened film, and leave the minimum possible empty space in the container for moist air to collect. The most common desiccant is silica gel powder or crystals, which can absorb large quantities of moisture. Keep the silica gel in small cloth bags for convenient handling and to prevent its dust from reaching the film. Periodically dry out the desiccant by heating it to 200°C (390°F). Never use silica gel when the atmosphere is already dry, as it may crack the film's emulsion or give rise to marks caused by static electricity. For storage precautions under extreme conditions, see pages 206–207.

Processing At home, trial and error will find the processing lab that gives you the most satisfactory results. A long-standing relationship with one can be a great asset. When travelling, it is usually best to keep the unprocessed film with you, stored carefully, and have it processed at your regular lab on your return. This, however, is only possible when you are travelling for a short period of time and can keep the film cool and dry. Otherwise, you must choose between sending the film home or having it processed locally. Sending film back is risky, not only because of the danger of loss, but because it may be exposed to damaging conditions such as heat or X-rays at airport security checks. The safest method is to send it in the charge of someone you know personally who is returning, or alternatively by courier, although this can be very expensive. Air freight is the next best choice, and the regular mail the last. If there is an international press representative or agency in town, or even a consul, they may be able to help, or at least advise.

To choose a reliable local processing lab, ask the opinion of local professional photographers. If there is no commercial lab, local photographers will process their own film, and you can arrange for one of them to handle yours. As a precaution, try a test roll in the first instance.

Kodachrome film, despite its popularity, can be processed at very few places in the world. Below are listed all the Kodak laboratories that currently accept Kodachrome. In addition, a few independent labs can also process Kodachrome, chiefly in the United States.

Kodachrome processing laboratories

Australia
Kodak (Australasia) Pty Ltd, PO Box 4742, Spencer Street, Melbourne, Victoria 3001
Austria
Kodak GmbH, Albert Schweitzer-Gasse 4, A-1148 Vienna
Belgium
NV Kodak SA, Steenstraat 20, 1800 Koningslo-Vilvoorde
Canada
Kodak Canada Ltd Processing Laboratory, 3500 Eglinton Avenue West, Toronto, Ontario, M6M 1V3
Kodak Canada Ltd Processing Laboratory, PO Box 3700, Vancouver, British Columbia, V6B 3Z2
Denmark
Kodak a s, Roskildevej 16, 2620 Albertslund
France
Kodak-Pathé, Rond-Point George Eastman, 93270 Sevran
Kodak-Pathé, 260, av. de Lattre-de-Tassigny, 13273 Marseille Cedex 2
India
Kodak Limited Colour Processing Division, 483, Veer Savarkar Marg, Bombay 400 025 (Send by registered post)
Italy
Kodak SpA, Casella Postale 4098, 20100 Milan
Japan
Far East Laboratories Ltd, Namiki Building, No. 2-10, Ginza 3-chome, Chuo-ku, Tokyo

Mexico
Kodak Mexicana, SA de CV, Administración de Correos 68, Mexico, DF
Netherlands
Kodak Nederland BV, Fototechnisch Bedrijf, Treubstraat 11, Rijswijk Z-H
New Zealand
Kodak New Zealand Ltd, PO Box 3003, Wellington
Panama
Laboratorios Kodak Limitada, Apartado 4591, Panama 5
South Africa
Kodak (South Africa) (Pty) Limited Processing Laboratories, 102 Davies Street, Doornfontein, Johannesburg 2001
Spain
Kodak SA, Irun 15, Madrid 8
Sweden
Kodak AB, S-175 85 Järfälla
Switzerland
Kodak SA Processing Laboratories, Case postale, CH-1001 Lausanne
Kodak SA Processing Laboratories, Avenue Longemalle, CH-1020 Renens
United Kingdom
Kodak Limited, Colour Processing Division, PO Box 14, Hemel Hempstead, Hertfordshire HP2 7EJ

USA
Kodak Processing Laboratory, 1017 North Las Palmas Avenue, Los Angeles, California 90038
Kodachrome Processing Laboratory, Wilcox Station Box 38220, Los Angeles, California 90038
Kodak Processing Laboratory, 925 Page Mill Road, Palo Alto, California 94304
Kodak Processing Laboratory, 4729 Miller Drive, Atlanta, Georgia 30341
Kodak Processing Laboratory, P O Box 1260, Honolulu, Hawaii 96807
Kodak Processing Laboratory, 1712 South Prairie Avenue, Chicago, Illinois 60616
Kodak Processing Laboratory Inc, 1 Choke Cherry Road, Rockville, Maryland 20850
Kodak Processing Laboratory, 16-31 Route 208, Fair Lawn, New Jersey 07410
Eastman Kodak Company, Building 65, Kodak Park, Rochester, New York 14650
Kodak Processing Laboratory, 1100 East Main Cross Street, Findlay, Ohio 45840
Kodak Processing Laboratory, 3131 Manor Way, Dallas, Texas 75235
West Germany
Kodak Farblabor, 7000 Stuttgart 60 (Wangen), Postfach 369

Colour film types 1

When choosing film, decide first the type of photography you will be using it for, and identify the qualities in the final picture that will be most important. With architectural photography, for example, you might want extremely high resolution of detail, whereas with candid photography you might want a film that has considerable latitude and allows you to use a fast shutter speed.

Many of the qualities of film, such as sharpness and graininess, are actually subjective, and depend much on who is looking at the photograph. Other qualities may be interesting only for special uses. Many, such as speed and graininess, are linked – an improvement in one inevitably means a loss in the other. In general, the most important qualities are colour balance, speed, sharpness, graininess and colour saturation.

Colour fidelity Apart from the colour temperature that a film is designed for (daylight or tungsten), some films give a more accurate rendering of certain colours than others.

Speed and graininess To achieve less graininess, the film speed must be slower, and a fast film inevitably has strong grain. Kodachrome 25 is one of the slowest and least grainy films available, while Ektachrome 400, although much grainier, is fast enough to be used handheld in many situations with low light levels.

Sharpness Sharpness is subjective, depending largely on resolution and contrast. Kodachrome 64, for example, because of its fine grain and fairly high contrast, often appears to give a sharper image than Ektachrome 64, yet Ektachrome 64, surprisingly, is better at resolving fine detail.

Colour saturation The strength of the dyes used in colour film are responsible for differences in colour saturation between makes and types.

Even when a need for one specific quality narrows the choice, it is still difficult to choose between similar emulsions made by one manufacturer (for instance, Kodachrome 64 or Ektachrome 64) and between competitive brands. Combining all the qualities, any overall assessment of a film is subjective, and the short descriptions of films on the following pages reflect some personal bias. Use this guide as a starting point, but make your own tests and judgement. When you have found one or two films that you like, stick with them as much as possible. The more familiar you become with a film's behaviour in different circumstances, the more control you will have.

Colour transparencies: daylight

Kodachrome 25 ASA 25. An extremely fine grain, very sharp film, with high resolving power at 100 lines/mm (lines per millimetre). A very good film for general photography when detail is important and having to use a slow shutter speed is not a hindrance. It has good exposure latitude. Processing is restricted chiefly to Kodak labs.

Agfachrome 50S ASA 50. A fine grain film (although Ektachrome 64 is finer). It is sharp and has high resolving power. Blacks are dense and pale colours are faithfully reproduced, but it has higher contrast and less latitude than Ektachrome 64.

Agfachrome CT18 ASA 50. The non-professional version of Agfachrome 50S. Its coarse graininess compares unfavourably with competitive types of film with similar speeds. Reds and yellows are well saturated, but other colours less so.

Kodachrome 64 ASA 64. A very fine grain, very sharp film with high resolving power (100 lines/mm). An excellent general purpose film used extensively by professionals, although designed for amateur use. Like Kodachrome 25 it is non-substantive, the dyes being added in the processing rather than being contained in the emulsion.

Ektachrome 64 ASA 64. Fine grain, very sharp, very high resolving power (125 lines/mm). Intended for general use, it is slightly grainier than Kodachrome 64, but has better colour saturation and distinguishes long wavelength colours, such as reds and yellows, well. It also resolves extremely fine detail better than Kodachrome 64. It is available in sheet film form as Professional 6117.

Agfachrome CT21 ASA 100. Agfa's non-professional, medium speed film. As CT18, it has coarser grain and poorer resolution than competitive types. Even the faster Ektachrome 200 is better in these respects.

Fujichrome 100 ASA 100. A medium speed film using the same E-6 process as Ektachrome. It is comparable with Ektachrome 200 in resolving power (125 lines/mm) and graininess, and has fairly high contrast. An acceptable general purpose film.

Ektachrome 200 ASA 200. A general purpose film with high speed. It has slightly higher contrast than Ektachrome 64 but the same high resolving power (125 lines/mm). Colours are slightly less saturated, but the graininess is only a little coarser. A versatile film.

Ektachrome 400 ASA 400. An excellent high speed film for low light conditions or action shots calling for fast shutter speeds. Inevitably, it is grainier than slower films and has less resolving power (63 lines/mm). This film is nevertheless extremely versatile, and even gives acceptable results in tungsten lighting. Its occasional blue cast can be a drawback.

Fujichrome 400 ASA 400. Competitive with Ektachrome 400, it has similar contrast and graininess, but with a generally warmer cast. Greens are reproduced particularly well. It cannot be push-processed very successfully.

Ektachrome Infrared The speed rating depends on the heat reflectivity of the subject and the filter used. With a Wratten 12 Yellow filter, use ASA 100 as a starting point. It is sensitive to infrared light, recording living vegetation as red with most filters, and also to blue and violet. These can be corrected with yellow filters. Its use requires experiment.

Colour transparencies: tungsten lighting

Ektachrome 50 ASA 50 (used with 3,200 lighting). The tungsten light version of Ektachrome 64. It is designed for fairly long exposures and at shutter speeds from 1/100 sec to just over 1 sec needs no correction for reciprocity failure (see pages 66–67). It has high resolving power (125 lines/mm).

Agfachrome 50L ASA 50 (used with 3,200K lighting). Its characteristics are in most respects similar to the daylight version, Agfachrome 50S.

Ektachrome 160 ASA 160 (used with 3,200K lighting). The tungsten light version of Ektachrome 200, with the same high resolving power (125 lines/mm) and similar graininess.

Ektachrome Professional 6118 The speed is rated by batches, but is generally around ASA 32 when used with 3,200K lighting. It is designed for use from 1/100 sec to 100 secs, but optimally at 5 secs exposure. It suffers from very little reciprocity failure.

Colour negatives: daylight

Agfacolor 80S ASA 80. Fine grain, very sharp and high resolving power. A general purpose film, comparable to and competitive with Kodacolor II.

Kodacolor II ASA 100. Ultra-fine grain, very sharp, high resolving power (100 lines/mm), and good colour saturation. This is a good general purpose film designed for amateur use.

Fujicolor FII ASA 100. Similar in all practical respects to Kodacolor II.

Sakuracolor II ASA 100. Similar to Kodacolor II and Fujicolor II.

Vericolor II Professional Type S ASA 125. A professional film, particularly good for portrait work, designed for short exposures by flash or daylight. It has slightly lower contrast and less colour saturation than Kodacolor II. Neutral and flesh tones reproduce well together. **Vericolor II Commercial Type S** ASA 100. Has intentionally higher contrast. It is useful in low contrast lighting conditions.

Kodacolor 400 ASA 400. A high speed film for low light conditions demanding fast shutter speeds. It is slightly grainier and has less resolving power (63 lines/mm) than Kodacolor II but is very versatile. It works well without filters even with tungsten and fluorescent light. It also has wide exposure latitude.

Agfacolor CNS 400 ASA 400. Similar to Kodacolor 400.

Fujicolor 400 ASA 400. Competitive with Kodacolor 400, with very similar characteristics but with less graininess.

Sakuracolor 400 ASA 400. Competitive with and similar to Kodacolor 400 and Fujicolor 400.

Colour negatives: tungsten lighting

Vericolor II Professional Type L ASA 100 (used with 3,200K lighting). The tungsten light version of Vericolor Type S. A professional film designed for exposures from 1/50 sec to 60 secs. At 1/50 sec the rating is ASA 80.

Filters with colour film 1

Colour balancing filters To match the film to the light, the range of filters in the table below will alter colour temperature (see pages 20–21). The 81 and 85 series are yellowish and so lower the colour temperature, while the 80 and 82 series are bluish and raise it. Each filter has a mired shift value, either positive for lowering colour temperature or negative for raising it. This simplifies filter calculations. Add or subtract the shift values to find the right combination. For example, daylight film is balanced for a colour temperature of 5,500K (182 mireds). To use it in tungsten lighting with a colour temperature of 3,200K (312 mireds), you need to raise the colour temperature of the light reaching the film by the difference between the two (182 minus 312 equals – 130, indicating an 80A filter).

Colour compensation filters These filters, in six basic colours – red, blue, green, cyan, yellow and magenta – are used to correct colour shifts due to differences between film batches from the manufacturer, reciprocity failure (see page 66) or deficiencies in the light source (see pages 38–39). Each colour is available in strengths of 05, 10, 20, 30, 40 and 50.

When assessing a processed transparency for colour balance, use a light box with as little extraneous light as possible. Lay different filters over the transparency until you find one that is visually correct – for instance, the transparency may have a greenish cast that appears to be corrected by a CC10 Magenta filter. Then, for future shooting with the same film under the same conditions, select a filter of half the strength – in this case, a CC05 Magenta.

Ultraviolet filters All glass filters absorb some ultraviolet light. Filters designed exclusively for UV absorption range from clear to yellowish, in increasing strength. As there are few situations where UV haze is desirable, fit one of these filters to each lens permanently. They also give valuable protection to the front of the lens.

Colour balancing filters: use and exposure increase

Filter	Exposure Increase	Mired shift value	Common use
85B	⅔ stop	+131	Using film balanced for 3,200K in daylight
85	⅔ stop	+112	Using film balanced for 3,400K in daylight
85C	⅔ stop	+ 81	
85EF	⅔ stop	+ 53	
81D	⅔ stop	+ 42	
81C	⅓ stop	+ 35	
81B	⅓ stop	+ 27	
81A	⅓ stop	+ 18	Using film balanced for 3,200K with 3,400K lighting
81	⅓ stop	+ 10	Slight warming effect on overcast days and with blue tinted electronic flash units
82	⅓ stop	– 10	
82A	⅓ stop	– 18	Using film balanced for 3,400K with 3,200K lighting
82B	⅔ stop	– 32	
82C	⅔ stop	– 45	
80D	⅔ stop	– 56	
80C	1 stop	– 81	
80B	1⅔ stops	–112	Using daylight film with 3,400K lighting
80A	2 stops	–131	Using daylight film with 3,200K lighting

Colour compensating filters: exposure increase

No increase
CC05 Yellow

⅓ stop	⅔ stop
CC05–CC20 Cyan	CC30–CC40 Cyan
CC05–CC20 Magenta	CC30–CC50 Magenta
CC10–CC40 Yellow	CC50 Yellow
CC05–CC20 Red	CC30–CC40 Red
CC05–CC20 Green	CC30–CC40 Green
CC05–CC10 Blue	CC20–CC30 Blue

1 stop	1⅓ stop
CC50 Cyan	CC50 Blue
CC50 Red	
CC50 Green	
CC40 Blue	

To correct a colour cast, select a filter of the complementary colour:

Colour cast to be corrected	Select
Red	Cyan
Magenta	Green
Blue	Yellow
Cyan	Red
Green	Magenta
Yellow	Blue

Polarizing filters Light that is polarized vibrates in only one plane. A polarizing filter allows light to pass only in one plane so that by being rotated it can quench polarized light. Outdoors, daylight that is reflected from non-metallic surfaces and from the area of a blue sky at right angles to the sun is polarized. As a result, a polarizing filter can do the following:

Eliminate reflections from water, glass and other non-metallic surfaces. Reflections are most strongly polarized at 35° to the surface.

Darken blue skies. The effect is strongest at 90° to the position of the sun. With a very wide-angle lens, uneven tone results.

Cut haze. Polarizing filters are even more effective at this than UV filters, and can be used in combination with them. Polarizing filters can be adjusted visually for effect. Increase exposure by $1\frac{1}{3}$ stops to compensate for light loss, whatever position they are in. A TTL meter will automatically make this compensation.

Neutral density filters Neutral density filters are plain grey, and reduce exposure equally across all wavelengths. They can be used in bright light or with fast film to achieve wide apertures or slow shutter speeds. They are also useful for exposure control with completely automatic cameras such as the Polaroid SX-70 (see pages 94-95), and with portable flash units (see pages 50-51).

Neutral density filters: exposure increase

ND filter	Increase exposure by	Light transmitted
0.1	$\frac{1}{3}$ stop	80%
0.2	$\frac{2}{3}$ stop	63%
0.3	1 stop	50%
0.4	$1\frac{1}{3}$ stops	40%
0.5	$1\frac{2}{3}$ stops	32%
0.6	2 stops	25%
0.7	$2\frac{1}{3}$ stops	20%
0.8	$2\frac{2}{3}$ stops	16%
0.9	3 stops	13%
1.0	$3\frac{1}{3}$ stops	10%
2.0	$6\frac{2}{3}$ stops	1%
3.0	10 stops	0.1%
4.0	$13\frac{1}{3}$ stops	0.01%

Colour balancing filter The combination of a slightly bluish batch of film and an overcast sky gave a cool rendering of this scene (above). Using an 81B filter in front of the lens (left) restored colour neutrality.

Polarizing filter The most common use of polarizing filters is to darken blue skies. The effect can be judged visually by rotating the filter, thus controlling the degree of darkening. If the sky occupies a large area of the picture, be careful not to give too much extra exposure or you will negate the darkening effect.

Graduated filters These are partly toned, usually so that slightly more than half the filter is clear. The smooth transition between the clear and toned areas makes the darkening effect appear more natural. They are particularly useful for darkening the sky in landscape shots. Graduated filters are available in different strengths and different colours, including neutral. The most adaptable design is an oversized square filter that can be shifted up and down in a rotating holder, thus allowing the transitional edge to be positioned to suit the scene. Two filters can be used together in opposite positions to leave a thin, clear central band. With the right exposure, the effect can be similar to a storm or night scene. Use the coloured varieties of graduated filter with great discretion – their effects can be very obvious and artificial.

Selective filtering You can achieve an effect similar to that of a graduated filter by cutting a gelatin filter and placing it so that it covers part of a clear glass filter, preferably an optical flat. This is useful for complicated outlines, particularly when using a wide-angle lens. With the camera on a tripod and the glass filter in place, tape a piece of waste gelatin in front. Stop down to the shooting aperture, and trace the outline over the waste gelatin. Then, using the marked waste gelatin as a guide, cut a fresh gelatin to shape, holding it in tissue paper to avoid marks. Shoot at a wide aperture, or the cut line will appear too abrupt.

Diffusers Diffusers use either etched lines or mottled glass to break up the overall definition. Some large format lenses can take a perforated disc between the lens elements for the same effect. Diffusers can be flattering to the subject in portraiture by concealing blemishes and wrinkles, and can also give an atmospheric halo with backlit shots. Used indiscriminately, however, the effect can appear in poor taste. Some diffusers are selective, with the centre clear.

Fog filters Fog filters reduce contrast and the saturation of colours, giving a resemblance to natural fog or mist. Breathing on the lens to form light condensation has a similar effect. A graduated fog filter, with the lower half clear, gives a sense of aerial perspective.

Star filters A pattern of engraved crossed lines breaks light up into small stars. The closer the lines, the longer the streaks that result.

Prism filters A glass filter cut with different faces produces multiple images. There is a great variety of possible prism shapes.

Diffraction filters These produce a multi-coloured, spectrum effect in different shapes and patterns. There are very few occasions where their use is justified.

Colour effects filters These are used to give a deliberate overall colour cast, and have only limited application.

Split-diopter lenses Essentially, these are supplementary close-up lenses (see pages 186–191) cut in half. They alter the focus over half of the picture (usually the lower half), and can be used to keep a close foreground and far background in focus at the same time without stopping down. For effective use, the transition area should be concealed by composing the shot so that it falls on a natural line in the scene.

Anamorphic lenses These are cylindrical or prism lenses designed for squeezing and stretching images for Cinemascope photography. Although not supplied specifically for still use, they can be adapted, but should be used with a small aperture to maintain image quality. For published photographs, a much simpler method of achieving such distortion is to have the image stretched by a specified amount when colour separations are being made.

Fish-eye attachments These fit in front of the camera lens and produce an effect similar to that of a regular fish-eye lens, but of poorer quality.

Other effects filters There is no limit to the number of ways in which an image can be degraded. Netting, petroleum jelly smeared on a plain glass filter, deliberate flare or light leaks, and many other tricks can be used. It is, however, easy to get carried away with the technique of an effect, and the most important precaution is to use these filters as solutions to problems rather than as ends in themselves.

Cutting a selective filter
1. First, mark the edge of the picture area to be selectively filtered with a pen on a discarded gelatin filter. Do not move the camera.
2. Use this piece of gelatin as a template to cut the filter you will use.
3. Place the cut film in the filter holder.

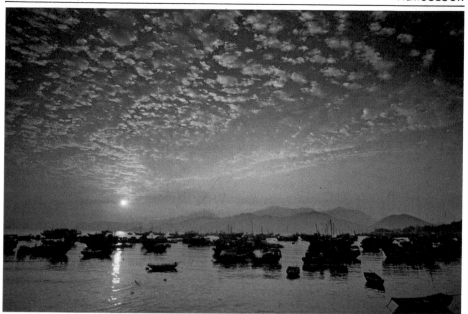

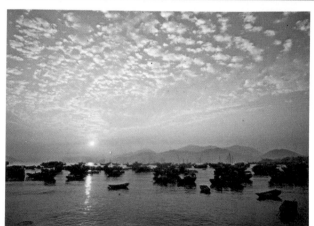

Graduated filters Neutral graduated filters are probably the most generally useful of all effects filters. In the photograph above, the graduated zone has been positioned in front of the lens to coincide with the horizon, darkening the sky by more than one stop to restore the detail and colour that would otherwise be lost (left).

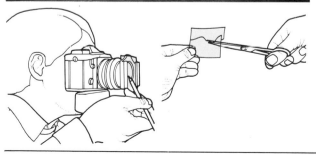

Film and lens tests

Once you have filled in the ID panel opposite with your name and address in bold block lettering, these two pages contain everything necessary to test and identify every roll of film you shoot. Lay the book open at these pages, in daylight, and photograph it. Then, in the event of the film becoming separated from your name sticker in the processing laboratory, or even if you lose it, the film itself carries your name and address. Although this may be too extravagant to do with every roll of 120 film, it is low-cost insurance when shooting on 35mm.

The other panels are more immediately useful. The colour patches give a constant check on the behaviour of film and lens. Try always to photograph them in direct sunlight or an open cloudy sky – not in open shade under a blue sky, which will give a pronounced blue cast. Then, after processing, compare the photographed result with the actual colour patches. Use them particularly when accurate colour reproduction is important – such as when photographing a flower. With colour negative film, they can be an accurate guide for the colour printer to follow when selecting the filtration for enlargement.

The grey scale can be used to check exposure and contrast range, particularly with black-and-white film. On the processed negative, look first to see if each end of the scale – white and black – have the proper density, and then see if there is adequate separation between each step. Each of the 20 steps is equally spaced and differs from its adjacent steps by approximately half a stop. The test shot can give a clue to several film faults, including X-ray fogging.

The sharpness test pattern can be used to compare and keep a check on lens performance. It gives a simple and fairly accurate guide to the resolving power of a lens. It can be useful not only to find out how many lines per millimetre a new lens can resolve, but also, in the event of suspected damage, to check that an old lens is still performing up to standard.

Grey scale The scale at left can be used in two ways. Firstly, you can judge the contrast range of a film or processing technique by photographing the scale and comparing the printed result with the scale itself. Secondly, it can be placed alongside subjects requiring precise reproduction of tones, such as copy-shots of old engravings or other pictures, and the printing can be adjusted to match the reproduced grey scale against the scale itself.

Colour patches The scale to the far right can be photographed and compared with the original to evaluate the colour fidelity of different films. In addition, like the grey scale it can be used when reproducing paintings to ensure accurate balancing of the colours to the original subject.

Paterson optical test target This commercially available target can be used to carry out a comprehensive series of tests of the performance of both lens and film. Open the book so the target is upright and place the camera at 90° to it so that the film plane is 40 times the focal length of the lens away (2,000mm or two metres with a 50mm lens). Photograph the target at a range of apertures and compare the processed results. The resolving power of the lens at different apertures can be read off the bar scale at the bottom, from 10 to 72 lines per millimetre. 30 lines/mm can be taken as satisfactory for work where great detail is required.

This film belongs to
Name

Address

Tel.

10 | 12 | 13 | 15 | 16 | 18 | 21 | 24 | 27 | 30 | 33 | 36 | 42 | 48 | 54 | 60 | 66 | 72 |

Altering colour film behaviour

All film is designed to be used in a certain range of conditions. In unusual circumstances, such as very dim light, it behaves differently. Very slow and very fast shutter speeds also cause changes, as does increased or decreased development. The effects may be unavoidable, and even unintentional, or they may be put to work deliberately to solve problems.

Reciprocity failure The reciprocity law states that the amount of exposure that film receives is the product of the amount of light and the length of time it falls on the film. In other words, exposure equals light intensity multiplied by time. At slow speeds (for many films 1/4 sec and longer), however, this stops being true, and for every extra step in exposure time, the film reacts less. So, with most films, increasing the exposure time from 2 secs to 4 secs does not double the exposure of the film. A similar failure occurs at very high speeds with some films. .

How to compensate for reciprocity failure
add filtration and increase exposure as follows: NR=not recommended

Exposure time	1/1,000 sec	1/100 sec	1/10 sec	1 sec	10 secs	100 secs
Kodachrome 25	—	—	—	+1 stop CC10M	+1½ stops CC10M	+2½ stops CC10M
Kodachrome 40 (tungsten)	—	—	—	+½ stop No filter	+1 stop No filter	NR
Kodachrome 64	—	—	+1 stop	CC10R	NR	NR
Ektachrome 50 (tungsten)	+½ stop CC10G	—	—	—	+1 stop CC20B	NR
Ektachrome 64/	—	—	—	+1 stop CC15B	+1½ stops CC20B	NR
Ektachrome 6117						
Ektachrome 6118 (tungsten)	See film instructions. Intended range 1/10 sec to 1/100 secs; normally no filtration needed at these speeds.					
Agfachrome 50S	—	—	—	+½ stop	NR	NR
Agfachrome 50L (tungsten)	CC05Y	CC05Y	—	—	+⅓ stop No filter	+⅔ stop CC10R or CC10Y
Fujichrome 100	—	—	—	—	+½ stop CC05C	+1½ stops CC10C
Ektachrome 160 (tungsten)	—	—	—	+½ stop CC10R	+1 stop CC15R	NR
Ektachrome 200	—	—	—	+½ stop CC10R	NR	NR
Ektachrome 400	—	—	—	+½ stop No filter	+1½ stops No filter	+2½ stops CC10C
Ektachrome Infrared	—	—	+1 stop CC20B	NR	NR	NR

Colour Negative Films

Kodacolor II	—	—	—	+½ stop No filter	+1½ stops CC10C	+2½ stops CC10C+10G
Vericolor II Type S	—	—	—	NR	NR	NR
Vericolor II Type L	NR	NR	See film instructions			
Kodacolor 400	—	—	—	+½ stop No filter	+1 stop No filter	+2 stops No filter

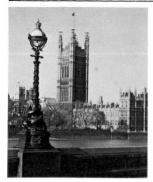
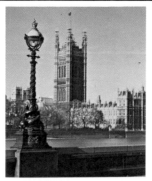

Reciprocity failure For this shot on Kodachrome 25, a long exposure of 5 secs was required so that pedestrians moving through the foreground would not record on the film (a neutral density filter was used to lower the light level). Reciprocity failure resulted (far left), with a notable colour cast. The addition of a CC10M filter (left) gave the necessary correction. Such correction is more likely to be needed when working in low light levels – with twilight or available light for example.

Reciprocity failure varies from film to film and details are normally given in the packed instructions. Part of the solution is to give even more exposure, but if this has to be done by increasing the exposure time, the problem is compounded. Also, the three layers of emulsion in colour film, each sensitive to a different wavelength, react slightly differently to reciprocity failure. As a result, there is usually a colour shift, frequently towards green or yellow.

The table at left gives the reciprocity compensation for some common films. Note that tungsten-balanced films appear to show less reciprocity failure – this is because they are designed for use at slower speeds. If a very long exposure time in daylight is unavoidable, it may be better to use one of these, converted to daylight use with an 85B filter.

Increasing development can also help, by reducing the exposure times needed, although this in itself changes contrast, graininess and colour balance.

Altering Development Over and under-developing colour film changes the way it behaves – most obviously altering its speed – and this can be used not only to correct exposure mistakes, but also for deliberate effect.

Good processing laboratories will either 'push' (increase development) or 'cut' (reduce development) to order – the process is a straightforward alteration of the first development time. Simply specify by how many stops the development should be altered. Kodachrome and other non-substantive films are something of an exception, however. The processing is more critical and Eastman Kodak labs will not alter development. A few individual custom labs in the United States will, at a price, undertake to push-process Kodachrome by up to one stop. Graininess is strongly increased, however, which negates the chief advantage of Kodachrome.

The majority of colour reversal (transparency) films can be pushed by up to two stops and cut by up to one stop. Beyond this, image quality suffers. The development of colour negative film is more difficult to alter, but its great latitude

(see page 8) can be used in the printing stage for similar results.

Reversal as negative For an unusual effect, transparency film can be processed as colour negative instead of normally. The result is a transparency with both tones and colours reversed, quite different in appearance from ordinary colour negative film, which has a built-in orange mask. The precise effect is difficult to predict without experience, and it is best to bracket exposures. If you want to conceal the fact that it is a negative, avoid obvious and definite shadows in the image.

The effects of altered processing

Increased or 'pushed' development

1. *Increased film speed* Most photographers use push-processing for this effect.
2. *Increased contrast* This can be useful for situations where the subject has low contrast. In aerial photography, for example, it is common to under-expose by half a stop and then over-develop by the same amount.
3. *Weaker maximum density* Shadow areas tend to become thin and fogged.
4. *Increased graininess* For most photography this is probably the chief drawback, but it can be used deliberately to help give an impressionistic result.
5. *Colour shift* This varies between makes of film. With Kodak's E6 process – the most widely used – the shift is generally towards yellow, by about CC10 when pushed one stop and CC20 when pushed two stops.

Decreased or 'cut' development

1. *Loss of film speed*
2. *Less contrast* This particularly affects the highlight areas. It is useful for compressing a wide tonal range that would otherwise be beyond the ability of the film to record.
3. *Colour shift* With E6 films, this tends towards blue or magenta, by about CC10 when cut one stop.

Colour film emergencies

If something goes badly wrong, through accident, malfunction or carelessness, it may be possible to salvage the results, or at least minimize the damage. Provided that some image has been recorded, there is nearly always a way of improving it. If the shot is sufficiently important, there are a number of techniques (often expensive, such as retouching) that can be used. First decide whether the effort of restoring the damage is worth more or less than repeating the shot.

Below are some common emergencies, and ways of coping with them. On page 86–87 are others, specific to black-and-white film.

The film has been wrongly exposed
If you discover this before processing, there are two possibilities with colour reversal film. One is to alter the development in compensation. Ask the laboratory to 'push' the film if it has been under-exposed, or to 'cut' it if over-exposed (see pages 66–67). If you do not know by how many stops the exposure is wrong, run a clip test, whereby the lab will process the first few frames only, as a check.

The alternative is to process the reversal film as a negative. Although it is difficult to alter development in a negative process, the increased latitude gives a good chance of making an acceptable print. If you are using colour negative film in the first place, this latitude will help even if the exposure is out by two stops.

Kodachrome has been under-exposed
Altered processing is not recommended for this film (see page 67), but a very few independent labs that have Kodachrome processing facilities will push Kodachrome up to one stop, for an additional fee.

The film has been wrongly exposed, and already developed
If you discover the exposure error only after the film has been processed, then the best solution is to make a corrective duplicate. Commercially this can be expensive, but it is possible to do it yourself. Duplicating is more successful with an under-exposed transparency than with one that is over-exposed – the natural tendency of a duplicate to increase contrast helps bring out shadow details when the picture is dark overall, but weak highlights always remain weak.

The camera jams
First of all, remove the film. If the rewind mechanism is stuck, construct or find an emergency darkroom (see pages 80–81). Open the camera back in the dark and carefully take out the film, winding the loose end back either onto one spool (in the case of roll film) or into the cassette (with 35mm film). In a 35mm cassette, remember not to wind the film completely in – leave a tongue sticking out so that you can use the unexposed part of the film later. Having removed the film, you can inspect the camera for the malfunction (see pages 150–153).

The film breaks inside the camera
If the film transport or rewind appears to stick and you force it, the film may tear or separate from the spool of its cassette. The tell-tale sign is when the cocking lever or rewind knob is first stiff or immovable, and then suddenly comes free. If in any doubt, do not open the camera back in the light. Use an emergency darkroom, and take with you an empty, light-tight film can. Open the camera in the dark, remove the

Original Lightened and contrast enhanced duplicate

cassette and the torn length of film, and put both into the can, sealing the lid afterwards with tape. There is no advantage in trying to wind the film back into the cassette. Simply give the can containing the loose film to a lab, with clear instructions.

Unused 35mm film is accidentally wound back into the cassette
One method of retrieving the film is to insert a piece of adhesive tape into the cassette as shown, winding the spool gently to help the tape get a grip on the film. When it appears to be sticking, carefully pull it out. It may take several tries, and as most tape is too flimsy double-sided tape stuck to a strip of thin card may be better.

Open cassettes in the dark by pressing the protruding spool end firmly down on a hard surface.

The other method is to open the cassette in the dark, take the loaded spool out (holding firmly so that it does not unwind) and reassemble correctly. Do not use a can opener to prise off the cassette lid as this will bend it. Instead, gripping the sides of the cassette, push down onto a hard surface so that the protruding end of the spool is forced up into the cassette, pushing out the lid at the other end. Once reassembled, there is a slight risk of light leak, and cassettes that have been machine-crimped are not suitable for this treatment.

Camera battery fails
If the metering display fades, it is still usually possible to get a few more minutes of use out of the apparently dead batteries. Switching off for several minutes will give them the opportunity to build up again. Also, warming them in your hand or close to a heater may bring them to life for a little longer.

Tungsten/daylight mix-up
Unfortunately, there is no really satisfactory solution to having used tungsten-balanced film in daylight, resulting in a strong blue cast, or daylight-balanced film in tungsten lighting, giving a strong orange cast. The former is the more objectionable, and the difference in colour temperature is so great that even corrective duplicating can only partly compensate for it. Converting the photograph to black-and-white, with an internegative, is the best that can be done.

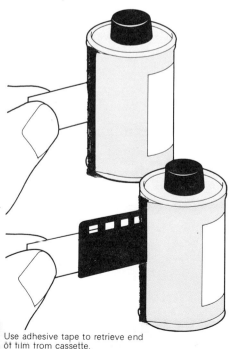

Use adhesive tape to retrieve end of film from cassette.

Colour film faults 1

Although some faults occur frequently enough to be familiar, others can be difficult to identify. Any fault whose cause is not obvious is a danger because you cannot predict when it may happen again. Use the list of examples on the following six pages and those on pages 88–89 for comparison.

The procedure in fault analysis is to narrow down the possibilities progressively. First, identify whether the error occurred in the film stock, when taking the picture, or during processing. Then isolate the specific part of the process.

There are often clues that will help you decide at which stage the fault lies. If the problem includes the film's edges or rebate, for example, it probably did not occur during picture-taking. On the other hand, if the fault seems to have optical characteristics, such as the image of a hair that is sharp at one end but blurred at the other, this suggests a camera or camera-handling cause.

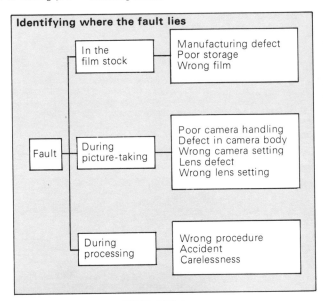

Identifying where the fault lies

Fault
- In the film stock
 - Manufacturing defect
 - Poor storage
 - Wrong film
- During picture-taking
 - Poor camera handling
 - Defect in camera body
 - Wrong camera setting
 - Lens defect
 - Wrong lens setting
- During processing
 - Wrong procedure
 - Accident
 - Carelessness

Tungsten-balanced film used in daylight Intended for use in 3,200K or 3,400K artifical lighting, tungsten-balanced film has a distinct blue cast when used in daylight. To avoid loading the wrong film, keep tungsten and daylight films separate from each other and clearly marked. Corrective duplicating cannot restore the original colour balance of the scene.

Light leak This type of light leak, on one side of the film and most pronounced by each sprocket hole, may indicate a loose-fitting top to the film cassette – possible if you load bulk film into reused cassettes. Alternatively, it may result from a mistake in the processing, allowing light to enter the top of the developing tank.

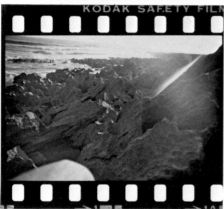

Lens flare Although modern lens coatings largely eliminate flare, it is still likely when shooting into the sun. The symptoms are bright patches and a generally degraded image. Dirt, grease or moisture on the lens, as here, exaggerates flare.

Beginning of the roll Really an extreme form of light leak, this happens at the beginning of a new roll of film when it has not been wound on a sufficient number of frames. Follow the camera manufacturer's instructions.

Ageing All film ages, unless refrigerated to a very low temperature, and the characteristics are usually loss of speed, loss of density and, in the case of colour films, a colour shift. Heat and humidity speed up ageing – this shot remained undeveloped for one year in humid tropical conditions without special precautions.

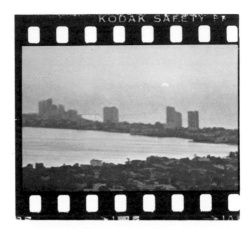

Crimp mark Rough handling, particularly when loading film into a processor or onto the spiral reel of a developing tank, often causes crescent-shaped marks (light on transparencies, dark on negatives) where the film has buckled sharply.

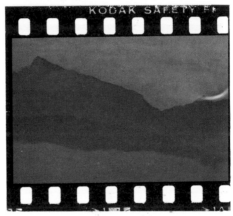

Manufacturing tolerances Most film manufacturers aim to keep the colour bias on transparency film very close to a set standard. Nevertheless, even within these limits, two rolls of the same film, each from a different batch, may differ marginally in one colour.

General faults 1

Wrong lens shade A particular problem with wide-angle lenses, fitting a lens shade designed for a longer focal length lens or too many filters causes vignetting in the corners. At smaller apertures this is less obtrusive, but the edges are more distinct.

Dirt This happens most commonly when the newly-processed film has not been dried in clean conditions. Airborne dirt sticks to the wet, swollen emulsion and can be difficult to remove. Wash again and dry in a drying cabinet.

Scratches During processing, this can easily occur at the start of drying if the hanging film is wiped with a squeegee or sponge that contains particles of grit. Emulsion is most delicate when wet. On colour film, light scratches are often cyan in colour, showing that only the upper, redder layers have been stripped away.

Double exposure Unintentional double exposure is easy enough to diagnose, and the causes are mechanical or concerned with camera handling. Inadvertently pressing the sprocket release catch (or rewind knob) is an example of the latter. A typical mechanical fault is failure of the film take up, common at the beginning of the film when using a motor drive.

Horizontal density streaks Although the effect is quite subtle, and not always obvious at first glance, light horizontal streaks are occasionally found on Kodachrome, and are a processing fault. When they occur, they are most prominent on vertically composed shots with even mid-tone areas.

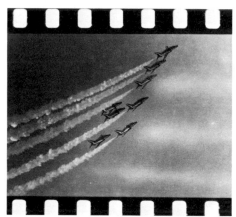

Light leak An indefinitely shaped light leak such as this, not obviously related to the sprocket holes, is more likely to have occurred during processing than in the camera itself.

Overlapping double exposure When the frame of the second exposure does not coincide with the first, the roll of film has been re-run inadvertently. If you have to remove a roll from the camera before you have used every exposure, mark clearly the number of frames left to avoid mistaking it for a fresh roll.

Hair in the gate After cleaning the inside of a camera with a brush, check carefully that no loose hairs have been caught in the mechanism. Although not a common fault, this can ruin whole batches of photographs. Characteristically, there is a dark line close to one edge of the frame, usually out of focus at one end.

Motor drive too fast for shutter With a motor drive on continuous setting, the shutter speed must be fast enough to complete its operation before the film is transported to the next frame. The slowest effective shutter speed depends on the motor drive – for example, at four frames per second, it would normally need to be at least 1/125sec. When a very slow speed, such as 1 sec, is used at several frames per second, the result looks like this.

Black-and-white film types 1

For general photography, there are three groups of black-and-white film, based on film speed: slow, medium and fast. As with colour film, the slower emulsions have less graininess, and the faster have more. Altered processing (see pages 84–85) is more commonly carried out with black-and-white photography, and this can affect the graininess. Some developers are designed to promote a fine grain structure, while push-processing increases grain. It is not possible to have both fine grain and high speed at the same time, This applies not only to the choice of film, but also to the way it is processed – developing a very fast film in a fine-grain developer wastes the advantages of each.

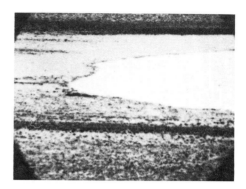

As well as films for general use, a large number of highly specialized films are available, chiefly for graphic design purposes. A few that can be used directly in the camera for special effects are also listed on the following pages.

Variable speed films Remarkable recent developments in film technology also have to be taken into account. Two films being introduced effectively revolutionize the use of black-and-white film at faster speeds. Agfapan Vario-XL and Ilford XP-1 can be used at speeds from ASA 125 to ASA 1,600, as decided by the photographer, with standard processing. Testing has shown that the performance of these two films is similar, with the best results being obtained in the speed range ASA 200 to ASA 400. At these speeds the grain size is considerably smaller and the contrast range is greater than conventional fast films such as Tri-X or HP5. The performance is still very good at ASA 800. Experiment with these films as they become available.

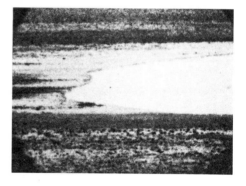

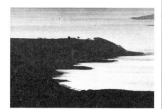

Fine-grain film Films with a fine, closely packed grain structure, here Panatomic-X, produce a cleaner, less textured image — most noticeably in great enlargement. The disadvantage of such film is the slow speed (Panatomic-X is rated ASA 32), but in situations where long exposures are possible, the great resolution of detail can be valuable.

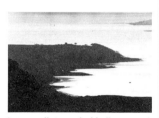

Intermediate grain Medium speed films (this is Plus-X, rated ASA 125) are fast enough for most situations and still have good resolution of detail. Grain structure and contrast are moderate.

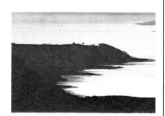

Fast films The grain size of Tri-X (ASA 400) and other fast films is noticeably larger. They are used either to obtain the grainy effect at great enlargement or, more usually, to cope with low light levels or a moving subject requiring short exposure.

Agfapan 25 ASA 25. A very slow, very sharp film with extremely fine grain and very high resolution (185 lines/mm). Similar to the Kodak and Ilford slow films.

Kodak Panatomic-X ASA 32. Extremely fine grain, very sharp and high resolution. Very good for recording fine detail or when great enlargements are to be made, but it is too slow for many hand-held situations. It can be processed to produce transparencies.

Ilford Pan F ASA 50. Similar in characteristics to Panatomic-X, it is very sharp and has extremely fine grain and high resolution. It has the same applications as Panatomic-X, including transparency processing.

Agfapan 100 ASA 100. A medium speed, very sharp film. It has fine grain and high resolution (145 lines/mm). For general use.

Kodak Verichrome Pan ASA 125. A medium speed film. It has extremely fine grain and high resolution. A very sharp general purpose film, designed for amateur use.

Kodak Plus-X Pan ASA 125. Similar in characteristics to Verichrome Pan but available in different formats. It also has a retouchable surface.

Ilford FP4 ASA 125. The Ilford equivalent to Verichrome Pan and Plus-X, with no significant differences.

Agfapan 200 ASA 200. A medium speed sheet film, very sharp, with fine grain and high resolving power (110 lines/mm). Can be retouched easily.

Ilford HP5 ASA 400. An excellent fast film, with fine grain and high resolving power. It is very sharp and has great latitude. The ASA rating is only nominal, for by choosing the appropriate developer the rating can be set anywhere between ASA 200 and ASA 650 with normal development procedures. It can also be push-processed successfully by up to three stops.

Tri-X Pan ASA 400. Similar to HP5 and equally suitable for situations with low light levels or requiring fast shutter speeds. Its speed can be increased by push-processing, with an inevitable increase in graininess.

Specialist films

Agfapan 400 ASA 400. The Agfa version of HP5 and Tri-X. It has similar characteristics with a high level of resolution (110 lines/mm).

Kodak High Speed Infrared The speed rating varies according to the heat-reflecting properties of the subject, but generally around ASA 50 with a Wratten 25 Red filter in daylight. It has coarse grain, poor sharpness and medium resolving power. It requires special handling.

Kodak
High Speed
Infrared Film
20 EXPOSURES
HIE 135-20

Kodak Royal Pan 400 ASA 400. The sheet film version of Tri-X.

Kodalith Ortho Type 3 Not intended for outdoor camera use, so establish the speed by trial and error, using ASA 12 as a starting point. An extremely high contrast film, lacking red sensitivity (that is, orthochromatic), with extremely high resolution and very wide latitude. It is available in 35mm and sheet formats.

Kodalith ortho film
type 3

Kodak Recording Film 2475 ASA 1,000. The fastest commercially available film in 35mm format. Its sharpness is low, its resolving power medium and its graininess coarse. It was designed for surveillance work, particularly in tungsten light (it has extra red sensitivity). It can be push-processed by up to two stops.

Agfaortho 25 Similar to Kodalith. When used with a high contrast subject and high contrast developer, it can reduce the tonal range to just black and white.

AGFAORTHO
25
135-36
Agfa PROFESSIONAL

DOCUMENT COPYING FILM

Royal-X Pan ASA 1,250. An extremely fast film available in 120 size only. It can even be push-processed by one stop. It is very sharp but its graininess and resolving power are only medium – the price to be paid for the film's great speed. As a result, it cannot be enlarged greatly.

Agfa Dia-Direct ASA 32. A film specifically designed for black-and-white transparencies, with a clear base. It requires reversal processing.

Agfa 135-36
DIA
DIRECT
FOR 36 B/W-SLIDES

Field processing

On rare occasions when travelling, you may need to process film immediately. The difficulties of accurate development are considerable in such circumstances, as conditions are usually far from ideal, but the instructions on these two pages show how to make the best of an awkward location. Nevertheless, before attempting field processing, think first whether instant film might not be an easier solution – in black-and-white, Polaroid Type 55P/N and Type 665P/N even give an instant negative.

For most black-and-white processing, recommended measuring tolerances are around one per cent, but reasonable results are possible within 10–20 per cent. There is the same sort of latitude in temperature and timing, provided accuracy and consistency are not essential. Colour processing, on the other hand, is not worth attempting in the field as the levels of tolerance are much lower.

The minimum equipment that you will need is illustrated (right). Remember that it is often possible to improvise – for instance, by using the developing tank as a measuring flask – and to make use of locally available items.

Special problems in hot weather
1. Emulsion tends to swell, so all processing stages should be carried out quickly. A quick rinse and dry can be followed several days later by more careful washing in cooler conditions without ill effect.
2. Temperature control is difficult – use a cool box if possible.
3. To avoid contamination of chemicals with sweat, wash hands frequently.
4. High-temperature processing can cause fogging. If there is any risk of this, add anti-fog powder to the developer.
5. High-temperature processing also increases graininess, particularly with films that already have a coarse grain structure.

Procedure
Make a temporary darkroom A small changing bag is ideal. Otherwise, find a darkened room, such as a motel bathroom, and seal over any light gaps with towels, pieces of cloth, card or tape. If you can wait until night-time so much the better. In any case, test the darkness by waiting inside the room for at least ten minutes, until your eyes have become adapted to the dark – if you can still see your hand when you move it, there remains the risk of fogging the film. Under these circumstances, load the film into the tank under a thick cloth.

A makeshift changing bag can be folded out of a jacket, but it will not be completely light-free and should be used in a darkened room.
Prepare the chemicals Making the chemicals up in advance, at home, is the easiest and most precise method, but the extra weight of water may make this impractical when travelling.

Although distilled water is ideal, it is often difficult to find and is not absolutely essential. Calcium and magnesium salts are commonly present in undistilled water, and these can cause cloudiness in the made-up solution, and there may be other contaminants and particles. Boiling will help, but you will then need time enough for the water to cool. In most circumstances, frequent agitation is the only answer. You may then need to reduce the development time by 10 to 20 per cent, depending on the chemical manufacturer's instructions.

Sea water can be used at all stages, although with a few developers such as D–76 it may cause a slight loss of speed. Simply allow any sediment to settle, and carefully drain off before using. Sea water is, in fact, very efficient at clearing fixer in the washing stage, but you will need to finish the wash in clean water to remove salt traces. This can be done later, after several weeks if necessary.

If you lack measuring facilities, remember that, on average, 20 drops is equivalent to one millilitre. Before processing, place all the chemicals – developer, stop bath and fixer – in a large dish filled with water at the recommended temperature, usually close to 20°C (68°F).
Load the film If 35mm, prise the top of the film cassette off in complete darkness with a bottle opener or by pressing firmly down on a hard surface so that the spool is forced up and out. Then square off the end of the film with the scissors or knife and, holding it by the edges, bow it slightly to fit it into the stainless steel reel, making sure that it is firmly attached to the core by means of the spike or clip. Rotate the stainless steel reel until the entire film is threaded along the grooves. Finally place the loaded reel in the developer tank and replace lid.
Develop Check the chemical manufacturer's instructions for temperature and development time. 20°C (68°F) is the ideal, but the range from 18°C (64°F) to 27°C (80°F) is acceptable. As a general rule, increase development time by about 10 per cent for every degree centigrade cooler than 20°C, and decrease development by the same amount for every degree centigrade warmer than 20°C. Pour in the developer quickly, tap the tank sharply to dislodge air bubbles, and agitate for five seconds every 30.
Stop-bath Pour out the developer, and fill with stop-bath, agitating continuously for 30 seconds.
Fix Pour out the stop-bath and replace with fixer. With most makes of fixer, leave the negative in the solution for 10 to 20 minutes.
Wash Wash for 10 to 15 minutes. Gently running water is ideal, as it removes traces of fixer efficiently. Otherwise, use a still bath, changing the water several times. The film can later be washed again in completely clean water.

Minimum Equipment

Developing tank/measuring flask Stainless steel, with a flexible cap and stainless steel spiral, is a more durable choice than plastic. The tank can double as a measuring cylinder if you make scratch-marks on the inside to indicate different volumes. If so, you will then need another

container such as a can or large cup into which the measured liquid can be transferred.
Watch With second counter.
Clips or clothes pegs Even without these, you can hang film up to dry by piercing one end and passing through a loop of string or wire.
Thermometer An essential item.
Scissors or penknife To cut and trim film.
Large dish To use as a temperature bath for the developing tank. In hot conditions, a cool box is better.

Chemicals Expanding plastic concertina bottles are best for storing made-up liquid chemicals because they automatically exclude air and so slow down oxidization. If you are carrying just the raw ingredients, powder is better than crystals as it is less affected by the atmosphere. As water can be used as a stop bath only developer and fixer are essential.

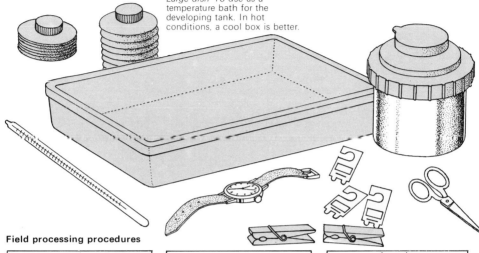

Field processing procedures

With practice, a changing bag can be used for loading film into the developing tank.

With the film in the changing bag, thread carefully onto the developing tank reel.

When no other means of measuring chemicals is available, 20 drops equal one millilitre.

Standing the developing tank in a bath of water makes it possible to maintain the correct temperature.

Ensure that the developing tank has sufficient agitation to remove all air bubbles.

Running water will provide an adequate stop bath in field conditions.

Filters with black-and-white film

Contrast control Filters are normally used in black-and-white photography to control the tones in which colours are reproduced. Without filtration, some colours may reproduce poorly – reds and greens together, for example, often appear the same shade of grey. Blue skies, due to the over-sensitivity of film to blue, appear over-exposed and white. The principle is straightforward: a coloured filter passes its own wavelength but blocks the remainder. For instance, a red filter will prevent most of the blues and greens in a scene from reaching the film, so that they appear darker in the print than the reds, which can pass unhindered.

The darkening of a blue sky by using a yellowish or reddish filter is the most well-known technique, but with a carefully chosen filter, the reproduction of any colour can be altered. As a general rule, to lighten the appearance of a colour in the print, use the same colour filter. To darken, use a filter covering the other parts of the spectrum. The intensity of the effect depends not only on the density of the filter, but on the colour saturation of the subject.

Filters with black-and-white: uses and exposure increase

Filter	Wratten number	Use	Exposure increase in daylight
Yellow	8	Standard filter for darkening blue sky and slightly lightening foliage. Also reduces haze.	1 stop
Yellowish-green	11	Corrects for tungsten lighting. Also lightens foliage more than yellow, and lightens Caucasian skin tones to a natural appearance.	2 stops
Deep yellow	12	'Minus blue'. A similar effect to Wratten 8, but more pronounced, strongly darkening blue sky.	1 stop
Yellow-orange	16	Stronger effect on sky than yellow filters. Reduces skin blemishes and spots in portraiture.	$1\frac{2}{3}$ stops
Orange	21	More pronounced contrast than Wratten 16, particularly at sunrise and sunset. Lightens brickwork, darkens foliage.	$2\frac{1}{3}$ stops
Red	25	Darkens blue sky dramatically, deepening shadows and exaggerating contrast. Under-exposure gives a moonlight effect, especially combined with a polarizing filter.	3 stops
Deep red	29	Same effect as Wratten 25, but even stronger. Useful with long-focus landscapes to darken sky close to a distant horizon.	4 stops
Magenta	32	'Minus green'. Darkens green.	$1\frac{2}{3}$ stops
Light blue-green	44	'Minus red'. Darkens red.	$2\frac{1}{2}$ stops
Blue	47	Accentuates haze for a sensation of depth in landscapes	$2\frac{1}{3}$ stops
Green	58	Lightens green foliage.	3 stops

Lightening and darkening specific colours

Colour of subject	To darken appearance Wratten numbers:	To lighten appearance Wratten numbers:
Red	58, 47, 44	29, 25, 32, 21, 16, 12
Orange	58, 47, 44	25, 32, 21, 16, 12
Yellow	47, 44	12, 11, 8, 16, 21, 25
Yellow-green	47, 32	11, 12, 8, 16, 58
Green	29, 25, 47, 32	58, 11, 12, 8, 44
Blue-green	29, 25	44, 47, 58
Blue	25, 16, 12, 11, 8, 58	47, 44, 32
Violet	58, 11, 12, 8	32, 47
Magenta	58, 11, 16	32, 47, 25

Because less light reaches the film through a filter, the exposure must be increased. The filter factor and f-stop increases given below are approximate, and may vary slightly from film to film. If the natural light is bluer or redder than normal this will also affect exposure. Do not rely on a camera's TTL meter when using strong filters – the meter's colour response may not be the same as the film's. An exception is when you are using a filter that is the same colour as a dominant subject (for example, 25 Red with a large red building). In these circumstances it is generally better to ignore the filter factor and not increase the exposure as the filter will only block light from the background.

Other filters Many of the filters used with colour film (see pages 60–61) do the same work in black-and-white. Ultraviolet, polarizing and neutral density filters give similar results as with colour, as do many of the filters used for special effects such as prisms and diffusers. Graduated filters can also be used with black-and-white film, but the same selective effect for different parts of the scene can be achieved during enlargement with a greater degree of control.

High-speed infrared film needs special filtration for its most dramatic uses – extremely high contrast, rendering a clear sky black, and vegetation white. For this effect use a Wratten 87. A red filter gives more moderate results.

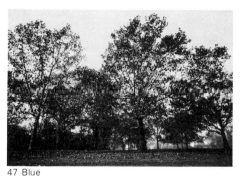

47 Blue

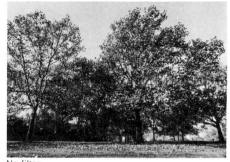

No filter

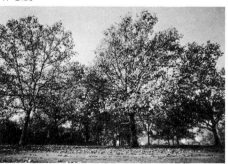

12 Yellow

16 Orange

Contrast control filters The relative tones of the sky, trees and grass in this scene can be altered to a considerable extent with filters. 47 Blue lightens the sky even further than the unfiltered result, where the sky is pale and uninteresting. 12 Yellow, 16 Orange and 25 Red increase the darkness of the sky by progressive amounts, the red filter making it almost black. A 58 Green would darken the sky and also lighten the grass in the foreground – an option worth considering.

25 Red

Altering black-and-white film behaviour

Altering development Compared with colour film (pages 66–67), altering the development of black-and-white film is a more useful device and is simpler to control. With only one layer of emulsion instead of three, the results are easier to predict. It is widely used as a technique for contrast control, and is an essential part of using the Zone System (see pages 18–19). Increasing the development expands the tonal range, increasing contrast, while decreasing the development has the opposite effect, compressing the tonal range and lowering contrast. When using altered development to make fine changes in contrast, remember to alter the exposure accordingly. For instance, if you want less contrast, and therefore plan to have the film under-developed by, say, one stop, then either open up the lens aperture by one f-stop or halve the shutter speed. Alternatively, halve the ASA rating – with Tri-X or HP5, set the film speed dial on the camera to ASA 200 instead of ASA 400.

Development can be altered by changing the dilution or temperature of the chemicals, or by changing the time. Two stops over or under-development is the practical limit before image quality is greatly affected.

Increased or 'pushed' development
1. Increased film speed
2. Increased contrast
3. Increased graininess

Decreased or 'cut' development
1. Loss of film speed
2. Less contrast

Black-and-white transparencies from negative film Black-and-white negative films can be given reversal processing, using special chemicals, to produce transparencies for projection. Agfa Dia-Direct is made specifically for this, but negative materials can also be used. Image quality depends on the film: Kodak Panatomic-X and Ilford Pan F produce quite good results with a direct, positive film developing outfit, although the slight overall grey tone cannot be removed and reduces the brightness of the image slightly.

Up-rate the film by about $1\frac{1}{2}$ stops (for example, to ASA 80 with Panatomic-X), and bracket exposures if possible, as there is less latitude with reversal processing.

Reciprocity failure, with black-and- white film
Reciprocity failure with black-and-white film is by no means as serious a consideration as it is with colour. There are no colour shifts, of course, and the great latitude of black-and-white negative film is usually more than enough to mask the effects of reciprocity failure at moderately long exposure times.

Altering contrast with black-and-white film
(for colour film, see pages 54–55)

To decrease contrast
1. Choose a low-contrast film (pages 76–79)
2. Use fill-in lighting (pages 50–53)
3. Shade off direct sunlight (pages 52–53)
4. Wait for daylight conditions to change
5. Over-expose and under-develop the film (see opposite)
6. Pre-expose the film (pages 94–95)
7. Use a fog or diffusing filter (pages 82–83)
8. Deliberately introduce flare
9. Use a coloured filter to bring colour contrasts together. For example, a blue filter will reduce the contrast between dark blue and light yellow subjects (pages 82–83)
10. Treat the negative with reducer (following manufacturer's instructions)
11. When the negative is being printed, use a softer grade of paper, weaker developer, a diffusing enlarger. etc.
12. Retouch the print or negative

To increase contrast
1. Choose a high-contrast film (pages 76–79)
2. Add lights to imitate direct sunlight (pages 52–53)
3. Wait for daylight conditions to change
4. Under-expose and over-develop the film (see opposite)
5. Shade the lens as efficiently as possible (pages 118–119)
6. Make a copy negative, which will automatically have higher contrast
7. Use a contrast-enhancing filter, to deepen shadows (pages 82–83)
8. Treat the negative with chromium intensifier (following manufacturer's instructions)
9. When the negative is being printed, use a harder grade of paper, more concentrated paper developer, etc.
10. Retouch the print or negative

Development 'cut' by one stop By rating the ASA 125 film at ASA 64 (therefore increasing the exposure by one stop) and then under-developing it by the equivalent one stop, the contrast in the scene was reduced. This approach would have been more suited to a high contrast scene with deep shadows and strong highlights that needed reducing.

Normal rating and processing The low light in this scene gives a somewhat bland result when the film's normal behaviour is used.

Pushed by one stop Uprating the film to ASA 250 and reducing the exposure by one stop increases the contrast because the film was 'pushed' or over-developed. Graininess is increased, but so too is the contrast in the shot, giving a more sombre, dramatic atmosphere to the mountain lake.

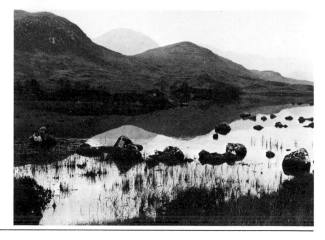

Black-and-white film emergencies

Many of the emergency procedures already described on pages 68 to 69, under the section on colour film, apply to black-and-white photography. With only one emulsion and a much wider latitude, however, there is a better chance of salvaging wrongly exposed or physically damaged black-and-white film. Retouching is less difficult, particularly on the print, and there are several overall chemical treatments that can be applied without professional help.

The film has been under or over-exposed As with colour film, if you know how great the exposure error is, it can be compensated by extended or reduced development. Because there is only one emulsion layer as opposed to colour film's three, there are no side effects. Also, precision is not absolutely necessary, as black-and-white negative emulsions have great latitude.

The negative has been scratched If the scratches are fine, the negative can be printed wet, in a glass carrier. In this method, the negative is covered with a film of water that covers over fine scratches and effectively conceals them. There are, however, dangers in this technique, particularly if parts of the film dry out in contact with the glass.

Alternatively, scratches can be retouched. This can be done on the negative with a dye or pencil if the film format is large, or on the print by knifing — gently shaving the blemish with a scalpel. The latter is a safer process as a damaged print can always be replaced as long as the negative is intact.

The negative has been lost If you already have a print, even a torn or damaged one, it is possible to make a new one, although perhaps of lower quality than the original. Simply copy the print by laying it flat on a table or the floor, lighting it evenly from two sides (from four sides, if possible), and re-photographing it on fine grain film with the camera on a tripod.

Reducing or bleaching Prints, or areas of them, can be lightened with the application of special reducers or diluted bleach.

1 Soften both emulsion and paper by soaking in water for 10 minutes.

2 On a flat, smooth surface such as a sheet of glass, swab off excess moisture.

3 If a precise area is to be reduced, mask off the surrounds with rubber cement.

4 Swab or brush on the reducer or diluted bleach with a smooth continuous action so that the effect is even.

5 As soon as the reduction is sufficient, wash the print immediately in water.

6 Peel off the rubber cement mask, if you have applied one.

Toning The use of toners can change the general hue of a print, or part of it – to sepia, for example.

1 While following the manufacturer's instructions for precise timing, soak the fixed, washed print in bleach solution for a few minutes, until the image has faded to pale yellow-brown. To apply locally, soak the print first in water, and then swab on the bleach, either using a rubber cement mask to protect the surrounding area or moving the swab constantly for a graduated border to the bleached area.

2 Transfer the print to a tray containing the toner. Toners are available in different colours, such as red, yellow and blue, and can be mixed to achieve a particular hue. Leave the print until the image has reappeared at its full intensity.

3 With some toners, a second bleach may be needed to remove the redeveloped black image that accompanies the new colour. This is largely a matter of taste, as the pure colour may appear weak on its own.

Dyeing Dye can be used to darken specific areas of a finished print.
1 Select a dye that matches the 'black' of the print exactly.
2 Soak the print in water for about 10 minutes.
3 Place the print on a tilted surface that is hard and smooth. Then swab off excess moisture.

4 Mask off any areas with rubber cement that are to be left untreated.
5 Wash the diluted dye onto the print with broad strokes, moving the brush constantly to avoid hard edges. Build up the intensity slowly in several stages. Immediate washing will remove most of the dye if you make a mistake.

Knifing Blemishes and unwanted elements in a print can be carefully removed by cutting away a thin film from the surface of the print. This procedure is frequently called for.
1 Hold a scalpel with a sharp blade well back along its stem and at a shallow angle. Shave large areas of the surface with short strokes, moving the wrist rather than the fingers. Do not penetrate to the paper base.
2 Clear up small spots with the tip of the blade.

Spotting Small blemishes that are lighter than the surrounding areas can be filled in with dye.
1 Load the fine tipped spotting brush generously with dye, and then draw it across absorbent paper to remove most of it.
2 Test the amount of dye delivered by the tip of the brush against your thumbnail. It should not form pools.

3 On a dry print, touch the centre of the white spot, dabbing gently until it matches the surrounding tone. Touch the edges of the spot as little as possible or the dye will build up into a dark ring.
4 With grainy prints, try to match the grain size and intensity with each dab.

Air brushing This skilful process can be used to make quite extensive alterations to a print. Considerable practice will be needed to achieve effective results.
1 Mask off the parts of the image that are not to be treated. If the edges are hard, apply a sheet of adhesive masking film.
2 Knife gently around the area to be sprayed, cutting the masking film but not the emulsion.
3 Peel off the film. Start off the spray on a scrap of paper held over the print in case there are any spurts of pigment, first pressing down on the button to regulate the air flow, and then pulling back to release the pigment.
4 Load the airbrush with pigment that has been diluted to the consistency of milk and well stirred to avoid blockages.
5 For a soft edged mask, hold a roughly shaped card about an inch over the surface of the print, moving it constantly.

Black-and-white film faults

Many of the common faults already shown on pages 70–75 apply equally to black-and-white film. Even if you do not do your own processing and printing, always examine the negative rather than the print or contact sheet if you have a suspected fault. The clear rebates (edges) and generally lower contrast range actually make it easier to spot errors on a black-and-white negative than on a colour transparency. Light leaks and flares are dark areas on a negative. Unexposed areas are clear.

Although modern black-and-white emulsions are tougher and more tolerant of mistakes than they used to be, the general standard of black-and-white processing is noticeably lower than that of colour. Incorrect agitation, dirt and drying marks are common faults, even with commercial laboratories. Because black-and-white processing is simple and needs very little equipment, many photographers do their own in order to ensure quality.

Completely unexposed A clear negative and a black print indicate that the frame is unexposed. Either something obstructed the lens (the lens cap was left on, for example) or the shutter failed to open. If the whole roll of film is like this, check the camera mechanism.

Under-development Superficially, under-development and under-exposure appear similar – a weak, thin negative. However, when not developed enough, the contrast is also flattened. The easiest way of distinguishing between the two is to examine the numerals and lettering on the rebate. These are pre-exposed by the manufacturer, so that if they appear weak and grey, as here, then the fault lies in the processing.

2 **2A**

Over-development As with under-development examine the rebates of the negative. The characteristic signs are black, thick and hazy numerals. The image itself may, in parts, be so dense as to be virtually opaque.

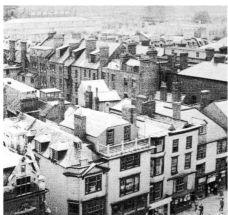

Reticulation A much less common fault now that films are tougher and can withstand mistreatment, reticulation, with its characteristic crazed appearance, is caused by sudden temperature changes in the processing. Typical causes are a hot developer and very cold wash. The sequence of expansion and contraction cracks the surface.

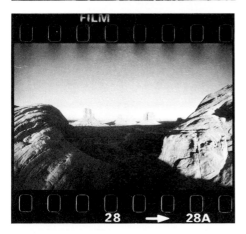

28 ➡ **28A**

Tension marks The tell-tale signs are regularly spaced 'shadows' tailing from the sprocket holes on 35mm film – light on the negative, dark on the print. Although sometimes due to inadequate agitation, they are normally caused by tightening the film in the camera. As a result, they are more common at the ends of a roll than in the middle. Motor drives sometimes cause them, as does tightening the rewind knob.

Instant films: colour

Instant film technology, pioneered and still dominated by Polaroid, has revolutionized some areas of photography. The ability to see the finished results almost immediately can be used not just to save effort, but to evaluate and then improve photographs on the spot. The uses of instant film are described on pages 98–99.

All instant film works on the principle of a sealed pod of chemicals squeezed over the exposed emulsion by rollers, but there is a major difference between 'peel-apart' film, where the negative is removed from the final print, and the newer 'integral' film (SX–70 and Kodak Instant Print), in which the negative and chemicals remain sealed inside the print, hidden from view by pigment.

Compared with normal emulsion, the general characteristics of most instant films are:
– High resolution, because they are contact-printed
– Narrow contrast range (therefore high contrast)
– Little latitude, not normally a problem because a wrong exposure can be corrected instantly by making a second one
– A diffuse silver haze, particularly noticeable in integral films. The effect has some slight similarities with that of a light diffusing filter.

The instant films currently available are for use either in special cameras or in film holders that can be fitted onto some medium-format and large-format regular cameras.

Polaroid SX-70 Polaroid's integrated instant colour film for use in special Polaroid cameras prints as you watch, without any peeling off of an outer layer. This means it is not possible to control the image by altering development time, but colour saturation and definition are of generally good quality.

Polaroid SX-70 Time-Zero Replacing the previous SX-70 colour film, Time-Zero is the world's fastest self-developing integrated colour film, reducing development time to about one minute. It also offers improved colour separation and saturation.

Polacolor 2 ASA 75. The five different Polaroid film sizes (Types 58, 108, 668, 88, and 808) have similar characteristics, and use the same, very stable, metallized dyes. Like all instant films, Polacolor 2 has rather high contrast, and cannot handle bright sunlight and deep shadows together. It has little latitude, and exposures need to be within half a stop.

Polacolor 3 (Polacolor ER) ASA 125. Polaroid's most recently announced peel-apart film shows considerable improvement over previous instant colour films and has been very well received by the photographic press. Its colour separation and saturation are extremely good, and it can be used successfully in a wider variety of lighting conditions than Polacolor 2. It also has

greatly increased exposure latitude. Initially, it will be available in 4×5in format (Type 59) and 8×10in (Type 809).

Polaroid SX-70 (no rating, but effectively somewhere around ASA 150). This is a self-timing, integral film for use only in special Polaroid cameras. Roller ejection is automatic, using an electric motor in the camera and batteries in the film pack, reducing the risk of uneven processing. The plastic and polymer layers that seal the print help to give the image a special quality. The most recent version, 'Time-Zero', takes only one minute to complete its processing.

Kodak Instant Picture Print Film PR10 (no rating, but effectively somewhere around ASA 150). Also a self-timing integral film, similar to Polaroid SX-70.

Polacolor 2 Generally available for use in special film backs for 6×6cm and view cameras, Polacolor 2 is a high quality aid to picture making, helping the photographer see the instant film result before switching back to normal materials. It also produces high quality images in its own right, quite good enough for publication. The major drawback of limited latitude is overcome in the latest version which is soon to be introduced, Polacolor 3.

Instant films: black-and-white

There are four types of instant black-and-white film available in sheets or packs: regular, high-speed, high contrast, and the exceptional positive/negative film that delivers both a print and a quality negative.

Polaroid Type 52 ASA 400. Available in 4×5in sheets only, Type 52 gives subtly graded, high-resolution prints with a contrast range that covers about six stops. With moderately high contrast, it is best suited to low-contrast scenes (such as portraits taken entirely in the shade or landscapes on overcast days). Print quality is extremely fine.

Polaroid Types 57, 87 and 107 ASA 3,000. These fast films are useful for available light photography at small apertures and high shutter speeds, and in dim light. They have higher contrast than Type 52, covering a range of about five stops only, and are also grainier. They are useful for adding life to low-contrast scenes.

Polaroid Type 51 ASA 320 in daylight, ASA 125 in tungsten light. This is a specialized film, giving extremely high-contrast prints, and is blue-sensitive rather than panchromatic, hence its slower speed in artificial light and when the sun is close to the horizon. It is useful for graphic effects, and for giving a bright, lively result under very dull conditions.

Polaroid Type 52

Polaroid Type 55 P/N ASA 50 for prints, ASA 25 for negatives. Polaroid 55 P/N (in 4×5in sheets) gives not only a high-resolution, finely-graded print, but also an instantly usable negative with the very high resolving power of 150–160 lines per millimetre. To clear residual chemicals from the negative, dip it in a sodium sulfite solution at room temperature within three minutes, and leave it for at least a minute. Alternatively, put it in water until you have access to the sodium sulfite solution. Polaroid supply a plastic tub for storing negatives in solution while on location. Finally, remove the metal tab and the black perforated strip, which can cause staining if left in contact with another negative. Then wash the negative in running water for five minutes. An acid hardening bath is optional, but not really necessary. Hang to dry.

Note the different ratings for print and negative. This means that a properly exposed print will give a thin negative, whereas a good negative accompanies an over-exposed print.

Polaroid Type 665 P/N ASA 75 for prints, ASA 35 for negatives. The medium format version of Type 55 P/N, with similar performance and procedures for use.

Polaroid Type 57

Polaroid Type 55 (positive)

Polaroid Type 55 (negative)

Care of prints
Unlike instant colour prints, most instant black-and-white prints should be coated within five minutes with the impregnated coaters supplied to remove traces of reagent (which would bleach light tones) and protect the surface against scratches, Coat smoothly and gently on a flat surface with six to eight overlapping strokes. Dry prints separately for several minutes, and store in the transparent bag provided.

Polaroid Type 51

Instant film: controlling the image

Most instant film cameras are fully automated – some Polaroid models even have sonar-operated automatic focusing – and offer few opportunities for altering results beyond a simple 'darken/lighten' camera control. The image on peel-apart films, however, can be controlled by various means, particularly when used in holders on regular cameras.

Exposure control On regular cameras with Polaroid backs, all the normal camera controls can be used. With most automatic instant film cameras, the 'darken/lighten' control normally covers a range of one stop over and one stop under. The SX-70 Alpha also has intermediate half-stop marks. For greater or more precise

changes, put a neutral density filter over either the lens or the sensor (but not both together). An ND 0.30 filter over the lens, for example, will reduce exposure by one stop. The same filter over the sensor will increase the exposure by one stop. The principle is the same as for automatic flash units (pages 50–51).

Development control: black-and-white This is not possible with positive/negative films Types 55 P/N and 665 P/N, which show no changes in contrast when the development time is altered. With other black-and-white films, however, increasing the devlopment time will darken shadow areas, while reducing the development time will lighten them. Light tones in

Controlling contrast This pair of Type 57 prints shows the range of contrast possible by altering development time. The print at right was developed for the minimum recommended time - 15 seconds – with a flat result. The second print was developed for the full 60 seconds, giving much higher contrast. To compensate for the extra density of an over-developed Polaroid, increase exposure by a half or one stop.

the print are not affected and can only be altered by varying the exposure. This means that increased development gives more contrast, while reduced development gives a flatter result. Generally, altering the development time by 50 per cent in either direction gives a one stop difference in the shadow areas.

Development control: colour This is not possible with integral films, which are self-timing. With Polacolor 2, longer development (75 secs or 90 secs instead of the recommended 60 secs) gives more saturated colours and deeper blacks, but also causes a blue-green colour shift. This can be corrected by using yellow or red filters, but the amount varies, and testing will be necessary.

Delayed coating The coating necessary with most black-and-white instant films halts further

bleaching. By delaying this coating for several minutes, the light tones are lightened further, thus increasing the contrast of the print. The darker tones remain unaffected.

Pre-exposure To lighten deep shadow detail in a high contrast scene, instant film can, like any other, be pre-exposed. To do this, aim the camera, well out of focus, at a completely blank subject such as a sheet of paper or a clear sky, reducing the exposure indicated by the direct meter reading by three stops. Then, on the same film, photograph the scene you want. The result will be lightened shadows but unaffected highlights. With automatic cameras, place a 0.90 ND filter over the lens only. With Polacolor 2, you can also make subtle adjustments to shadow colours by pre-exposing through a coloured filter.

Intensifying colour With Polacolor 2, the longer the development time, the stronger the colours. At the minimum recommended development time of 60 seconds, the image (left) is noticeably paler and less saturated than when the print is developed for 90 seconds. The only disadvantage with extra development is an increasingly blue-green cast, which can only be corrected by filtering the shot – in this case, the right hand exposure needed an extra CC10 Red and CC05 Yellow.

Instant film faults

Most of the problems with instant films occur at the moment when the film is ejected or pulled through the rollers. Basic precautions are:
1. Never press packs or the pod area of sheets
2. Keep the rollers clean
3. With peel-apart films, pull smoothly
4. With integral films, do not obstruct the film ejection slit

No image/black The film is unexposed, possibly due to it having been inserted the wrong way round, the metal strip catching when the film was loaded, the paper envelope not having been withdrawn before exposure, or to a fault with the camera.

No image/white The test chemical pod has failed to spread over the film. This occurs when the pressure rollers are open – at the 'L' setting on the Polaroid 545 holder.

Pale, mottled image The film was processed when too cold.

White corners The film was withdrawn too quickly after exposure.

Reciprocity failure: Polacolor 2
Compensate for long exposures with increased
exposure and filters used together as follows:

Exposure time	1/1,000– 1/100 sec	1/10 sec	1 sec	10 sec	100 secs
Exposure increase	–	$+\frac{1}{3}$ stop	$+1\frac{1}{2}$ stops	$+2\frac{1}{2}$ stops	+3 stops
Filters		CC05R +CC05Y	CC10R +CC20Y	CC30R +CC20Y	CC30R +CC20Y

Black edge The paper envelope
was only partly withdrawn before
exposure, so cutting off part of
the film from exposure.

Evenly spaced marks Dirt or
other particles stuck to one of the
rollers produces a row of white
marks at regular spacing.

Uneven streaking The
chemical pod burst before
exposure. Avoid pressing the pod
at all times.

**White blemish at bottom
edge** With integral film, the film
is ejected mechanically.
Obstructing the exit, perhaps
with a finger, causes an uneven
spread of chemicals.

Using instant film

Because instant film has been promoted chiefly for snapshot use, its possibilities have still not been fully explored. The high quality of the film and most of the equipment makes it valuable in ways that go beyond casual picture-taking.

As a substitute for normal film Far from being inferior to 'real' film, the image qualities of most instant films are in may ways better. Types 52, 55 and 665 have exceptional resolution and subtle gradation, while the negatives of Types 55 and 665, although a little flat, have the highest resolution of any commonly available film. Polacolor 2 and SX–70 metallized dyes are the most stable and fade-resistant available. For professional use, there is no problem in reproducing them in printed publications.

For testing In regular cameras, instant films are an invaluable means of testing composition, exposure and filtration when shooting with normal film and are widely used in this way. They are not only low cost insurance, but give the opportunity of judging, and possibly improving, photographs on the spot.

As a learning technique Because photographs can be produced for immediate assessment alongside the subject, instant films offer a

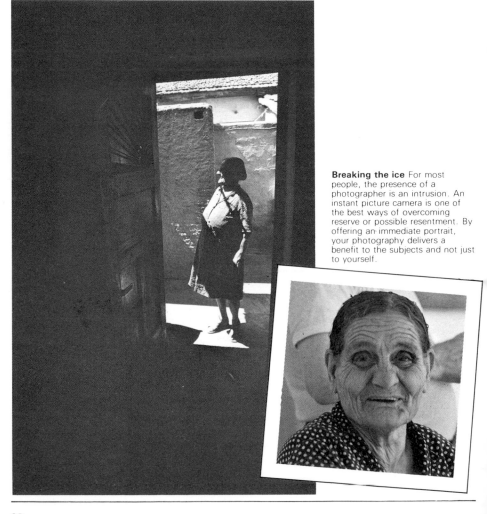

Breaking the ice For most people, the presence of a photographer is an intrusion. An instant picture camera is one of the best ways of overcoming reserve or possible resentment. By offering an immediate portrait, your photography delivers a benefit to the subjects and not just to yourself.

unique opportunity for learning practical composition and image management.

For single opportunity shots In some situations, particularly when fast, unpredictable action is involved, there may be great uncertainty as to whether the right image has been captured. Instant film removes all doubts.

For goodwill To help relax subjects or to gain their co-operation, an instant print is more valuable than any promise of sending photographs at a later date. Rather than approach someone for permission to take a photograph for your own benefit, you can start by offering to give them a portrait.

Making a grey scale To make a completely accurate grey scale, ideal for testing film (pages 64–65) or for Zone System use (page 18–19), start by photographing a lightly textured mid-toned surface, such as a towel or rough paper, using black-and-white instant film. With automatic exposure or a direct meter reading, the result should be 18 per cent grey (Zone V). For accuracy, check against an 18 per cent grey card (see pages 14–15) and adjust the exposure if necessary. Then, by using neutral density filters in one stop steps, over the lens for darker tones and over the sensor for lighter tones, or by adjusting the aperture and shutter speed, you can make an accurately graded series of prints from white to black. Cut and paste the prints together in sequence on a piece of card or on the inside cover of this manual.

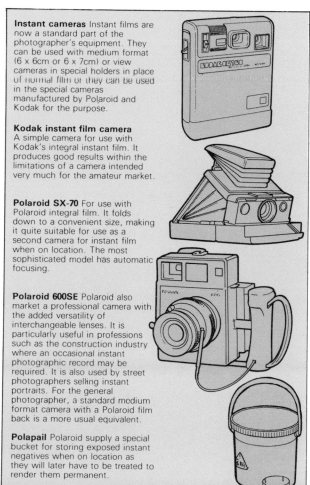

Instant cameras Instant films are now a standard part of the photographer's equipment. They can be used with medium format (6 x 6cm or 6 x 7cm) or view cameras in special holders in place of normal film or they can be used in the special cameras manufactured by Polaroid and Kodak for the purpose.

Kodak instant film camera
A simple camera for use with Kodak's integral instant film. It produces good results within the limitations of a camera intended very much for the amateur market.

Polaroid SX-70 For use with Polaroid integral film. It folds down to a convenient size, making it quite suitable for use as a second camera for instant film when on location. The most sophisticated model has automatic focusing.

Polaroid 600SE Polaroid also market a professional camera with the added versatility of interchangeable lenses. It is particularly useful in professions such as the construction industry where an occasional instant photographic record may be required. It is also used by street photographers selling instant portraits. For the general photographer, a standard medium format camera with a Polaroid film back is a more usual equivalent.

Polapail Polaroid supply a special bucket for storing exposed instant negatives when on location as they will later have to be treated to render them permanent.

3. CAMERAS AND OTHER EQUIPMENT
Handling: 35mm and small format

The two principles of camera handling are steadiness and access to the camera's controls. A steady or an unsteady grip can make a difference equivalent to two or three exposure stops. In difficult conditions such as low light, being able to use a slow shutter speed without a tripod or other support can determine whether or not a shot is possible. Being able to reach all the controls easily and quickly makes operating the camera less distracting, so improving reaction time and allowing you to concentrate on the image. Practice will improve camera handling.

35mm, standard horizontal format With the basic grip for a 35mm camera, for a horizontal format, the camera body rests on the heel of the left hand, which is cupped so that the thumb and forefinger are free to move either the focusing or aperture ring on the lens. Most lenses – except tele-photos, large fish-eyes and zooms – are less heavy than the camera body, so there is no need to grip the lens hard; this only makes re-focusing or changing aperture slower. The heel of the right hand and three fingers grip the side of the camera, leaving the forefinger poised over the shutter release and the thumb ready to operate the cocking lever.

Horizontal grip The weight of the camera is distributed equally between both hands. Tuck both elbows into your chest to reduce muscular strain and improve steadiness. Press hands and camera against your face.

Motor drive, horizontal format With a motor drive fitted, the shape of the body is altered, usually with a prominent grip on the right-hand side. Despite the extra weight, the whole camera is easier to hold, and the right thumb no longer has to work the cocking lever. As a result, the complete weight can be supported in the right hand.

Motor drive, horizontal Use the additional hand grip on the motor drive if there is one. The left hand will then be entirely free to operate the lens – an advantage with fast shooting.

35mm, vertical format The normal grip for a vertical format has the top of the camera to your left, the camera body then fits well into the palm of the left hand, leaving thumb and forefinger free to operate the lens. The nearly vertical left forearm, held against the chest, supports the camera's weight. The right hand, which has to curl over the top to operate the shutter release and cocking lever, is of little use to carry the camera's weight, but can steady it back against the forehead.

Vertical grip In the standard method, the left hand takes the camera's weight.

Alternative vertical grip Reversing the grip is more awkward although the left hand is freer.

Motor drive, vertical format When used for vertical format shots, motor drives are distinctly awkward to hold, and both hands have to take some of the weight.

Motor drive, vertical 1 Bulky motor drives are difficult to use vertically. Take more of the weight in the right hand.

Motor drive, vertical 2 You may find the reverse grip more comfortable. Experiment with the two possibilities.

110 cameras Because basic 110 cameras do not have reflex viewing, the most important precaution is to keep the fingers away from the front of the camera, where they may block the lens, light meter or flash. Being light, they are easy to hold, except at slow shutter speeds when, because both elbows cannot be held into the chest, camera shake is more of a danger than with 35mm cameras. So always take the precaution of pressing the camera against your face.

110 horizontal Keep fingers clear of lens and viewer, and take extra care to avoid camera shake.

110 vertical Use right hand to take the weight and release the shutter. Experiment.

Handling: 35mm stance

Standing Although standing is a less reliable shooting position, it is the easiest for most situations. Hold the camera as already described, and for the steadiest balance stand with your feet slightly apart, one a little in front of the other. To distribute the weight equally between both legs, lean forward slightly. This stance gives the least strain. Leaning backwards or crouching increase strain and so are disadvantageous.

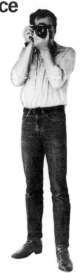 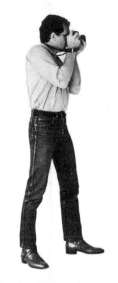

Standing posture Spread your weight between both feet, placing one slightly in front of the other. Attempt to find as relaxed and balanced a stance as possible, holding your elbows into your chest for support.

Using available support If there is any solid support close to you, take advantage of it. Use a wall as a brace, taking the weight on your outer leg, and pressing your hand, forearm and head against it.

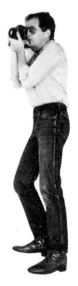

Supports Leaning against a wall or tree can help. If necessary use a jacket as a protective cushion.

Kneeling and squatting positions These are both good shooting positions, although in many situations they may be too low to avoid foreground obstructions. The aim of kneeling on one leg is to form a squat 'tripod': the three points of support are the left foot (in a direct line through the knee and forearm to the camera), bent right foot (in direct contact with the spine) and right knee (pointed out for steadiness). When squatting, crouch forward and rest both elbows on the knees. Although uncomfortable at first, with practice this can give a steady, relaxed hold.

Kneeling This is much more stable than standing even though less convenient. Rest on your

heel and support your left elbow on your knee, making a solid vertical camera rest.

Squatting The intention is to form a camera platform with your body. Rest elbows on knees and

lean forward, forming a compact, relaxed structure.

Ground level shooting position Low shooting is easiest with an SLR that has a detachable prism head. For a ground level position, remove the head and hold the body against any clean, dry surface – use a cloth if the ground is wet.

Shooting from high up If no ladder or vantage point is available, shoot from above your head with arms outstretched. This can be useful for shooting over the heads of a crowd. If you can, remove the detachable prism and compose directly on the ground glass screen.

Ground level Compose directly on the ground glass screen if you can remove the viewing head

Above your head To see over crowds: guess the composition or remove the viewing head

103

Handling: 35mm long-focus

Standing Rigidity is more important with a long-focus lens than with any other. Not only is the image magnified, so is any movement. Longer lenses tend to have smaller maximum apertures and so need slower shutter speeds. They are also heavier. To combat these disadvantages, use every support that conditions allow. With practice, it is nearly always possible to improve on your minimum shooting speed. Every improvement extends the lighting conditions in which you can work effectively.

Standing positions are the least stable, but often unavoidable. Stand with legs slightly apart, one foot a little in front of the other. Pull the lens towards you. The lens used here is a 400mm f5.6 telephoto. With regular practice, 1/250 sec is safe from a standing position,

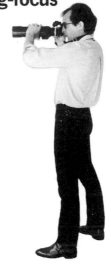

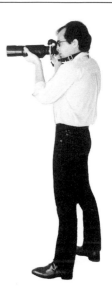

Overhand horizontal An overhand grip on the lens mount helps to pull it back firmly against the face.

Underhand horizontal With the left elbow firmly against the chest the weight is supported from below.

Crouching These are more stable positions than standing and, although the viewpoint is lower, use them whenever possible. Spread the body's weight and make sure that the contact line between legs and ground is rigid (ball of hand – elbow – knee – foot). Muscles are less stable than bones, so avoid lifting the lens to shoot.

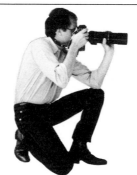

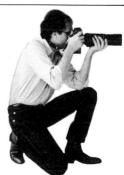

Side grip, motor drive Although less easy to alter focus, gripping the lens mount from the side is more stable.

Underhand, motor drive Here all the weight is supported by the left hand and leg. The right hand is free.

Prone In many ways, using a long-focus lens is like firing a rifle, and the rifleman's prone position is the most stable of all, short of using a tripod. Spread and flatten the legs as far as possible, and turn the body slightly at the waist.

No support The weight rests on both elbows. Place left hand far forward.

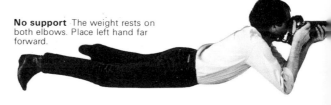

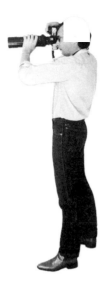

Overhand vertical Very little adjustment is needed to use the underhand grip with a vertical format.

Underhand vertical, motor drive With a motor drive attached, the extra bulk is more awkward and less stable.

Overhand horizontal motor drive This is one of the least stable positions although focusing is rapid.

 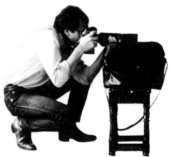

Squatting, motor drive horizontal This position uses both hands, elbows and knees. Ankles are crossed.

Squatting, motor drive vertical Much less stable than the previous position with all the weight on one knee.

Available support Use any surface at the right height for extra support. Here, a camera bag is often useful.

Available support A camera bag or other object gives a three point support.

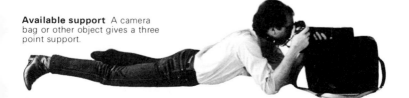

Handling: larger formats

Standard focus When focusing and composing directly on the ground glass screen of a medium format reflex camera, hold the camera comfortably at waist level, taking all of its weight in your cupped left hand, and press it against your body for extra support. Without a magnifying attachment, there are no advantages in holding the camera higher, and it will be less steady. Hold your forearms firmly against your body. With the Hasselblad shown here, the forefinger of the left (supporting) hand, operates the shutter release.

Waist level Hold the camera firmly against your body for support. Your feet should be spread, with one slightly in front of the other. Compose on the ground glass screen, using the right hand for focus.

6×6cm viewfinders With a magnifier attached to the viewing screen, the camera has to be held away from the body. To compensate, tuck your elbows into your sides and hold the camera up against your face. A 45° viewer is marginally less steady than a right-angled magnifier, but the principles for holding the camera remain the same.

Magnifier Difficult without a tripod. Hold the elbows firmly against your body to provide support. Learning to compose the shot at a 90° angle when hand-held takes practice.

45° viewer Even less stable than the magnifier, but easier to frame the shot correctly. Once again, keep the elbows tightly in.

Non-reflex 6×6cm for mat The Hasselblad SWC Super-wide is a non-reflex 6×6cm camera with a unique design. The optical viewfinder is a separate unit which slots into the top of the camera. The squat body is very easy to hold firmly in a cupped left hand in the same way as the basic 35mm position, leaving the right hand free to operate the shutter release and wind-on crank. Viewing, however, is a little awkward. Perhaps the steadiest method is to press the cheek and side of the nose against the magazine back.

Direct viewer Easy framing and good support is possible with practice. Press the camera firmly against your face for support, with the elbows in.

Viewer and long lens combination Particularly when having to use a combination of 45° viewer or eye-level viewer and a heavy, long lens, a pistol grip is very useful, much more so than with 35mm cameras, which are better designed for hand-held shooting and rarely need this extra support. The left hand and arm takes all the weight. Hold your elbow in for steadiness. Because this eventually puts a strain on the left forearm, use the right hand, holding the lens, to pull the camera back against your face.

Pistol grip To steady a long-focus lens use a pistol grip. Stability is difficult to achieve.

Instant camera With integral film instant cameras, an electric motor pushes the exposed film through the rollers and ejects it. The most common handling fault is leaving a finger in front of the ejection slit, blocking the path of the film. With the Polaroid SX-70, take most of the weight in the flat of the left hand, but for extra firmness, cover it with all but the forefinger of the right hand. Because of the unusual folding design, the base of the SX-70 has to be tilted up for horizontal shooting.

Polaroid SX-70 Use your left hand to take the weight. The shape of the camera requires an unusual tilt, but with practice you will become accustomed to it.

Camera supports 1

Tripods, in various forms, are the basic mechanical support for situations where a slow shutter speed, weight of equipment, or high magnification may cause camera shake, or where precise composition is necessary. Rigidity is the basic quality of any tripod, although in outdoor photography, this sometimes has to be compromised for portability. Much depends on how well you use the tripod – for example, it is at its most stable with the legs splayed out as wide as possible and with the extensions fully retracted. More elaborate configurations are shown on the following page. Try always to shelter a tripod from the wind.

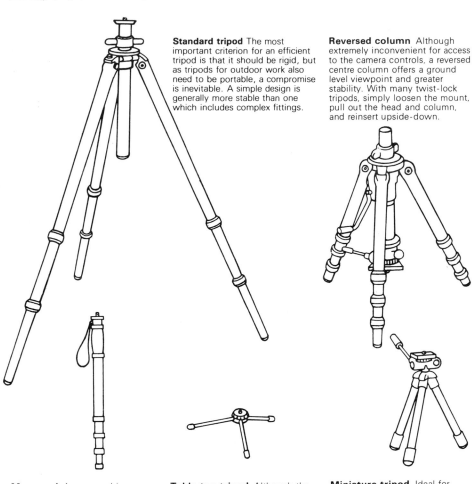

Standard tripod The most important criterion for an efficient tripod is that it should be rigid, but as tripods for outdoor work also need to be portable, a compromise is inevitable. A simple design is generally more stable than one which includes complex fittings.

Reversed column Although extremely inconvenient for access to the camera controls, a reversed centre column offers a ground level viewpoint and greater stability. With many twist-lock tripods, simply loosen the mount, pull out the head and column, and reinsert upside-down.

Monopod A monopod is essentially a brace for hand-held shooting, offering an extra point of support. How useful it can be depends on individual preference. It may or may not offer a significant improvement depending on the stability of your normal hand-held stance (see pages 100–7).

Table top tripod Although the legs are not adjustable, this small tripod will rest securely on most fairly level surfaces. Another method of use is to press it firmly against a wall.

Miniature tripod Ideal for close-up work – flowers and insects, for example – because of its low height, a miniature tripod can also be used for other subjects if placed on a wall, rock or other elevation. Its outstanding advantage is that it is light and compact enough to be carried permanently in a shoulder bag.

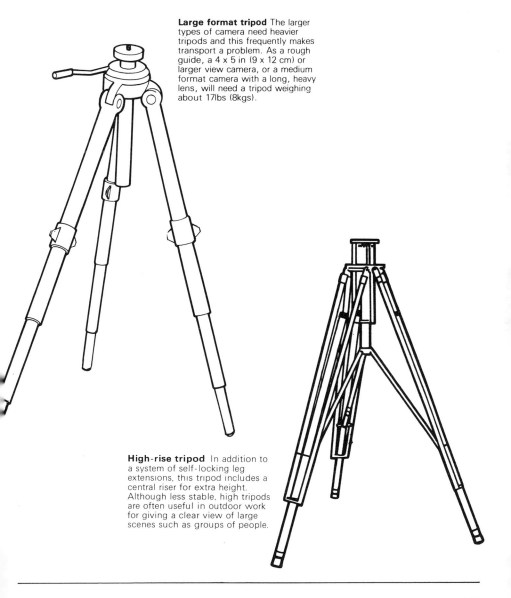

Large format tripod The larger
types of camera need heavier
tripods and this frequently makes
transport a problem. As a rough
guide, a 4 x 5 in (9 x 12 cm) or
larger view camera, or a medium
format camera with a long, heavy
lens, will need a tripod weighing
about 17lbs (8kgs).

High-rise tripod In addition to
a system of self-locking leg
extensions, this tripod includes a
central riser for extra height.
Although less stable, high tripods
are often useful in outdoor work
for giving a clear view of large
scenes such as groups of people.

Widespread position This is a very useful facility for outdoor photography, as the greater angle of spread is not only mechanically more stable, but can lower the camera on windy days to a position where there is less air movement. Most good basic tripods can be adjusted to a low position.

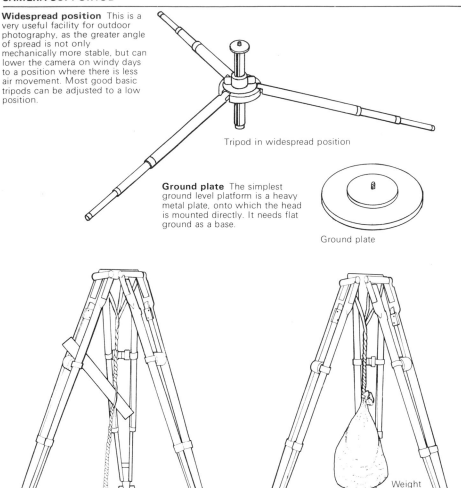

Tripod in widespread position

Ground plate The simplest ground level platform is a heavy metal plate, onto which the head is mounted directly. It needs flat ground as a base.

Ground plate

Crows feet

Weight

Spreader

Tying down For maximum stability secure the tripod by its centre of gravity to the ground, and apply tension. Spikes or tent pegs can be used to attach one end of the rope or cord to the ground. To tighten, place one end of a stick between the strands and twist, finally locking the other end against one of the legs. Crows feet can be cut out of blocks of wood and pegged down to stop the feet slipping.

Weighting Although not as safe as tying down, a weight suspended from the centre has a similar effect. A sack or bag can be weighed with locally found rocks or earth. A spreader, which usually folds up for transport, locks the feet in position.

Horizontal arm When shooting vertically downwards, it is sometimes difficult to keep tripod feet out of the shot. A horizontal arm, normally with adjustable extension, places the camera out to one side. At full extension and with heavy equipment, check that the camera is not off balance.

Horizontal arm

Clamps Provided there is a suitable fixture in the location, a clamp with a ball-and-socket head fitted may be the best support of all. Two common designs are a G-clamp and a vise grip. Either can be attached to branches, posts or railings.

Vise grip

G-clamp

Ball and socket head A ball and socket design has the advantage of being extremely quick and simple to use, although fine alterations are more difficult than with a pan and tilt head. For situations that need support but freedom of movement, such as a sports event with a long-focus lens, half-tighten the joint and support the camera partly by hand.

Ball and socket head

Pan and tilt head

Feet For most outdoor photography, the most useful tripod feet are metal spikes or jointed grips. The former are of no use in indoor work.

Pan and tilt head This standard head has a three-way movement: 360° rotation, forward/backward tilt, and left/right tilt. The advantage of three separate movements is that small adjustments can be made in a single direction, without upsetting the others.

Spike foot Jointed foot

Focusing and framing 1

In principle, focusing is a straightforward process, particularly with reflex cameras, where the precise image can be seen before making the exposure. The mechanics involve moving the lens (or some of its elements) backwards or forwards in relation to the film plane. With lenses for most small and medium cameras, the inner barrel is moved by a helical screw. The range over which it can be shifted is typically from infinity focus (farthest back) to around half a metre (farthest forward), although some lenses have a close-focusing ability and very long-focus lenses have a narrower range.

A recent, improved focusing system uses internal focusing, where the individual lens elements, rather than the whole group, are moved. With this arrangement, there are no external movements, and the mount can be

hermetically sealed – helical focusing tends to act like a suction pump for dust.

View cameras use the most basic of all focusing systems – operating with uncalibrated movement of both lens panel and film holder over either a geared bed or a rail.

Visual focusing Reflex cameras rely on a screen at the equivalent of the film plane. There are many designs, and in some cameras focusing screens are interchangeable. Screens can use any of four surfaces to aid focusing, sometimes in combination.

Plain ground glass The roughened surface of the glass makes the image visible in great detail, making fine focusing possible. Its disadvantage is that the image appears brighter in the centre than at the edges, especially with wide-angle lenses. This can be a serious problem with the

Focusing screens

Plain ground glass Ideal for detailed focusing in unhurried situations where there is adequate light. The typical 'hot-spot' effect of ground glass is most apparent with wide-angle lenses.

Ground glass with cross-hair Similar to the plain ground glass screen, with a clear glass centre and a reticle. The very bright central image is useful for high-magnification photography, such as with a microscope or telescope.

Ground glass with grid The standard screen for view cameras, it allows careful focusing of details and a check on the alignment of verticals and horizontals.

Fresnel The least distracting of all screens and particularly good for very long focus lenses that have small maximum apertures. When following movement, such as birds in flight, the unobstructed central area is very useful.

Fresnel with split-image rangefinder A general purpose screen, but more suited to normal and wide-angle lenses than long-focus.

Fresnel with angled split-image rangefinder. Identical to the previous screen, but with the central prisms set at 45°. Focusing is easier on subjects that have horizontal edges.

Fresnel with small microprism An alternative to the fresnel screen with central split-image rangefinder, for general use.

Fresnel with large microprism For dim light conditions, the bright central area allows critical focusing, although the combination of two large screen types can be distracting.

Full-frame microprism Designed for use at very low light levels, when visual focusing would otherwise be extremely difficult, a microprism covering the whole picture area allows images to be focused anywhere in the frame.

Fresnel with microprism and split-image rangefinder A compromise general purpose system, combining three screen types in one, this is often supplied as standard for 35mm cameras. The confusing central area is a disadvantage.

large ground glass of a view camera.
Fresnel screen One answer to the uneven brightness across a plain ground glass is a lens. A Fresnel lens is flat and extremely thin by virtue of a pattern of concentric rings with curved surfaces. The result is a brighter image, but slightly more difficult to focus.

Split-image rangefinder Two small prisms, in the centre of the screen, act as a rangefinder by splitting the image when it is out of focus. When the image is matched in both halves, the focus is sharp. This is a rapid, bright focusing aid, but not useful at small apertures or with long-focus lenses, which both darken the prisms.

Microprism A more developed version of the split-image rangefinder, a microprism grid uses many very small three or four sided prisms. Its advantage over the split-prism is that it can be used without a straight-edged subject. At small apertures, however, and with long-focus lenses, the field darkens.

Rangefinder focusing Most non-reflex small cameras use an optical rangefinder for focusing. A system of rotating mirrors or prisms compares two views of the subject from different positions on either side of the camera body, in effect triangulating to calculate the distance. In practice, a secondary 'ghost' image appears in the viewfinder. Most camera rangefinders are linked to the lens focusing ring, so that the image is focused when the images are aligned.

Automatic focusing Several methods of automatic focusing are possible, and some recent cameras now use them. Accurate use depends on the main subject being in a fairly central position, unobstructed by foreground objects. The Polaroid SX-70 uses sonar pulses, while other systems rely on an infra-red beam bounced back to the camera from the subject and electronically timed, or twin images compared by a CdS cell for contrast differences (a similar principle to the visual rangefinder).

Fresnel with grid The vertical and horizontal lines are invaluable for critical alignment, not only with architectural subjects, but also with horizons, and particularly with very wide angle lenses.

Fresnel with split-image rangefinder and grid Similar to the previous screen, with central prisms to aid rapid focusing.

Clear with graduated scales For high-magnification work, as in photomicrography, the clear screen with central reference cross-hairs is designed for parallax (aerial image) focusing. With this specialized technique, which needs practice, the cross-hairs help keep the eye in focus. If you move the eye from side to side whilst the image is out of focus, the subject will appear to shift relative to the cross-hairs. Turn the focusing ring until no movement is apparent. The image is then focused.

Fresnel with TV outline For shooting transparencies intended for TV broadcast, this screen shows the outlines of both the transmitted picture and the masked-down image on a receiver.

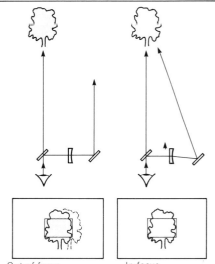

Out of focus In focus

Rangefinder focusing In principle, a rangefinder measures the change in the angle of view towards a subject from two points on the camera body – equivalent to binocular vision. A common method is to split the light path, passing one half through a sliding prism. Moving the prism changes the angle. By altering the focus, the two images can be made to coincide – this point indicating the image is in focus. In some rangefinder cameras, this focusing procedure automatically focuses the lens simultaneously.

Framing Matching the precise area of the picture to the viewfinder image is easiest with a reflex camera, where the picture-taking lens is used for viewing, but even this system is not always practical. In fast action situations, a supplementary viewfinder may be quicker.

Direct viewing screen View camera screens show the precise image. Most small and medium-format cameras' viewfinders, however, show only about 90 per cent of the image area, as a safety precaution for operator error and to correspond to the size of most transparency mounts. Check the coverage of your camera.

Optical viewfinder Although the image in an accessory viewfinder is bright, it is inevitably off-centred, and parallax is the greatest problem. At great distances, the different positions of the viewfinder and lens are insignificant, but closer than about six feet (two metres), some allowance has to be made. Most non-reflex camera viewfinders have marks to show parallax correction at close distances. Otherwise, if using a tripod, you may be able to shift the camera after selecting the composition so that the lens occupies the previous position of the viewfinder (see opposite). Optical viewfinders are either matched to the lens focal length, or contain several frames in one. The latter are known as universal finders.

For precise framing, a ground glass screen can be fitted temporarily to some non-reflex cameras. Even if there is no regular fitting, you can open the camera back before loading the film, lock open the shutter, and place either a small piece of ground glass, or even the opal acetate backing of a transparent film sleeve, over the film plane.

Framefinder Non-optical finders have the advantage of extreme simplicity, and rely on visual alignment of their three-dimensional structure.

Focus shift with new glasses

Focus shift can occur with some modern high-quality glasses that are used to reduce chromatic aberration to a minimum. These glasses are sometimes affected by temperature changes, altering the focus slightly. Visual focusing remains unaffected, but the engraved scale is not always correct. To allow for focus shift, the closest point of focus of the lens to the film is beyond infinity focus. The obvious danger is in turning the focusing ring to its furthest point and assuming that it is at infinity focus. With reflex cameras, always check infinity focus visually.

Infrared focus

Most lenses focus different wavelengths at slightly different distances – the cause of chromatic aberration. Even when this aberration is well-corrected, infrared wavelengths are still so much longer than visible light that, when most lenses are used with infrared film, they need to be focused at a position that seems slightly blurred visually.

Some lenses have a red mark engraved on the lens barrel against which the focusing scale can be set for infrared photography. For precise calculation, or with view cameras, move the lens forward by 0.25 per cent of the focal length (for example, 0.25mm for a 100mm lens). A simple way of doing this visually is to focus by eye at full aperture, and then move the lens forward (that is, focus closer) until the focused image just begins to go out of focus. This is not perfectly accurate, but it does give reasonable results.

A few modern lens glasses are so well corrected that no infrared adjustment needs to be made.

Optical aids

Magnifier This replaces the pentaprism of a reflex camera for an enlarged image (giving about four to six times enlargement). It can usually be adjusted for eyesight correction.

Eyesight correction lenses These are more useful if you have an eyesight deficiency for which you do not normally wear spectacles or contact lenses. If you do wear spectacles, removing them each time you use the viewfinder becomes tedious.

Rubber eye-cup Essential for spectacle wearers to avoid scratching the glass. Thick eye-cups, however, cause vignetting of the viewfinder image with spectacles.

Large format reflex magnifier For view cameras, this rectifies the inverted image. With experience, however, most view camera users become accustomed to the upside-down image on the screen. The magnifier also cuts out extraneous light for easier focusing.

Action finder An extra-large prism allows viewing at up to 20mm away from the camera. Useful when wearing goggles or when it is impossible to put the eyes close to the camera.

Supplementary optical viewfinder With extreme wide-angle and long-focus lenses, this is essential for a non-reflex camera. Also, with reflex cameras, some fish-eye lenses can only be used with the mirror locked up.

Framefinder Useful in fast action, or in difficult viewing conditions such as aerial photography.

Correcting parallax error with non-reflex cameras
1. Viewfinder frame Most viewfinders have marks to show the framing needed for close-up shots. Follow the manufacturer's instructions.

2. Shifting the camera With a Hasselblad SWC, for example, the camera can be moved after composing to bring the lens into the line of sight of the viewfinder.

3. Makeshift screen With the camera unloaded and the back open, place a viewing screen (for example, a piece of tracing paper) at the film plane and open the shutter.

4. Close-up frame For a specific focused distance, construct a wire frame that screws onto the base of the camera. Use the makeshift screen method (above) to draw the limits of the picture area, and then bend the wire to size.

Focusing in dim light
To overcome the problems of focusing in the dark, which is particularly difficult with reflex cameras, try one or more of the following methods:
Full-frame microprism screen Gives a much brighter image than an ordinary Fresnel screen.
Substitute focus If you can find something brighter than your subject at what appears to be a similar distance, focus on that and then aim the camera at the subject. At night, look for street-lights, lit windows or car lights.

Pre-set scale To rely completely on the engraved scale on the focusing ring of the lens, you need good distance judgement. To make it easier to select distance settings, mark the focusing ring at distances that you are likely to need – say, 10 feet, 25 feet, and 50 feet. A few lenses have a built-in ring of sliding knobs, but it is not difficult to make a plastic ring to fit over the barrel, and this can then be scored or marked.

Depth of field control

For every subject distance there is one lens setting where the image is as sharply focused as it can be. Nevertheless, sharp focus is a subjective quality, depending largely on what you are prepared to accept as reasonable resolution of detail. In front of and behind the plane of sharpest focus, the image becomes increasingly blurred, and the points at which it becomes unacceptably out of focus mark the limits of the *depth of field*. As a definition, the depth of field is the zone on either side of the plane of sharp focus in which the image is acceptably sharp. It depends on the following:

The criterion for sharp focus Lens imperfections cause points to be imaged as tiny circles. To the human eye, circles below a certain size look like points. This size is called the *circle of confusion* and sets the limit for a sharply focused image. The problem is to define the size of the circle of confusion, and this causes differences in estimates of the depth of field. Some lens manufacturers cheat by using over-large circles of confusion as the basis for claims of performance, but a fairly severe standard used by Zeiss is 0.033mm for all focal lengths.

Distance to subject The depth of field decreases as the distance decreases. In close-up work, the depth of field may be virtually non-existent (see pages 188–189).

Focal length and lens quality The greater the focal length, the less the depth of field. Wide-angle lenses have the greatest depth of field. Extremely long-focus lenses have hardly any. High resolution lenses, paradoxically, have less depth of field simply because they are more capable of critical focusing.

Aperture Depth of field increases when a lens is stopped down to a small aperture. Conversely, very fast lenses with wide maximum apertures have shallow depth of field.

Lighting Because sharp focus is subjective, diffuse lighting or even the use of diffusing and fog filters will give an apparent increase in the depth of field.

Using depth of field The most commonly used method of altering the depth of field is to change the lens aperture. Shooting at the maximum aperture gives very shallow depth of field with all but the most wide-angle lenses. Thus a wide aperture can be used to separate a sharply focused subject from a confusing background or foreground. With a long-focus lens at full aperture, it may even be possible to shoot through foreground obstructions such as leaves and branches, which may be so far out of focus that they hardly interfere with the image.

On other occasions, you may want the maximum depth of field so that as much as possible

Near focus (12.25 metres), f1.2

Far focus (infinity), f1.2

Using depth of field On the widest aperture of a standard lens, some areas of this woodland scene would inevitably be out of focus, at whatever focus setting (above). By focusing between the near and far tree trunks and stopping the lens down to its minimum, however, the depth of field could be broadened to include the whole scene (left).

Mid focus (25.1 metres), f16

of the image will be in sharp focus. This can involve critical decisions, because not only do you need to know whether the stopped down image will have the depth of field you require, but you must also be able to find the right point of focus. Depth of field tables are available for specific lenses from most manufacturers, but these are slow to use in practice and are not really useful for outdoor still photography. In most situations, you can work out the depth of field in the following ways:

Visual check With a reflex or view camera, stop the lens down to the working aperture (press the preview button with lenses that are normally viewed at full aperture) and check the sharpness by eye. The main difficulty is being able to resolve detail in the dim image; cover your head with a jacket or piece of cloth to exclude light for easier viewing.

Lens scale Except with view cameras, most lenses have a depth of field scale engraved on the mount. This shows the near and far limits for each aperture setting, and is straightforward to use. Another system, on Hasselblad Zeiss lenses, for example, uses moving pointers to do the same job. Some view cameras, Sinar, for example, have a scale fitted to the focusing knob that moves the rear standard.

Lens scales give only an approximate idea of the depth of field, and rather than rely on them absolutely, it is better, when you have the time, to combine the lens scale with a visual check as

shown below.

Rule of thumb Even without a scale, it is possible to make an approximate focus setting that distributes the depth of field around the subject. At 'normal' distances (that is, between several feet and infinity), focus the lens between the nearest and farthest points so that roughly two thirds of the subject lies behind, and one third in front. This generally makes the best use of the depth of field. The method is only approximate, and at close distances it is better to focus midway between the nearest and farthest points as the depth of field will be more evenly distributed in front of and behind the plane of focus.

Hyperfocal distance This is a special case, but often needed. Frequently, you may want as much depth of field as possible provided the horizon remains in focus – for instance, with wide-angle views and many landscapes. Focusing on infinity wastes depth of field, as two thirds of it lies beyond infinity focus. To make the best use, focus the lens so that infinity just lies at the farthest limit of the depth of field. This point of focus is called the hyperfocal distance, and varies with the aperture.

With the lens depth of field scale, use the infinity mark as an 'anchor', placing it against the working aperture. The lens is then focused on the hyperfocal distance. If you then bracket exposures, or alter the aperture for any other reason, remember to readjust the focus.

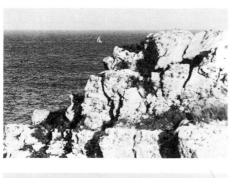

Hyperfocal distance The correct focus for the distant yacht was the infinity mark on the lens focus scale. In the first photograph this was the setting used but, even with the lens stopped down fully to f32, the foreground rock was outside the depth of field of the telephoto lens. By refocusing so that the infinity mark was set against the far limit of the depth of field scale, much better use of the depth of field was made, extending it towards the camera and making the rock acceptably sharp.

Lens fittings

Two important lens attachments are filter holders and lens shades. The varieties of filter types are described on pages 60–63 and 82–83, but the materials of which they are made and the way in which they are used can have important optical effects. Filters are normally available in four forms.

Optical flat Very high quality glass, relatively thick, and expensive.

Glass Less expensive than optical flats, lower quality but perfectly adequate for most picture-taking.

Plastic Scratches more easily than glass, but lighter, and has made available at reasonable cost certain kinds of filter (graduated, for example) that would be extremely expensive in glass.

Gelatin Although very fragile and easily damaged by moisture, heat and abrasion, gelatin filters are so thin that they hardly degrade the image at all, and are cheap enough to allow a large stock of filters to be carried. For colour correction and colour balancing, they are extremely useful.

The ways in which filters can be fitted are illustrated here. The chief problem with mount-

Attaching filters

Filters are available in glass, plastic or thin gelatin. Most glass and plastic filters are designed for specific lens fittings and diameters, either screw, bayonet, or Series, which have a plain rim, dropped inside the lens mount and held in place by a retaining ring. Others are square and fit into a special filter holder attached to the front of the lens. Glass quality varies, the term 'optical flat' signifying a filter with the least distortion.

Gelatin filters are relatively inexpensive and are too thin to affect the optical performance of the lens. For colour balancing and colour compensation, where a set of filters is usually necessary, they are particularly useful. They can be used in a filter holder or taped in front of the lens, but take care to shade them from direct sunlight, as any slight buckling may show as flare. Alternatively, they can be taped behind or inside the lens for greater protection. This is a way of using filters with fish-eye lenses which have too wide an angle of view to accept anything in front. Gelatin filters are delicate and are easily damaged by moisture, fingerprints and scratches. Handle them only by the edges or corners.

Some lenses, notably fish-eyes, have a built-in turret of filters which can be manually selected.

Series filter fitting: dropped into the lens front and held with a retaining ring.

Bayonet filter fitting: inserted in front of the lens and locked in place by a half turn.

Filter mount: gelatin filters can be dropped into this special holder with a professional lens hood attached.

ing filters in front of the lens is the extra opportunity for flare, making a lens shade doubly important. Using a filter behind the lens removes this danger, and is the only practical way of filtering with an extremely wide-angle lens, but only gelatin filters are thin enough to avoid the distortion that is more likely with this position.

Lens shading is vital, even with multi-coated lenses. Its purpose is not only to exclude direct sunlight from the front of the lens, but also to cut out any extraneous light from anywhere outside the picture frame. Ideally, a lens shade should mask right down to the picture area – professional bellows shades do this, but the majority are less effective for the sake of convenience.

f numbers
The f number scale is marked in bold figures. Intermediate settings are either in thirds (left-hand table) or halves (right-hand table), depending on the design of the lens aperture ring. The maximum aperture of the lens, which may be a non-standard figure, is normally engraved on the front of the lens mount and is used as a general description (for example, Nikkor 180mm f2.8).

In steps of one third	In steps of one half
1.	**1**
1.1	1.2
1.3	
1.4	**1.4**
1.6	1.7
1.8	
2	**2**
2.2	2.4
2.5	
2.8	**2.8**
3.2	3.4
3.6	
4	**4**
4.5	4.7
5	
5.6	**5.6**
6.4	6.8
7.1	
8	**8**
9	9.5
10	
11	**11**
13	13.5
14	
16	**16**
18	19
20	
22	**22**
25	27
29	
32	**32**
36	38
40	
45	**45**
51	54
57	
64	**64**
72	76
81	
91	**91**
102	108
114	
128	**128**

Screw mount: a standard filter mounting with 35mm camera systems.

Gelatin filter mount: attached to a 35mm camera, this gelatin filter holder allows quick and easy changing of a wide range of filters.

Specially cut gelatin: with a wide-angle lens, cut gelatin to size and fit it in the back of the lens.

Subject movement

There are three basic ways of handling subject movement: using a high shutter speed to freeze all movement for maximum sharpness; panning at more moderate speeds so that the moving subject is recorded sharply against an unsharp background; and using extremely slow shutter speeds for deliberate and pronounced blur. On pages 176–179, these methods are examined.

Leaf shutters are normally more reliable than focal plane shutters, which are frequently inaccurate at speeds faster than 1/1,000 sec. Because focal plane shutters travel from one side of the frame to the other, they can distort the image of a moving subject if the camera is panned in the direction, or against the direction, of the shutter movement. This either compresses or stretches the image.

Freezing movement The blurring of a moving subject depends on how quickly it moves across the picture frame. A vehicle photographed at 30 feet (9 metres) will appear to move twice as fast as when photographed at 60 feet (18 metres) or with a wider-angle lens. Equally, a subject moving diagonally towards the camera appears to be moving more slowly than when travelling straight across the field of view, and may hardly seem to move at all if approaching the camera directly. The amount of blur that is acceptable is subjective. Nevertheless, as a general rule to achieve acceptable sharpness, use a shutter speed that is 1/500 of the time that the subject takes to cross the longer side of the picture frame. For instance, with the camera held horiz-ontally, a walking figure that fills the frame takes about two seconds to cross the picture. 1/250 sec will therefore give a reasonably sharp image. For a totally frozen image, double the speed.

The illustrated table opposite shows movement-stopping speeds for some common situations. Note the value of panning.

Panning Following the movement of a subject with the camera may be the only way of achieving sharpness, but it also helps to convey a feeling of motion by allowing the background to blur while preserving sharpness in the subject itself. The lower speed limit for panning depends on how smoothly you can operate the camera and on the jerkiness of the subject. A car, for example, can be panned at 1/60 sec or less, while a galloping horse with rider needs a much faster speed.

Deliberate blur By using a shutter speed much slower than the one needed to freeze a particular movement, the blur becomes a definite streaking. In some circumstances, this can convey a stronger and more accurate impression of movement than a sharp image. Used in an extreme way – with speeds of one or two seconds with rapid action, for example – the result may be quite striking, sacrificing detail for the sensation of motion. This type of streaking is most effective when there is a definite tonal or colour difference between the subject and its background. A white bird flying against a dark backdrop is an example of the type of subject that responds well to this treatment.

Blur for effect Occasionally, the deliberate blurring of the subject can be used for a more exciting and graphic effect, giving a strong sense of movement and drama. This bullfight was given the slow exposure of 1/4 sec at f16 on ASA 64 film.

Minimum shutter speeds to freeze movement

	Fully framed	Half the frame	Panned	Moving diagonally towards camera
Rowing boat 2 mph (3 kph)	1/125 sec	1/60 sec	1/60 sec	1/60 sec
Person walking 3 mph (5 kph)	1/250 sec	1/125 sec	1/125 sec	1/125 sec
Person jogging 7 mph (11 kph)	1/500 sec	1/250 sec	1/125 sec	1/250 sec
Person running 13 mph (20 kph)	1/1,000 sec	1/500 sec	1/250 sec	1/500 sec
Cyclist, moderately fast 20 mph (32 kph)	1/2,000 sec	1/1,000 sec	1/125 sec	1/1,000 sec
Horse galloping 30 mph (48 kph)	Too fast	1/2,000 sec	1/500 sec	1/2,000 sec
Person kicking ball	1/1,000 sec	1/500 sec	Not applicable	1/1,000 sec
Car 50 mph (80 kph)	Too fast	1/2,000 sec	1/125 sec	1/1,000 sec

Movement inside the frame, such as the rower's arms or the cyclist's legs, is often greater than the movement across the frame, and may still be blurred. Generally though, this is not too objectionable if most of the subject is sharp.

121

Following movement

Photographing moving subjects, such as racing cars on a track or birds in flight, calls for fast reactions and complete familiarity with your camera equipment. The best shot may present itself only for a fraction of a second, allowing little time for adjustment to the camera settings. Panning is the basic technique. The most difficult part of this kind of photography is correct focusing.

Panning Under most circumstances, panning is quite straightforward and merely involves moving the camera to keep the subject in frame the whole time. A camera with a line-of-sight viewfinder is essential, and an SLR is ideal. If the subject is moving across your field of view at a constant distance, then focus changes will be small and the only important precaution that you need take is to anticipate the subject's course. Provided that the distraction is not too great, keeping both eyes open is a help. As most photography of movement uses a long-focus lens, follow the examples on pages 104–105 for steady hand-held shooting. A rifle-stock can be helpful, and in some situations it may be

possible to mount the camera on a tripod, leaving the head fairly loose.

With a distant subject, it may be tempting to use a very long-focus lens so that the frame is filled. However, not only is it important to leave some space in the frame around the subject to allow for panning errors, but the longer the focal length, the more difficult it is to handle. Many wildlife photographers prefer to use a less powerful lens – say, 200mm or 300mm on a 35mm camera – and be more certain of having a sharper, if smaller image. The photograph can always be cropped later.

With SLR cameras, if you are able to change the viewing screen, fit a matt ground glass rather than one with a clear or split-image centre. The latter is inappropriate because a small centred moving subject appears to be in focus even when it is not.

A motor drive is extremely useful, and frees the attention for framing and focusing.

Focusing technique If the subject is moving towards you or away from you, even if on a diagonal line, it can be difficult to keep in focus

Panning To freeze a subject's movement, with a blurred background to give an impression of speed, panning is the ideal technique. Use a relatively slow shutter speed (say 1/60 sec) following the moving subject in the viewfinder before and after the exposure is made. 35mm SLR cameras are ideally suited to panning with their direct viewing of the subject which is framed exactly as on the film.

Follow focus This difficult technique can be helped with specialist equipment as shown here. The Novaflex system has a 400mm or 600mm lens (on a 35mm camera) with a rifle-stock and trigger focus, making it unnecessary to turn the focusing ring and leaving both hands free to support the camera and keep the subject in the frame.

the whole time. Things in flight – birds or planes – are a notorious problem, as there are no other reference points to help you focus. There are three basic methods of focusing on movement: *Follow-focus* This most natural technique, but usually the least successful, is to try and keep the subject in focus all the time. With an ordinary lens, this means turning the focus ring at precisely the right rate, and as the focus always begins to drift after a few seconds it can be extremely difficult to decide how to restore it. One design, the Novoflex system, replaces the conventional ring with a spring-loaded pistol grip, and while this is quicker to operate, the basic problem of drift remains.
Continuous re-focusing As the main argument against follow-focus is that focus drift wastes time, continuous re-focusing is usually more reliable. With this technique, focus on the subject, shoot, and then deliberately move the ring to start focusing again. Doing this rapidly, it should be possible to get a sharply focused shot at least every two seconds.
Fixed focus This is a single shot approach that gives the greatest certainty of one well focused image, at the expense of quantity. Simply focus in advance of the moving subject, and shoot

when it comes into focus. With a car, for example, you can focus precisely on a point on the road. Photographing a bird or aircraft, on the other hand, there are no reference points, so that you must focus first approximately on the subject, and then quickly re-focus closer.
Exposure If the subject is moving against a changing background, finding the correct exposure can be a problem. An automatic exposure system can be very useful here, but only if there are no great tonal differences between the subject and background. If there are, as with an aircraft against either white clouds or a dark blue sky, the exposure meter in the camera will be overly influenced by the background. A TTL meter that reads only from a central circle (see pages 10–11) will help, but it is still important to exercise judgement while shooting. A substitute or incident reading is more accurate in most situations, but if you are using a TTL meter, follow this general guide for flying subjects:
Light clouds: plus two stops
Moderately dark clouds: as TTL reading
Very dark clouds: minus one stop
Light blue sky, near horizon: plus one stop
Dark blue sky, directly overhead: minus one stop

Focal plane shutters Moving subjects are very slightly distorted by focal plane shutters, appearing shorter when they are travelling against the direction of the shutter's roller blinds (top) than when moving in the same direction (bottom).

Choosing focal length

The picture angle depends on both the focal length of the lens and the film format. A 300mm lens may be standard for an 8×10in (18cm×24cm) view camera, but is definitely a long-focus lens for a 35mm camera. There is no hard and fast rule about what constitutes 'normal' perspective, as the human eye, with its wide angle of view but narrow angle of sharp focus, produces images in quite a different way from a camera lens. By convention, however, a 'normal' lens is one with a picture angle of about 40–50°. Long-focus lenses cover narrower angles, and wide-angle lenses generally cover from about 60° up to around 100°. Fish-eye lenses, which involve considerable distortion, sometimes up to the point of giving a circular image, can exceed 200°.

Most angles of view are quoted for the diagonal of the film format, but for practical picture-taking, the longer side of the film is a more useful measurement. In the table opposite these are the angles given – from edge to edge rather than from corner to corner.

For most cameras, which have rigid bodies and therefore no movements except focusing,

lenses cover just the film frame, and very little more. With view cameras, however, the only way to make full use of the valuable camera movements (see pages 126–131) is to use a lens that covers a wider area than the film. This can cause confusion when choosing a lens, as manufacturers invariably quote the full angle. The figures shown here refer only to the angle across the picture area.

It is much easier to choose the right lens for a shot if you can visualize its picture angle. As a rough guide, use these hand positions. All except the wide-angle position are with arms stretched out fully to the front. These angle measurements are very approximate, not least because of the differences between individual arm lengths and hand widths, but for most people they are a useful guide. Even so, it is a good idea to check them yourself against the actual picture angles by trying a set of camera lenses from one position – use a skyline with several definite features. Remembering these hand guides, you can quickly choose a focal length without having to experiment with actual lenses.

Angles of view For most people, these hand positions, with the arms fully outstretched in front, give a quick, approximate guide to the angles of view of the most useful focal lengths. If your arms are particularly long or short, or if your hands are large or small, you can work out alternative methods to suit your own dimensions by comparing these hand positions with different lenses.

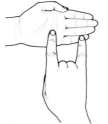

4–5°
35mm camera: 400/500mm lens
6×6cm camera: 650/800mm lens
9×12cm camera: 1,500mm lens

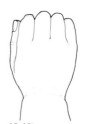

10–12°
35mm camera: 200mm lens
6×6cm camera: 300mm lens
9×12cm camera: 600mm lens

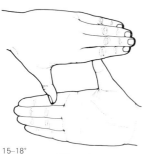

15–18°
35mm camera: 135mm lens
6×6cm camera: 250mm lens
9×12cm camera: 450mm lens

40–50°
35mm camera: 50mm lens
6×6cm camera: 80mm lens
9×12cm camera: 150mm lens

Wide-angle In this case, the thumbs touch the tip of the nose.

90–100°
35mm camera: 20mm lens
6×6cm camera: 30mm lens
9×12cm camera: 60mm lens

Angle of view

Angle of view across longer side	Focal length of lens (in millimetres)				
	35mm camera	6×6cm (2¼×2¼in) camera	9×12cm (4×5in) camera	13×18cm (5×7in) camera	18×24cm (8×10in) camera
220°	6mm circular fish-eye				
180°	8mm circular fish-eye				
137°	16mm circular fish-eye				
112°	30mm full-frame fish-eye				
108°	13				
100°	15				
90°	18		60	90	120
84°	20			100	135
78°			75		150
76°		38			
74°	24	40		120	
72°					165
67°	28		90	135	180
62°		50	100	150	
60°					210
58°				165	
54°	35	60	120	180	240
48°			135		
46°				210	
44°			150		300
41°		80	165	240	
39°	50				
37°	55		180		360
33°		100		300	
32°		105	210		420
30°					450
28°		120	240	360	480
25°		135		420	
23°	90	150	300	450	600
20°	100			480	
19°			360		
17°			400	600	
16°			420		
15°	135		450		
14°		250	480		1,000
12°					
11°	180		600		1,200
10°	200	350		1,000	
8°				1,200	
7°	300		1,000		
6°		500	1,200		
5°	400				
4°	600	1,000			
3°	800				
2°	1,000/1,200				
1°	2,000				

View camera movements 1

Camera movements, which are possible with view cameras but generally not so with smaller formats, offer great flexibility in controlling the image. When all the movements are available, as in the monorail camera shown here, they allow careful selection of the picture area and close control over sharpness and perspective. Movements involve changing the shape of the camera so that the relative positions of the film plane and the lens are altered. As this usually means making use of different parts of the image area formed by the lens, camera movements are only possible when using a lens that covers a much larger area than the film format (see below).

In 35mm and roll film cameras, this flexibility has been traded for compactness and sturdiness, but shift movements are possible with special perspective control lenses from some manufacturers. Swing and tilt movements are very uncommon in small formats, except with the bellows attachments used for macro work (see pages 186–187).

The principles are the same for all types of camera. Apart from focusing, the four main movements are vertical shift, lateral shift, tilt and swing. In outdoor photography, the two most common uses of these movements are to correct converging verticals in architectural work by using vertical shifts and to bring foreground and background into focus together in landscape work by using tilts. Specific examples of these two uses are shown in the section on landscape photography (pages 154–157) and architectural photography (pages 160–163). Generally, fewer contortions are necessary when using camera movements outdoors than in the studio, partly because the larger scale of subjects calls for a smaller range of focusing, and also because subject proportions are more predictable.

Coverage
The key to using camera movements is to have a lens with a wide covering power. The lens projects a circular image, and if the camera format uses only a part of this, then the position of the film can be moved around inside this image area. This kind of movement is known as a shift, either vertical or lateral. Cut-off occurs when the film area is moved outside the circle of coverage. Close to this edge, the image is usually poor.

Using no movements, the film area occupies the centre of the inverted image, on the lens axis.

Raising the lens panel or lowering the rear standard carrying the film enables a higher part of the scene to be covered.

Moving the lens panel or rear standard to the side records another section of the image area produced.

Controlling sharpness and perspective

By swivelling the lens panel and the rear standard, the distribution of sharpness can be changed quite radically and the perspective of the photograph can be altered in a number of ways. When either of the two camera parts are swivelled up or down, the movement is called a tilt. When they are rotated from side to side, the movement is called a swing. Tilting or swinging either the lens panel or the rear standard alters the plane of sharpness according to the magnificent-sounding Scheimpflug rule, described below, but swinging or tilting the rear standard also alters perspective (or shape). The rule is: tilts/swings of the lens panel alter sharpness distribution but not shape, while tilts/swings of the rear standard alter sharpness distribution and shape.

So, according to the effect you want, you can choose which of the two to alter. You can also move one to compensate for unwanted effects caused by moving the other. For instance, tilting the rear standard can produce the right perspective for the shot, but a completely wrong distribution of sharpness, yet this can be corrected by strongly tilting the lens panel. Remember:

To alter sharpness distribution only tilt or swing the lens panel

To alter sharpness distribution and shape tilt or swing the rear standard

To alter shape only tilt or swing the rear standard and correct the sharpness distribution back to its original state by tilting or swinging the lens panel until it is parallel to the rear standard.

There are very many permutations of these movements, best explored by practice. The following pages demonstrate in graphic form the effects of the principal camera movements. They will give you some idea of the effects you can achieve and the controls that are at your disposal. At the same time, it is important to remember that the use of camera movements is largely a matter of solving the particular problems of each composition by trial and error.

The Scheimpflug rule When the three planes – film, lens and subject – are parallel to each other, then the image is sharp from edge to edge, assuming the focus has been properly adjusted. But when one of the planes is tilted, the image will only be sharp when one or both of the other two planes has been adjusted so that all three planes intersect at the same point (see diagram). Practically, this means that if the subject is at a tilt in relation to the camera, only one small part of it will be in sharp focus if the lens panel and rear standards are in their normal positions. However, either of them can be tilted so that the three planes intersect, bringing the whole of the subject into sharp focus, even with the aperture wide open. When setting up the camera, try to visualize these planes – this will make the movements easier to predict.

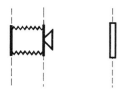

With film, lens and subject planes parallel, the whole subject will be in focus.

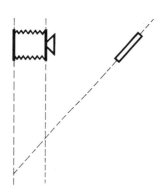

With the subject at an angle to the lens and film planes, only part will be in sharp focus.

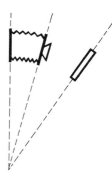

The film, lens and subject planes intersect. The whole subject will be in focus.

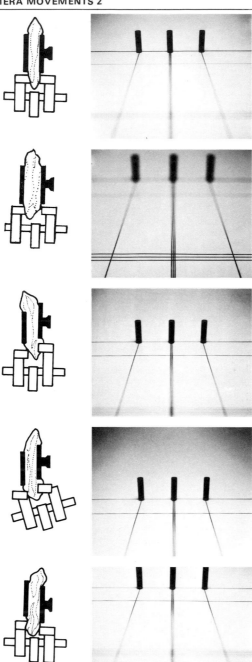

Infinity focus In this configuration, no movements are being used. The camera is 'at rest'. At the widest aperture, sharpness falls off rapidly towards the camera.

Close focus The most basic camera movement of all – so basic that it is often not thought of as such – is focusing. In all cameras this means altering the distance between the lens and the film plane.

Rising front (vertical shift) By moving the lens panel up (or the rear standard down), the horizon line is lowered. With objects very close to the camera, some differences can be noticed between the effects of moving the lens panel and moving the rear standard, but in most outdoor photography the effect is negligible.

Rising front with tilted rail (vertical shift) A more extreme shift is possible by tilting the rail or bed of the camera, and then tilting the lens panel and rear standard until they are both once more vertical.

Falling front (vertical shift) Moving the lens panel down or the rear standard up raises the horizon line. More of the foreground is now in the picture.

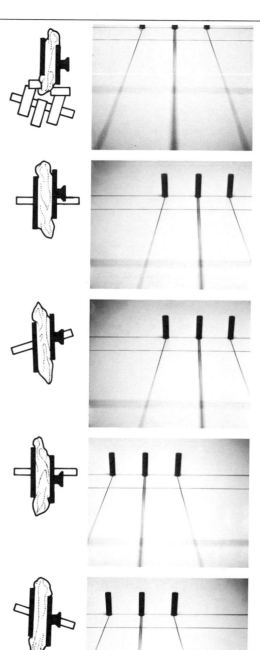

Falling front with tilted rail
(vertical shift) Tilting the whole
camera downwards, and then
readjusting the lens panel and
rear standard, gives an even
greater movement.

Front standard to left (lateral
shift) In this movement, the lens
panel or rear standard are shifted
horizontally. In architecture, this
can be used to 'see round'
foreground obstructions such as
lamp posts by moving the whole
camera to one side and then
using the lateral shift to restore
the building to the centre of the
picture.

**Front standard to left with
angled rail** (lateral shift) As
with vertical shifts, another
method of achieving the effect of
lateral shift to the lens panel or
rear standard is to aim the camera
diagonally and then swing the
lens panel and rear standard
round until they are parallel to
their original positions.

Front standard to right (lateral
shift) By moving the lens panel
to the right or the rear standard
to the left, the opposite side of
the image area is brought into
view.

**Front standard to right with
angled rail** (lateral shift) Aiming
the camera to the right and then
readjusting the lens panel and
rear standard makes greater
horizontal movement possible.

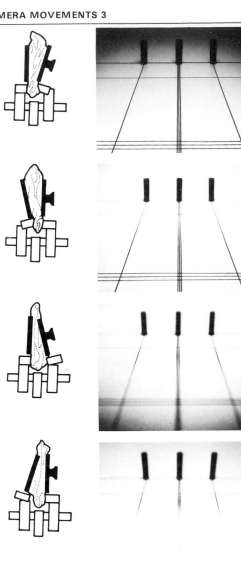

Lens panel tilted forward Tilting the lens panel downwards brings the foreground into the same sharp focus as the background. Shape (the perspective effect) remains unaltered.

Rear standard tilted back Tilting the rear standard upwards has the same useful effect on sharpness as tilting the lens panel, but it also introduces a stronger perspective. Verticals in the image now converge upwards.

Lens panel tilted back By tilting the lens panel upwards, the plane of sharp focus is altered so that it cuts across the subject, and most of the image is thrown out of focus.

Rear standard tilted forward Tilting the rear panel downwards also places the plane of sharp focus counter to the subject, altering shape at the same time. Vertical lines now appear to converge downwards.

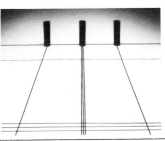

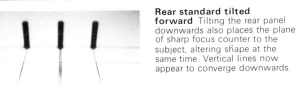

Lens panel tilted forward, rear standard back When both the lens panel and rear standard are tilted together, so that their planes converge below the camera, the shape of the image is altered and the sharpness distribution is changed strongly – in this case over-correcting the focus problem.

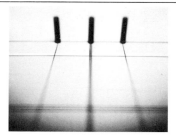

Lens panel tilted back, rear standard forward Tilting both parts so that their planes converge above the camera also alters shape and sharpness distribution, but in the opposite direction.

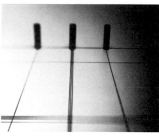

Lens panel swing to left By swinging the lens panel to the left, the plane of sharp focus is made to run diagonally from the left foreground to the right-hand edge of the horizon. Shape is not affected.

Rear standard swing to right Swinging the rear standard to the right has the same effect on the plane of sharp focus, but also distorts the shape.

Lens panel and rear standard converge to left Swinging both parts of the camera so that they converge towards the left places the plane of sharp focus at a very strong diagonal angle, altering shape at the same time.

Lens panel and rear standard converge to right Reversing both swings so that the lens panel and rear standard converge towards the right reverses the effect. Swing movements like these can be useful when, for example, there is a wall close to one edge of the picture, stretching into the distance.

Miniature and 35mm systems

Camera bodies The most commonly used format is 35mm. The smaller 110 is also widely distributed, but recent advances of miniaturization have brought 35mm cameras such as the Olympus XA within similar dimensions. A few sub-miniature cameras use film even smaller than 110, but these are not recommended for general photography.

Non-reflex 35mm cameras are becoming less common. They suffer the disadvantage of not showing the precise image in the viewfinder and there is no completely satisfactory way of using interchangeable lenses. Nevertheless, the best models are quiet and unobtrusive and are well suited to some candid photography.

Single lens reflex (SLR) cameras come in different degrees of technical sophistication. The present trend towards automatic systems and electronic control is geared mainly to the amateur market. Professional cameras that do have these features always have manual override facilities.

110 Instamatic

Leica M4 rangefinder camera

110 Minolta

Automatic 35mm SLR

Simple rangefinder camera

Professional 35mm SLR

Olympus XA, 35mm miniature

Minox 35GL, 35mm miniature

Lightweight 35mm SLR

Triggering accessories Pistol grips can be useful for steadier hand-held shooting. Soft shutter releases fit over the standard release and make it easier to avoid jabbing. For use with a tripod, cable releases reduce risk of camera shake with both manual and motor drive use.

Pistol grip

Shutter cable release

Soft shutter release

Finders and other accessories

Eye level finders are standard, either with or without through-the-lens (TTL) metering. Some TTL cameras now have the metering system in the body. Other finders are for special uses – right-angled, magnifying or enlarged image (action finders). Viewfinders can be fitted with correction eyepieces for people with poor eyesight, although removing spectacles for each shot is not very satisfactory. Caps protect lenses that are not in use. Lens hoods and filter holders control image quality.

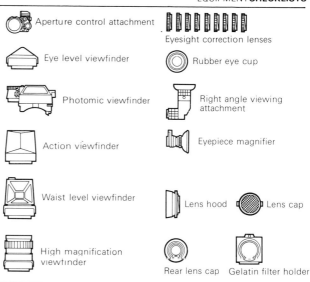

Aperture control attachment

Eyesight correction lenses

Eye level viewfinder

Rubber eye cup

Photomic viewfinder

Right angle viewing attachment

Action viewfinder

Eyepiece magnifier

Waist level viewfinder

Lens hood Lens cap

High magnification viewfinder

Rear lens cap Gelatin filter holder

Motor drives and remote control

The value of motor drives lies not so much in their ability to fire rapid sequences of photographs but in making camera operation easier and therefore less distracting. Winders are simpler and less expensive, and cannot fire continuously.

Intervalometers time a series of shots over a wide range of timing. Radio control and infrared pulse remote control are useful for wildlife photography and situations where there is no room for the photographer.

Battery packs, chargers and AC/DC converters act as alternative power sources.

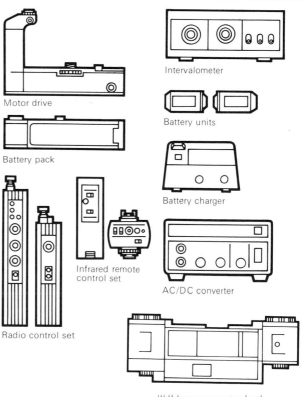

Motor drive

Battery pack

Radio control set

Intervalometer

Battery units

Battery charger

Infrared remote control set

AC/DC converter

250 frame magazine back

133

35mm format lenses 1

Fish-eye The extreme barrel distortion of a fish-eye lens restricts its use to special effects, either graphic or to achieve the widest coverage. A true fish-eye produces a circular image, but a lens such as the 16mm f2.8 covers the full frame, although still including the barrel distortion.

6mm (220°)

Fish-eye finder

8mm (180°)

16mm (137°)

Extreme wide-angle Extreme wide-angle lenses impose strong graphic control over the photograph, and can, with care, be used to create a striking composition with a mundane subject. They are also very useful in cramped interiors and for exploiting the relationship between foreground and background. Distortion near the frame edges, however, is a problem.

15mm (100°)

18mm (90°)

20mm (84°)

24mm (74°)

Wide-angle Moderate wide-angle lenses are useful for fast reportage photography, where their angle of coverage and wide depth of field make framing and focusing easy, and in confined spaces. The 35mm may be used an alternative to the standard 50mm lens.

28mm (67°)

35mm (54°)

Standard The standard focal length of 50mm gives a perspective and angle of view that appear 'normal' to the eye. It can be designed with a very wide maximum aperture, and is therefore useful for low-light photography.

50mm f2 (39°)

50mm f1.2 (39°)

Long-focus Each focal length in this category has its own pictorial characteristics. The 85mm is a good general purpose and portrait lens, and often has a wide maximum aperture for available light conditions. The 105mm is excellent for portraits because of its perspective. The most popular 'standard' long focus lens is the 135mm, whilst the 180mm design is available with a surprisingly wide maximum aperture, and is a common professional choice for street photography, news and fast indoor sports events. A teleconverter can be a lightweight occasional alternative to carrying an extreme long focus lens.

85mm (23°)

105mm (20°)

135mm (15°)

Teleconverter

180mm (11°)

200mm (10°)

300mm (7°)

Extreme long-focus Lenses with focal lengths over about 300mm are useful when close approach to the subject is not possible (as in wildlife photography), for isolating subjects from backgrounds, and for compressing perspective. The longer lenses need tripods and careful handling. Reflex lenses, which use mirrors to fold the light path, are relatively cheap and compact, but have fixed apertures. A teleconverter increases the focal length, but reduces the effective aperture, and only a few makes are of good optical quality.

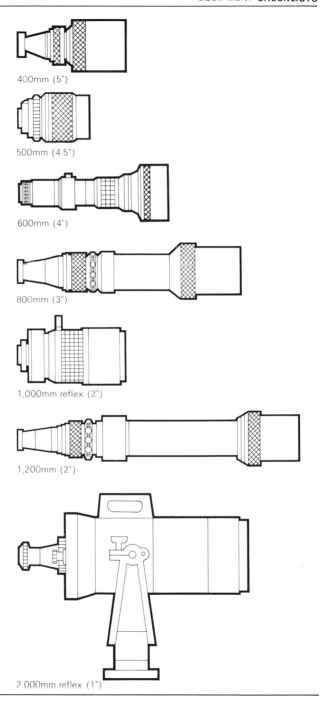

400mm (5°)

500mm (4.5°)

600mm (4°)

800mm (3°)

1,000mm reflex (2°)

1,200mm (2°)

2,000mm reflex (1°)

Zoom lenses These are most useful for precise framing from fixed positions, such as in sports stadiums, and as a replacement for a larger number of lenses of different focal lengths which may add unwanted bulk when on location. Although individually slower and heavier than regular lenses, one zoom can replace three of fixed focal length. Optical quality is generally slightly poorer.

28mm–45mm

35mm–70mm

80mm–200mm

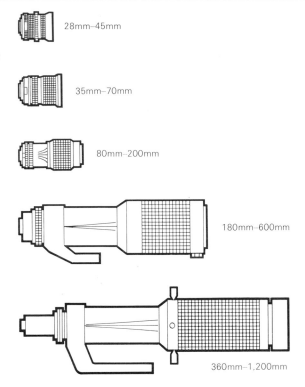

180mm–600mm

360mm–1,200mm

Special lenses The two most common types of lens designed to cope with specific photographic problems are shift lenses and night lenses. Shift or perspective control lenses are particularly useful in architectural photography, for keeping the vertical lines of a building parallel instead of converging (see pages 162–163). Night lenses, such as this 58mm Noct-Nikkor have not only large maximum aperture but also an aspherical front to the lens, which reduces flare from street lights or other light sources appearing in the shot (see pages 40–41). Aspherical lenses are expensive to manufacture.

28mm perspective control lens

58mm f1.2 Noct-Nikkor night lens

Close-up equipment Because most lenses are designed to perform at their best at 'normal' distances, defined as a few feet to infinity, close-up work needs special optics for good image quality. Close-up lenses with a normal focal length are the most generally useful, but 100mm and 200mm lenses are better with most insects and small animals, as the extra focal length allows a greater working distance and is less likely to disturb or frighten the subject.

Medical lenses have a useful place outside operating theatres and dental surgeries. Their built-in ringflash and extremely simple operation (extra magnification is achieved with a set of special supplementary lenses) make them ideal for standardized shots of insects and other non-static subjects in a variety of locations.

Supplementary lenses (diopters) are a simple method for taking moderate close-ups, although the optical quality is not as high as lens extensions – rings, tubes or bellows.

55mm macro lens

105mm macro lens

200mm Medical-Nikkor

Supplementary lenses (diopters)

Lens reversing ring

Extension tubes

20mm macro lens

Bellows extension

6 x 6cm/6 x 7cm systems 1

6×6cm cameras The basic models are twin lens reflex (TLR), single lens reflex (SLR) and non-reflex. TLRs are now largely superseded – the need for two matched lenses makes any system of interchangeable lenses awkward and relatively expensive. Medium-format SLRs are bulkier and much slower to use than their 35mm equivalents, even with motor drive. They are better for static subjects and a more considered approach than for situations needing fast reactions. The Hasselblad SWC is a unique non-reflex design – wide-angle and fast to use.

All Hasselblad models accept interchangeable backs, making it possible to change films from shot to shot. Apart from the standard back, available in square or rectangular formats, backs are also available for 70mm sprocketed film, sheet film,and Polaroid packs.

Twin lens reflex

Single lens reflex
Hasselblad
500 C/M

Hasselblad
SWC/M

Hasselblad
500 EL/M

Film holder In addition to the basic, interchangeable, 120 roll-film, other backs are available: for 220 roll film, 70mm sprocketed film, 6 × 4.5cm format 120 roll film, cut sheet film, and Polaroid film.

Sheet film
holder

Standard back

70mm film
magazine

Polaroid
film back

Viewfinders In place of the normal right-angled viewing, prism heads can be used to give an eye level or shallow angled view. A magnifier can be used for critical focusing. For situations where reflex viewing is difficult – in aerial photography, for example, an external frame finder can be very quick to operate, although it is less accurate.

Magnifying
viewfinder

TTL viewfinder

90° prism
viewfinder

Direct
viewfinder

Viewing screens Screens can be interchanged for different situations. For example, a grid-etched screen can be fitted for aligning verticals and horizontals. This is useful for architectural photography.

Standard
viewing screen

Grid-etched
viewing screen

Accessories Instead of the standard winding knob, a lever allows faster operation. Alternatively, a knob can be fitted that contains a small exposure meter.

Pistol grips or rifle stocks can aid hand-held shooting at slow shutter speeds, or with long-focus lenses.

Winder knob
exposure meter

Quick focusing
handle

Pistol grip

Fish-eye lenses The widest 6×6cm format fish-eye lens has a 112° angle of view and gives a full-frame picture with characteristic barrel distortion.

30mm wide fish-eye

Standard lenses The 'standard' lens, giving what is generally thought of as normal perspective, is 80mm.

80mm

Wide-angle lenses For this format, 40mm is extreme wide-angle, 50mm and 60mm regular wide-angle. Their uses and features are similar to the 35mm format equivalents.

40mm

50mm

60mm

Special Lenses Hasselblad manufacture some lenses with highly specialized characteristics. The 105mm UV lens passes ultraviolet light that would be blocked by normal lens glasses. It is used for such purposes as the photographic examination of old paintings. The 120mm lens is remarkably free of distortion and may be used in map-making by aerial photography, for example.

105mm

120mm

Long-focus lenses Long-focus lenses for 6×6cm cameras are inevitably very bulky and unwieldy. Hand-held shooting with a 500mm lens is only practical at high shutter speeds — with a fast film or in bright light.

150mm

250mm

350mm

500mm

Zoom lenses Medium-format zoom lenses are as unwieldy as telephotos, and generally best on a tripod.

140-200mm

Close-up Similar close-up equipment is available in medium-format as in 35mm – supplementary lenses, extension tubes and bellows.

Extension tubes

Supplementary lenses (diopters)

Extension bellows

Remote control Extension cables can be used to trigger motor driven cameras at a distance, but usually need an amplifier to prevent voltage loss. Radio control is also possible.

Amplifier

Lens fittings As well as the simpler lens hoods designed for each focal length, a professional lens hood, adjustable by means of bellows, gives the most thorough shading.

Lens shades

Professional lens hood

Special accessories An automatic diaphragm unit adjusts the aperture for correct average exposure, using a servo motor. Die-cast aluminium housings are for underwater use.

Automatic diaphragm control unit

SWC underwater housing

6 × 7cm cameras There are two widely used systems. The first is a scaled-up 35mm SLR produced by Pentax. The second is the Mamiya RB67. It is illustrated here, together with its main accessories. Although bulkier than the Hasselblad, with which it competes, and so rather less manageable in many outdoor situations, the RB67 has two outstanding advantages. First, its 6 × 7cm format more nearly fits the proportions in which most photographs are printed or published, and so makes better use of the film. Secondly, there is a built-in bellows focusing system, which allows trouble-free close-up photography. Film backs are interchangeable, and the standard 120 roll-film back revolves so that vertical or horizontal formats can be selected without moving the camera. Shutters are fitted to each lens. Focusing screens are interchangeable.

Fish-eye lens A full-frame fish-eye with typical barrel distortion. As with other fish-eyes, it has limited use, largely for graphic effect.

Wide-angle lens These match the Hasselblad range, although the slightly larger format makes the angle of coverage rather greater.

Standard lens According to personal preference, either the 90mm or 127mm lens can be used as a standard lens – 'normal' focal length is a largely subjective concept.

Pentax 6×7cm SLR

Macro lens In combination with the camera's built-in bellows, the extra close-focusing range and correction of this lens allows close-up and macro-work with few complications. Extension tubes can be added for greater magnifications.

140mm macro

Long-focus lenses The range of long-focus lenses varies from 150mm to 500mm. The 150mm lens is designed as a portrait lens, and one of three plastic diffusion discs can be fitted in the lens for a soft focus effect. The other four lenses have focal lengths comparable with those for the Hasselblad.

150mm

180mm

Mamiya RB67

250mm

37mm

360mm

50mm

500mm

65mm

90mm

127mm

Film backs Interchangeable backs with the Mamiya RB67 give the same advantages as they do for the Hasselblad. To change from vertical to horizontal format, a revolving adaptor avoids having to turn the camera body on its side.

Roll film back Sheet film holder

Polaroid film back

Viewfinders The standard waist level finder simply shades the screen for a right-angled view. The CdS meter finder also gives a right-angled view but allows TTL exposure measurement. The dual magnifying hood has two levels of magnification. The prism finder, available with or without a CdS meter, gives 30° eye level viewing. A quick action sports finder can also be fitted.

TTL meter viewfinder Magnifying viewfinder

Waist-level viewfinder Prism viewfinder

Lens attachments Lens shades range from simple hoods (built-in, slip-on or screw fitting) to a customized French flag and professional bellows shade.

Professional lens shade Slip-on lens shade

Screw-on lens shade Filters

Accessories A variety of standard accessories are available, including pistol grip, bar grip, double cable release, 500mm lens support and motor drive.

Cable release

Pistol grip

View cameras 1

Cameras The traditional flat bed field camera, usually of mahogany and brass, is still used occasionally, although something of a period piece. Its light weight offers some advantages on location, but it is very prone to camera shake in wind. A technical camera, such as the Linhof Technika, is the modern equivalent. Monorail cameras such as Sinar, Horseman and Cambo, are the most precise types of view camera, but very cumbersome on location, and not very portable.

The System Monorail cameras are designed on a system principle. The monorail, which clamps onto the tripod head, is the base, and onto this the front and rear standards, and other elements, are fitted. A monorail system can be used for outdoor work if transport, such as a car, is available, but as it is not intended to be carried, back-packing is tedious, and the camera has to be assembled and disassembled at each location.

Lenses There is no simplified range of lenses for view cameras. A wide variety is available, differing not only in quality and focal length, but in coverage, an important factor if you want to make the best use of the camera movements. Lens panels normally have to be specially drilled for the lens you select.

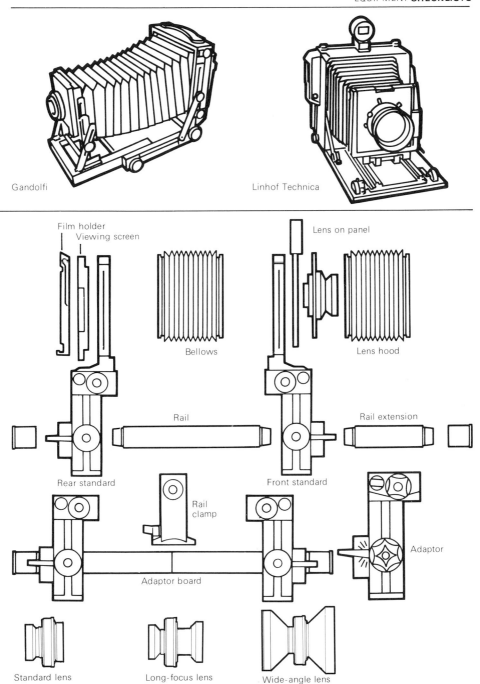

Gandolfi

Linhof Technica

Film holder
Viewing screen

Lens on panel

Bellows

Lens hood

Rail

Rail extension

Rear standard

Front standard

Rail
clamp

Adaptor

Adaptor board

Standard lens

Long-focus lens

Wide-angle lens

143

Film holders There is a very large range of film types and sizes for view cameras. The principal formats are 4×5in (9×12cm), 5×7in (13×18cm) and 8×10in (18×24cm). The standard film holder is the double dark slide taking two sheets of film. A roll film holder accepts 120 film. Other holders are made for Polaroid sheet film and pack film.

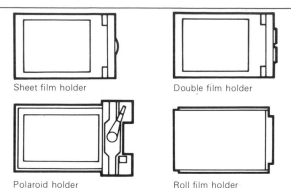

Sheet film holder

Double film holder

Polaroid holder

Roll film holder

Bag bellows Because wide-angle lenses have short focal lengths, there is less clearance between the lens and the ground glass screen. At these short distances, ordinary concertina bellows are not flexible enough to allow significant movements (see pages 126–131). Instead, bag bellows, made of either leather or vinyl, are more useful.

Alternative viewers Large format viewing is frequently awkward, particularly outdoors in strong ambient lighting. A fresnel screen gives a more evenly illuminated image, although slightly less detailed than with a plain ground glass screen. A bag bellows, fitted with a hooded viewer, can be attached to the rear of the camera to shade off extraneous light.

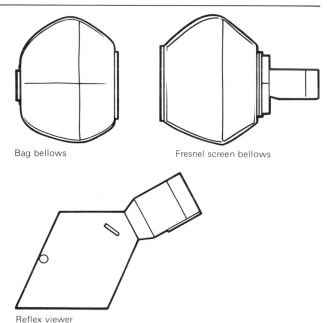

Bag bellows

Fresnel screen bellows

Reflex viewer

Probe exposure meter An advanced and very precise metering system takes spot readings from the actual film plane, on the ground glass screen. The large area of view camera formats makes this practical.

Probe exposure meter

Special purpose cameras

**Large format
superwide** Using an extremely
wide lens (47mm), the Sinar
Handy special wide-angle camera
covers a 4×5in format. No
movements are possible, but the
rigid body makes this camera
easy to use hand-held, with an
optical viewfinder and spirit
levels. Similar cameras are made
by some other view camera
manufacturers.

**Rotating panoramic
camera** In the Widelux and
similar panoramic cameras, the
lens is rotated in a drum-like
housing, so that it projects the
image onto a wide strip of film.
As a result, there is some barrel
distortion, similar to that
produced by fish-eye lenses.

**Fixed body panoramic
camera** An alternative way of
producing a panorama uses
virtually the full coverage of a
large format lens – a 90mm
Super-Angulon – on a 6×17cm
strip of roll-film. There is no
barrel distortion, but because the
outer part of the lens is used,
there is a slight darkening away
from the centre of the picture. To
correct this, a centrally graduated
filter can be fitted.

Weatherproof cameras Sealed
cameras suitable for underwater
photography can also be used for
bad weather conditions. The
Nikonos 35mm amphibious
camera is particularly rugged, and
has interchangeable lenses, some
of which are designed only for
underwater use and are not
suitable in air. The Minolta
Weathermatic takes 110 film and
is very simple to use.

High-speed camera The Nikon
M2H makes use of a fixed mirror
that passes some of the light
back to the film and reflects the
rest up to the viewfinder. Being
fixed, speeds of 10 frames per
second are possible. The mirror
caused a light loss to the film of
about one stop. The Hulcher high
speed camera is a specialist
instrument which can take
between five and 65 exposures
per second.

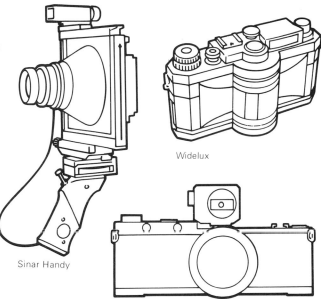

Widelux

Sinar Handy

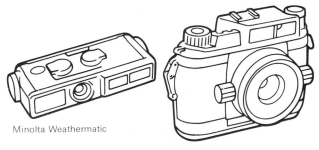

Linhof Technorama

Minolta Weathermatic

Nikonos

Nikon M2H

Hulcher 112

Equipment care

Regular camera care helps to prevent breakdowns. Pack and carry equipment so that it is well protected (see pages 200–201). Check it frequently for malfunctions and for general wear and tear, and clean it regularly. Use lens and body caps for extra protection, and keep a clear, ultraviolet filter fitted permanently to lenses.

Avoid subjecting moving parts to strain – use the least force necessary when fitting or detaching lenses, winding on film, and with other mechanical operations, and leave tensioned parts, such as the shutter and fully automatic diaphragms (FADs), uncocked when the camera is not being used.

Depending on how heavily you use your cameras, have them serviced and cleaned professionally, by the distributor or accredited service centre, on a regular basis. Do this every two or three years for normal use, every year if you work constantly with them, and after each trip that they have been exposed to extreme conditions (see pages 206–207).

Maintenance checks Regularly inspect lenses and bodies, following a set procedure. Check them, whenever possible, against the same makes and models of equipment. When checking the accuracy of a TTL meter, set the camera on a tripod and aim it at a constantly lit target, changing heads or bodies and noting the readings. If the difference in meter readings is more than a third stop, have them serviced.

Damage checks If you drop a camera and lens, check the following likely areas of damage. After a visual inspection, gently shake each removable part and listen for loose components:
1. Lens elements (cracked or chipped)
2. Diaphragm blades (fail to move)
3. Prism (cracked or chipped)
4. TTL meter (no display, or wrong reading)
5. Shutter (sticking or gives wrong speed)
6. Mirror (fails to move, sticks, or is loose)
7. Wind-on mechanism (sticking or is stiff)
8. On view cameras, misaligned standards (check with spirit level)

Checking a lens

Scratches on front and rear elements: re-grind

Worn coating on front and rear elements: re-coat

Focusing movement soft and liable to move itself if held vertically: change grease and tighten

Play in focusing movement, which moves slightly without the lens elements responding: tighten

Play in bayonet lens mount, due to worn lugs (look also for fine metal shavings, part of the normal bedding-down of a new lens, but a sign of excessive wear in an old lens): replace

Dust inside lens, a sign of age: dismantle and clean

Cracked or discoloured lens cement, sometimes causing misalignment: separate and re-cement

Damaged thread on a screw mount: replace

Diaphragm sticking when the aperture is altered: dismantle and reassemble

Loose or rattling elements: tighten retaining ring

Chipped or shiny blades, causing flare: replace

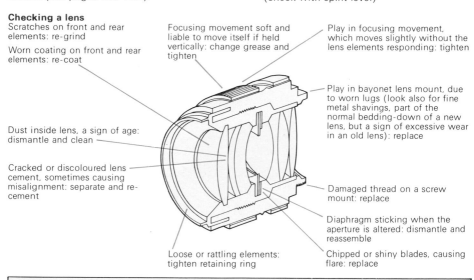

Hiring equipment In major cities and wherever there are a number of resident professional photographers, it is possible to hire cameras, lenses and lights. There is little economic sense in owning specialized equipment if it is used infrequently and most professional photographers make good use of dealers' hire departments. Photographic stores that cater to professional needs are, in fact, the major source for hiring. Provided you are close to one, there is no need to consider any of the equipment shown in this book as inaccessible. Most items can be hired by the day.

Because of the high value of much equipment, you will usually have to provide business references before a dealer will hire to you, and you may have to give a deposit to the value of the equipment until you are better known. Most hire departments only have a limited range of camera types – chiefly those most popular with professional photographers

Checking a body
TTL meter inaccurate: service. To use immediately, alter the film speed dial by the number of stops the meter is out

Shutter release sticking: dismantle and clean

Flash connector not working: make sure first that the fault does not lie in the flash unit or cable. Then service

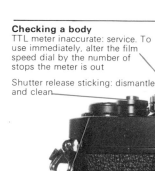

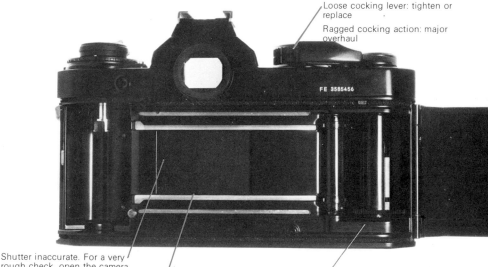

Release catch sticking: dismantle and clean

Scratches on mirror: replace

Play in bayonet lens mount: compare fitting with other lenses to see if the wear is on the camera or the lens and replace as necessary

Loose cocking lever: tighten or replace

Ragged cocking action: major overhaul

FE 3585456

Shutter inaccurate. For a very rough check, open the camera back, hold the camera up to the light, and run through a sequence of speeds from slow to fast while looking through the back. With practice you can detect major discrepancies: service

Chipped, torn or bent shutter blinds: replace

Film flakes around take-up spool: remove

147

Cleaning equipment

Clean cameras and lenses as frequently as possible. Look for dust, large particles, grease or oil, and deposits from evaporated liquids. Grit and sand can be very abrasive, so blow them away (preferably with compressed air) rather than wipe them off. As a general cleaning sequence, start with air, then use a brush, and finally a cloth. Never use oil anywhere, and use lens cleaning fluid sparingly, if at all.

Moisture Moisture is particularly damaging to cameras and lenses, corroding metal parts if left in contact long enough, and shorting electrical circuits. If it contains salts or chemicals in solution, these can speed up corrosion and even damage lens surfaces. See pages 32–33 for the precautions to be taken in wet conditions.

Raindrops Always wipe clean. Rainwater usually contains impurities, and will leave a deposit if allowed to dry.

Condensation Changes in temperature in a moist atmosphere cause condensation. This can happen in cold weather when coming into a heated area from outside, and in hot weather when entering an air-conditioned room. Condensation on internal lens surfaces and inside the camera body is particularly dangerous. The best protection is to seal the equipment in a plastic bag first, but if condensation has already occurred, let it evaporate by natural warming up.

Salt water This is much more corrosive than fresh water, and salt deposits are very difficult to remove. Clean from outer surfaces by swabbing with warm fresh water, but if there is any possibility that salt water has entered the mechanism, have the camera or lens serviced immediately.

Compressed air: available in regular sized and miniature cans. Do not use tilted, as a deposit of propellant may spray out. A small compressor with a plastic tube can also be used. Do not use close to focal plane blinds, leaf shutter or diaphragm blades, as these are fragile and may be bent.

Penknife and pencil eraser: for scraping or cleaning batteries and removing stains.

Lens tissues: alternatives to these commercially available materials are chamois leather or a well-washed handkerchief.

Toothbrush: for cleaning body and lens exteriors. Too rough for delicate parts.

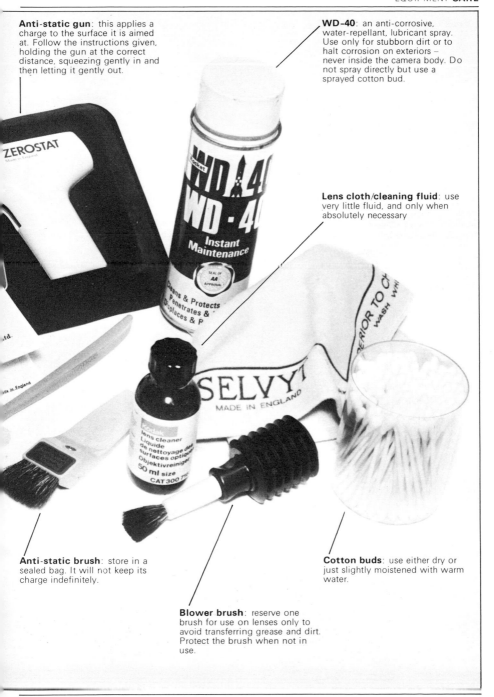

Anti-static gun: this applies a charge to the surface it is aimed at. Follow the instructions given, holding the gun at the correct distance, squeezing gently in and then letting it gently out.

WD-40: an anti-corrosive, water-repellant, lubricant spray. Use only for stubborn dirt or to halt corrosion on exteriors – never inside the camera body. Do not spray directly but use a sprayed cotton bud.

Lens cloth/cleaning fluid: use very little fluid, and only when absolutely necessary

Anti-static brush: store in a sealed bag. It will not keep its charge indefinitely.

Cotton buds: use either dry or just slightly moistened with warm water.

Blower brush: reserve one brush for use on lenses only to avoid transferring grease and dirt. Protect the brush when not in use.

Cleaning procedures

The procedure for cleaning specific pieces of equipment will vary, but these sequences of photographs show the principles. Only open sealed areas such as the camera interior and filter-protected front lens element in an environment that is dust-free, or you may introduce more dirt than you remove.

Clean batteries with a pencil eraser periodically to ensure good electrical contact.

Use compressed air to remove film fragments and dust from the film winding mechanism.

Lens cloths can be used to keep the film path free of dust and grease.

The return mirror and other delicate moving parts should be dusted lightly with a blower brush.

Clean the ground glass screen carefully with a blower brush to remove dust.

Treat lens surfaces carefully, first removing coarse dust particles with compressed air.

A blower brush can be used to remove dust, dislodging fragments from corners.

Use a toothbrush to clean difficult angles on the camera body – but not lens surfaces!

Cotton buds, used gently, can clean inaccessible corners around the viewfinder and lens glasses.

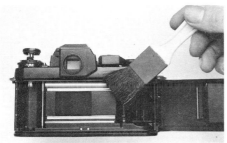

A soft brush can also be used to remove dust from the camera interior.

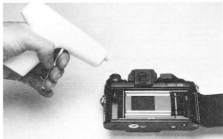

An anti-static gun will apply a small charge to surfaces, helping to keep them dust-free.

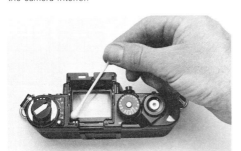

Difficult corners of the ground glass screen can be wiped clean with cotton buds.

Check the smooth action of the rewind mechanism and repeat the cleaning of the film path with the shutter cocked.

Only after all dust and grit is cleared should the lens be wiped. Use a clean lens cloth.

Fit an ultraviolet filter to keep the front of the lens clean and safe from scratches or other damage.

Camera breakdowns

Camera breakdown or apparent breakdown can be due to the following causes:

1. *Failure to appreciate the instructions* Often there is, in fact, no fault and what appears to be wrong is just part of the camera's normal functioning. A common example with TTL cameras is a dead meter display when a new film has been loaded. With many models, the meter is activated only on the first frame, and not before. A large number of 'repairs' received by the service departments of mass-market camera manufacturers fall into this category.

2. *Battery failure* Most modern cameras use batteries for some functions, commonly metering, shutter and motor. Using the wrong type of battery and dead batteries make up together the single most common cause of apparent camera failure.

3. *Accident* Dropping equipment can cause a number of unpredictable faults. Follow the damage check on page 146. Another kind of accident is really caused by misuse, such as forcing a mechanical action. Trying to detach a Hasselblad lens from an extension tube when both are removed from the body is a typical example, and is the most common misuse that Hasselblad distributors have to deal with.

4. *Wear and tear* Moving parts are the most susceptible, so that generally, mechanical cameras are more likely to suffer than those with mainly electrical functions. Plastic and nylon parts wear quickly, and screws can be loosened by vibration, sometimes causing mechanical damage by jamming an action. The proportion of electrical components that are solid-state rather than wired is increasing, giving greater reliability, although because this area of manufacture is sub-contracted to component producers, quality control is more difficult (see below). TTL metering and fast shutter speeds of 1/1,000 sec and over can drift from their calibrated settings with time.

5. *Manufacturing faults* These are unpredictable, but on the whole uncommon. In modern cameras, solid-state components are an area of risk, but they are much more likely to be faulty to start with than to develop problems later.

Self-repair As a general rule, never start to dismantle or attempt to repair any equipment that you are not completely familiar with. You may increase the damage by trying to repair it yourself. However, there are situations where the shot is vital and the chance of restoring at least some of the functions outweighs the risk of an even heavier repair bill.

If you have to attempt a repair yourself, follow these procedures. No camera manufacturer will endorse the idea of ill-equipped tinkering, but the approach outlined here will help minimize damage:

1. Remove the film. It may itself be the cause of the problem, and in any case you will need free access to the camera.

2. Remove the motor drive if detachable, and any other attachments.

3. Depending on the nature of the fault, disassemble the equipment as far as can be done by hand. At this stage, do not undo any screws.

4. If the fault is mechanical and the part accessible, try easing it gently by hand. Work close to its final point of operation rather than using the exterior control – for example, pull a focal plane blind shutter directly rather than continue trying to work the shutter release. If the part is inaccessible by hand, use one of the tools shown opposite, but be aware that there is great risk of scratching or pressure damage. If you

Compare the operation of a part to be repaired with an undamaged duplicate. This will help both identifying the fault and correct reassembly.

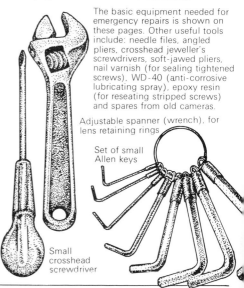

The basic equipment needed for emergency repairs is shown on these pages. Other useful tools include: needle files, angled pliers, crosshead jeweller's screwdrivers, soft-jawed pliers, nail varnish (for sealing tightened screws), WD-40 (anti-corrosive lubricating spray), epoxy resin (for reseating stripped screws) and spares from old cameras.

Adjustable spanner (wrench), for lens retaining rings

Set of small Allen keys

Small crosshead screwdriver

have a second camera, side by side comparison may be the best help of all.

5. If there are any loose parts, such as a screw, it is usually a straightforward matter to find where it belongs. The problem is that the component it retained may have worked itself into a different position. Again, if you can compare the appearance with an identical camera, you can check for displacements.

6. Dismantling procedure: without a record of what you do and a logical sequence, this can prove irreversible. Have another camera at hand for comparison, if possible. Try to work out in advance what will happen when any part is removed – the greatest danger results from parts under tension, such as springs. If you have an instant film camera available, take close-up photographs at regular stages so that you can work backwards later. Otherwise, make sket-

ches of each stage of the dismantling. Generally speaking, the more elaborate the retaining fitting, the greater the danger of a mechanism flying apart. Screws with regular heads may not be too much of a problem. Those needing a special key may be more risky. Lens retaining rings with opposed grooves are intended to be opened by a special tool. Do not try to use an ordinary sharp-nosed tool such as a screwdriver – if it slips you may damage the lens. Split rings are immensely difficult to replace, even if you succeed in removing them.

Place small groups of parts, such as a set of screws, in small marked bags or in clear piles on a large sheet of paper. Keep them in the order of dismantling.

Remember, you are taking a great risk in dismantling an expensive camera, and if possible you should leave it to a qualified repairer.

As parts are removed, label them and keep each stage separate to help with reassembly.

Take Polaroid shots of mechanisms before disassembling and at each major step in the process.

Toothbrush

Regular pliers

Set of jeweller's screwdrivers

Camera tape, for sealing light leaks

Jeweller's claw

Tweezers

Long nosed pliers

Flat file

4. SUBJECTS
Natural landscapes 1

The difficulty in making really good landscape photographs stems from the complexity of most landscapes themselves. They contain a wide variety of impressions, from the quality of lighting to a sense of space and the details of rocks, plants and animals. The essence of most landscape photography is to distill one image from a complex total of sensory impressions – no simple task in most cases.

There are three basic approaches: representational, impressionistic, or abstract. The first of these aims to convey the landscape in a realistic, straightforward way, whereas the second relies

on photographic techniques to give a less tangible sense of the subject, and the third explores the graphic possibilities. Within the framework of these three alternatives, there are a number of techniques that can be used. The most common choice, which usually determines the focal length of the lens used, is between a distant view and a panoramic view. Distant views are the province of long-focus lenses, which impart a compressed, magnified treatment unknown to landscape painting before the advent of photography. Panoramic views tend to take the observer into the scene, invoking the

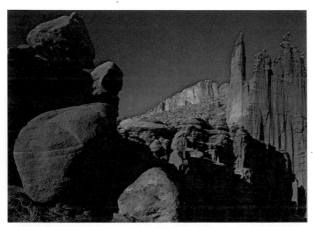

Representational This view of Fisher Towers, Utah is a direct treatment of landscape, exploiting rich detail and saturated colour to the full. It delivers a large amount of information about its subject, and is easily recognizable.

Impressionistic Airborne dust and backlighting make this crag almost disappear. By using the simplest shape, a single colour and a very small tonal range, this approach sets out just to convey an impression of haze, light and hidden rocks.

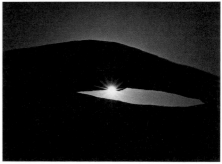

Abstract Gross under-exposure and a wide-angle lens turn the simple shape of a rock arch into a two-tone pattern, a deliberate departure from any normal impression of the scene.

sweep of a landscape and frequently combining the small-scale details of the foreground with the larger elements of the distance.

The quality of lighting is usually the make-or-break factor with landscape photography. Although uncontrollable, it can often be anticipated. When you come across a possibly interesting view for the first time, consider whether it would look better at a different time of day, or under different weather conditions. Early and late in the day are often the most productive times, not because of the common appeal of a rising or setting sun, but because the quality of light changes rapidly, offering quite different lighting conditions within the space of an hour or so. Use the time of day information on pages 22–23 when planning landscape photography.

Composition depends largely on the subject at hand, and there are few useful guidelines. However, one consideration frequently overlooked is where to place the horizon line. Where it falls in the picture frame strongly determines the emotional impact of many scenes. The classic positions are fairly central, but placing it very high or very low can be more exciting.

Finally, details can sometimes be selected to give an impression of the whole landscape, or at least to supplement a wider view and so give a balanced coverage. At the layout stage, whether for a publication or an exhibition, detail shots can be juxtaposed effectively with panoramic views.

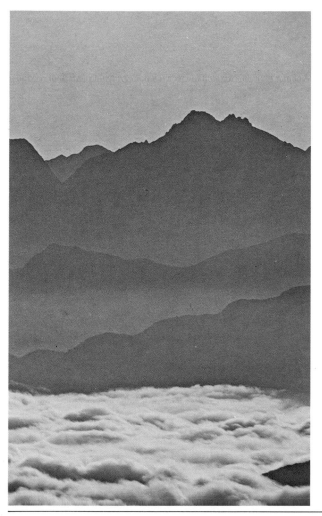

Compressed perspective With a long-focus lens, the narrow angle of view and magnified image gives truer proportions to the different elements in a landscape. As here, distant peaks loom large over their foothills – a useful technique for making mountains seem imposing. By shooting towards the sun, haze is accentuated, helping to separate the landscape into distinct planes. This, and a high viewpoint, make a vertical composition possible.

Distant views Use a long-focus lens to select and magnify distant scenes. From one viewpoint it may be possible to find several completely different compositions, some of them not immediately obvious to the naked eye. This style of landscape photograph works particularly well in mountains, or anywhere that has strong relief, because a long-focus lens compresses perspective. This foreshortening accentuates true scale, so that a distant mountain will appear to loom over a nearer subject, such as a figure or tree. By compressing parts of the landscape into distinct planes, a long-focus lens also gives good graphic possibilities, and in exploiting these a vertical format is often effective. The longer the focal length used, the more extreme the foreshortening and the more selective you can be. On the other hand, more care is needed in camera handling.

Several technical problems may be encountered. Long-focus lenses magnify optical aberrations as well as the image, and good quality lenses with high resolution are expensive. Depth of field is shallow, so take particular care over accurate focusing. As most landscape photographs appear best when sharp throughout, stop down to a small aperture. This inevitably means using a tripod. Try any of the methods on pages 108–111 to make the tripod more rigid, and set it up as low and widely spread as possible. Tripods with legs that can be opened wide are very useful. Shelter the camera and tripod from wind, use a cable release, and lock up the instant return mirror, if there is one.

Minimize flare not only by using a lens shade, but also by holding a card or your hand over the lens to shade the front element from direct sunlight. To reduce the exaggerated effects of haze, use a strong (that is yellowish) ultraviolet filter, or better still, a polarizing filter.

Panoramic views The best panoramic photographs evoke a sense of being there, involving the viewer in a treatment of landscape that is quite different from the more objective distant view. Wide-angle lenses and a horizontal format are the most usual technique, and it is usually possible to play on the relationship between foreground and background. Edge-to-edge sharpness is nearly always the ideal. Wide-angle lenses have inherently great depth of field and, to make the best use of this, stop the lens right down. This will usually call for a slow shutter speed, and a tripod, especially from close to ground level, is often useful. Even light movements of the air can blur foreground grass and flowers with a shutter speed slower that 1/30 sec. But unless it is very windy, there are usually quiet moments between gusts. Time the exposure to coincide with a lull.

Panoramic cameras: Specialized panoramic cameras use either a rotating lens or a wide-angle lens with great covering power to produce a narrow horizontal image, usually in the proportion 3:1. Although they have limited use in

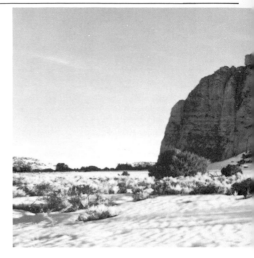

general, they are well suited to panoramic landscapes, and reproduce some of the impression of a sweeping vista.

The view camera's special qualities: By being able to position the plane of greatest sharpness more or less anywhere, the movements of a view camera make the larger formats particularly suited to panoramic views. By tilting the lens panel downwards or the rear standard upwards (or both together), both the horizon and extreme foreground can be brought into focus together. An added bonus is the wealth of detail possible from the large film size.

Details Not all landscape photography needs to be on a large scale. More intimate views of rocks, pools, tree roots and so on can be equally effective in conveying the feeling of a particular scene, if chosen carefully. Look for features that are typical of the landscape, or that contribute to its special character.

▲
Panoramic format The typically
three to one proportions of a
panoramic camera go some way
towards reproducing the way that
the eye scans most landscape
views. For scenes that lack a
strong vertical component, this
format can make composition
easier, removing the problem of
excessive sky or foreground area.
This photograph was taken with
a fixed-lens Linhof Technorama
(see page 145). With scanning
panoramic cameras, there may be
some barrel distortion.

◄ **Details** Close details, shot with
a long-focus lens or from close to
as here, can give a completely
different and often surprising
view of a natural landscape.

▲
**Camera movements to
control sharpness** The tilt
movements of a view camera,
described on pages 128–131, are
particularly useful in landscape
photography. By making the
plane of sharpest focus almost
horizontal, foreground and
background can be made sharp
without having to stop the lens
down to its minimum aperture,
which can cause problems due to
slow shutter speeds.

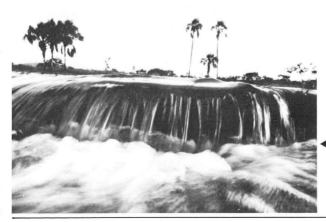

◄ **Wide-field view** A low
viewpoint and small aperture
make the best use of this
approach, relating close
foreground to background. A very
wide angle of view, such as that
of a 20mm to 28mm lens on
35mm format, is normally best.

157

Urban landscapes

As subjects, towns and cities are in many ways similar to natural landscapes, with the important addition that they reflect human activity. Therefore, whether or not people appear in the photograph, a shot of an urban landscape inevitably reveals something of the relationship between man and his surroundings. Architectural photography and candid photography of people have their own distinctive approaches (see pages 160–163 and 164–167). Urban landscape photography combines something from both.

Viewpoint is usually more of a problem than it is with natural landscapes. The most effective shots are often taken at a distance and at some height with a long-focus lens. The difficulty lies in finding this kind of camera position. Try any prominent tall building nearby. With residential high-rise blocks there are often no restrictions to access, although with offices or official buildings you will normally need to obtain permission in advance. Otherwise, look for adjacent stretches of open ground or water – a park or the opposite bank of a river, for example.

As with landscapes and architecture, antici-pate the lighting conditions that will give the effect that you want. A high sun usually gives greater contrast in a city than in an open landscape, tall buildings casting large dense shadows, and for most conventional shots is not very suitable. A low sun gives better modelling and as backlighting can be very effective when combined with industrial haze in separating the image into distinct planes. Night-time is often rewarding, particularly at dusk, when just enough daylight remains to show details. Many of the photographs in the section on available light photography (pages 38 to 47) give specific details for cityscapes after dark. Several different stylistic approaches are possible, of which the following are examples:

– A comprehensive view of a city's layout
– Exploiting the graphics of skylines, particularly in industrial areas
– Juxtaposing people and landscape to show how one relates to the other
– Deliberately excluding people to give a sombre, deserted appearance
– Details that reflect the character of a city and its inhabitants.

Long-focus establishing shots This basic treatment for a city makes use of a high viewpoint (in this case a hill overlooking an area of downtown Caracas) to avoid foreground obstructions. A long-focus lens (400mm on a 35mm camera) compresses the perspective, crowding the buildings so that they fill the frame and appear densely packed. Although the complete assembly of office blocks is the subject of the photograph, it usually helps to pick out one distinctive shape or colour as a focus for the composition. In this case the tapering block was a natural choice.

Skylines Also from an elevated viewpoint, the skyline of a city can often be made to convey some of its distinctive features. Here the Eiffel Tower immediately establishes the city as Paris, but juxtaposing it with the jumbled rooftops of Montmartre sets it in a different perspective. Skylines are often most effective in silhouette against an early morning or late afternoon sky, and with a long-focus lens.

Details By careful selection, close-up details can convey an idea of the complete city. Look for details that are characteristic of, and preferably unique to, one place. This old streetcar, clearly named *Desire*, could only be in one city – New Orleans.

Architecture

Most architectural photography involves interpretation – appreciating the design and function of a building, and conveying a representative impression. Before setting up the camera and tackling the technical problems, study the building from all viewpoints and decide the following:
1. What was the architect's intention? Was the building, for example, designed to be imposing, or to make the best use of available space, or to blend in with existing architecture, or what?
2. Was the building designed for a best view?
3. Does the building seem more relevant when photographed in isolation or in its setting?

4. Does the building have one outstanding quality?

From these, you can determine what the photograph should convey, selecting suitable lighting, filtration, lens and viewpoint. With some buildings, these technical considerations may virtually dictate the shot – if there is a restricted view, for example. In some cases, more than one shot may be necessary. Pay particular attention to details, which can give the relief of a different scale, just as in landscape photography.

Lighting Although natural light is not always predictable, work out in advance what the ideal daylight conditions for the photograph would be – the angle of the sun, cloud cover and the colour temperature. If possible plan around

Composition and setting By placing the castle at the bottom of the frame, the large area of sky gave a sense of setting, which was felt to be important in this photograph of the royal estate in Scotland – Balmoral. Composing the shot so that the castle appeared at the top, above foreground detail, was another possibility, but in this case the main subject's immediate surroundings were rather plain and uninteresting.

A red filter gave a deep tone to the blue sky and shadow areas, delineating the clouds, and making them a more definite element in the composition.

these, even if it means delay or more than one visit. Strong frontal lighting gives good colour saturation, backlighting can be used to silhouette buildings with strong outlines, the diffuse light on an overcast day reduces shadows on complicated details, and cross-lighting – the most generally useful – reveals texture and shape. Some public buildings may be well floodlit at night, usually with tungsten or sodium lamps – in this case, twilight is normally the best time, with some tone remaining in the sky to define the building's shape.

Filtration In both colour and black-and-white, a careful choice of filter can give precise control over the tonal range and colour contrast (see pages 60–61 and 82–83). Darkening a blue sky is probably the most common use of filters, with a yellow, orange or red filter in black-and-white photography, and a polarizing filter in colour. Any dominant colour in the building – red brickwork, for example – can be lightened when using black-and-white film by using a filter of the same colour, or deepened with one of a complementary colour. With colour film, light-balancing filters can be used to bring warmth or coolness to a scene.

Lens and viewpoint The purpose of the photograph being taken and accessibility of the building will determine the camera position, at least to a general area, and this in turn will restrict the choice of lenses to be used. Converging verticals are a special problem of architectural photography, and are dealt with on the following pages.

Viewpoint 1 By examining the building from all angles, and trying different focal lengths of lens, it is often possible to construct photographs that differ radically from each other. From the crowded city streets below the Acropolis in Athens, the Parthenon becomes part of a busy and not very attractive city. There is no sense of dominance.

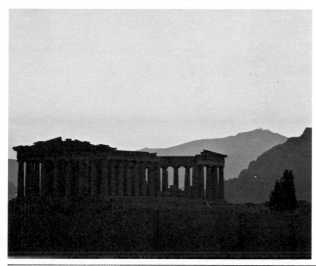

Viewpoint 2 From a nearby hill, however, the impression is quite different with a long-focus lens (400mm) shooting into the dawn sky. Here, the elevated viewpoint, long lens and silhouette have all been used deliberately to isolate the Parthenon and to give an impression of how it might originally have looked.

Converging verticals

Most buildings have vertical sides, and when viewed from close-to and below, these appear to converge upwards. Although convergence is an entirely normal feature of perspective, and one that the eye accepts without question, when it is reproduced in two dimensions in a photograph, it usually looks distorted. As the normal viewpoint for most buildings is from ground level and fairly close, correcting converging verticals is often a major preoccupation for architectural photographers.

There are a number of ways of overcoming the problem, but most rely on being able to aim the camera horizontally:
1. If you have access, choose a viewpoint half way up the building opposite.
2. Use a perspecive control lens on small format cameras, or the shift on a view camera. In both cases, the lens – which must have a greater covering power than needed for the film size – rises in relation to the film, so bringing the upper part of the building into frame (see pages 126–129).
3. Use a very wide-angle lens, aimed horizontally, and crop off the lower, wasted part of the shot later. This fulfils exactly the same function as a perspective control lens.
4. Again with a very wide-angle lens aimed horizontally, compose the shot in such a way that you make effective use of the foreground.
5. If you are using negative film, tilt the camera upwards to take the shot, but in printing tilt either the baseboard or enlarger head to compensate.
6. If the view is unrestricted, move farther back and use a long-focus lens, with correspondingly less upward tilt.
7. Under certain circumstances, make deliberate use of the distortion for dramatic effect. Convergence is less objectionable when clearly intended, but on the whole only some modern buildings accept this treatment successfully.

Unwanted convergence Buildings with vertical sides tend to appear distorted when photographed with a standard lens from a normal viewpoint because of the upward camera angle. In daily life, the mind compensates for this effect but it is unsatisfactory in the photographed image.

Lens shift The ideal solution to converging verticals is the shift lens which moves the lens up in relation to the position of the film in the camera and corrects the distortion. This approach is normally the prerogative of view cameras but perspective control lenses using the same principle are also available for some 6×6cm and 35mm SLR cameras.

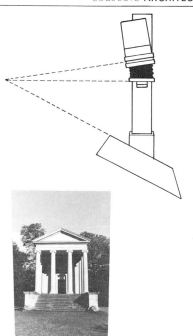

Wide-angle lens By using a wide-angle lens and cropping the image later an image can be obtained with corrected verticals. With a vertical format, place the building high in the frame.

Distorted printing When using negative film, the distortion can be corrected in the printing by angling the enlarger to the baseboard and then cropping the print to a rectangular shape.

Long-focus lens If you can, move further back and use a long-focus lens. The reduced upward tilt of the camera will avoid the converging effect.

Deliberate convergence By moving in close and pointing the camera up at a sharp angle, a dramatic and purposeful image can be achieved.

163

Candid shots 1

Successful candid photography demands that the person or group being photographed is unaware of the camera, or is at least undisturbed by it. To achieve this requires two qualities of the photographer – the ability to remain unobtrusive and to react quickly when an opportunity presents itself.

Keeping a low profile Whenever it seems possible, conceal photographic equipment as it is likely to put subjects on their guard, leading to stiff and unnatural poses and expressions. A plain shoulder bag is better than one obviously intended for cameras. Dress to blend in with the situation. The following techniques can help you avoid disturbing the subject.

Long-focus lens Use a long-focus lens so that you can work from a distance. The subject will be less likely to notice you. Framed horizontally, two or three people standing or walking will fill the picture area of a 35mm camera at about 120 feet (36 metres) using a 400mm lens. The limiting factor is usually the shutter speed. Use the slowest speed you can manage without a tripod (see pages 104–105 for ways to improve this) which will be fast enough to avoid subject movement. 1/250 sec is generally suitable but slower speeds may be acceptable in the right circumstances.

Wide-angle lens When working close to the subject, a wide-angle lens can be used to avoid aiming the camera at the subject. Compose the shot so that the subject is not central, and make it appear that you are photographing something to one side. With a very wide-angle lens – 20mm on a 35mm camera, for example – the camera will not seem to be pointing at the subject, making it possible to photograph someone at a distance of only a few feet without their being aware of your intentions.

Concealed position Working from a concealed location, such as a window, balcony or the interior of a shop or restaurant can produce good candid shots. Although this type of opportunist photography will limit you to things that happen by chance in the area in front of you, camera operation is usually made more straightforward. Elevated camera positions often prove particularly successful.

Disguising shooting Cameras with ground glass screens that can be viewed at right angles (including 35mm cameras with removable prisms) can be very effective if you put the camera down and pretend to be cleaning or examining it. Provided that you do not look directly at the subject, and appear to be absorbed in the camera itself, few people assume that you are actually taking pictures.

Remote control If you are prepared to accept a high failure rate, you can operate the camera by remote control with an extension cable release or some other remote triggering system (see pages 132–133). In this case, conceal the camera from view – in a bag, or under your coat. A wide-angle lens avoids incorrect framing.

Low shutter noise You are less likely to disturb the subject with a quiet shutter. Cameras with between-the-lens shutters are less noisy than those with focal plane shutters and instant return mirrors. Even among 35mm SLR cameras, there are differences in noise of operation.

Quick shots with a wide-angle lens A moderately wide-angle lens (35mm on a 35mm camera) was ideal for this shot of a man taking flowers to a grave at a Chinese spring festival in Hong Kong. The extra coverage made it possible to shoot from very close in the middle of a crowd. The wide maximum aperture and a high speed film allowed the use of a fairly fast shutter speed.
ASA 400: 1/250 sec at f2.

Long-focus lens A long lens is a basic tool for unobtrusive photography. On market day in a small Mexican town, this shot was taken from across the street at about 60 feet (18 metres) using a 400mm lens on a 35mm camera. At this distance it is possible to remain unnoticed for long periods.
ASA 64: 1/125 sec at f5.6.

Concealment A concealed position gives even greater freedom in choosing subjects and waiting for the right moment. One of the most readily available viewpoints is from above – a window or balcony – as people rarely notice what happens above eye-level. A long-focus lens (here 400mm on a 35mm camera) is nearly always needed if the subject is to fill the frame.
ASA 64: 1/250 sec at f5.6.

165

Preparing for a quick response The second necessary skill for candid photography is the ability to respond instantly to photographic possibilities. This is largely a question of being prepared before the event by having the camera settings adjusted to the situation.

Focus Set the focus to the most likely distance or focus on an object at the same distance away as you anticipate the subject will be. Automatic focusing is available on a few cameras and this can solve the problem, but beware of anything in the foreground that may give rise to an incorrect automatic focus.

Exposure With cameras that have manually adjusted exposure, set the shutter speed and aperture to the most probable lighting con-

ditions. In most outdoor locations, there are only a limited number of possible light levels, according to whether the subject is in the sun, shadow or deep shadow. Check the different brightness levels you are likely to encounter and be prepared to change from one to another rapidly. For most candid photography, a fast shutter speed is more important than great depth of field. Set the shutter to a fast speed that still allows some leeway for bracketing.

Automatic exposure Cameras with automatic exposure adjustments are ideal for candid photography. Their principal disadvantages are that readjustment to compensate for backlighting and other unusual conditions involves delay and that bracketing is not possible. With shutter

Spectators One subject that can be unusually interesting is the reaction of people watching an event. If the occasion is sufficiently riveting for the spectators, as at this climax to a race meeting, you can have complete freedom to take candid shots without bothering to conceal yourself or the camera. The variety of expressions can be very great.

People at work People at work provide excellent opportunities for candid photography. With their attention taken up with their job, they are usually less aware of being photographed. Even if they are, they are less concerned or distracted by the camera.

priority systems, select the fastest speed possible for the conditions. With aperture priority, choose a wide aperture.
Readiness Check that there are sufficient frames left on the film, keep the camera's meter switched on and have the camera ready to hand.
Equipment Use equipment and film that allow fast handling. An eye-level viewing camera is essential for most candid photography. 35mm SLR cameras allow visual accuracy that gives them an advantage over rangefinder cameras in focusing and close-up framing. A motor drive can be useful for removing the distraction of winding on. Although the noise does little to help the photographer remain inconspicuous, this is not important with long-focus lenses

used at a distance. Lenses with wide maximum apertures and fast film are required.
Lenses Fit a lens with a focal length that allows the correct framing at the distance you are likely to be working at. If, for example, you are photographing across a street about 30 feet (10 metres) wide, a 150mm lens on a 35mm camera will just cover a standing or walking person framed vertically. In crowded situations, or whenever really fast reactions are needed and you can get in close, use a wide-angle lens. The wide coverage will help ensure that the subject is fully in the frame, and the great depth of field will make careful focusing unnecessary. For most situations, set the focus to the hyperfocal distance (see page 117).

Outdoor portraits

A prearranged photographic session gives you the opportunity to plan ahead and select the setting, time of day, and details such as dress and props to suit the photograph. It also presupposes that the person being photographed has an interest in the shot. With impromptu portraits, on the other hand, you will usually have to make the best out of the situation. It may even be necessary to persuade the subject to co-operate. Here instant picture film can be invaluable as an immediate way of giving a person the results of the session. Few people are immune to the offer of a photograph of themselves.

An important choice has to be made between the different styles of an eye-contact portrait and one where the subject is involved in some activity. When the subject looks directly at the camera, the photograph almost inevitably has an air of formality. The character of the subject may help decide which approach to use: some people find it less of a strain to be photographed doing something, others are able to take up an informal pose naturally. An assistant can be useful to distract the subject's attention, and one approach sometimes used in photo-journalism is to photograph the person being interviewed.

Composition Although there are variations, most outdoor portraits are either tight shots, concentrating on the head and shoulders or upper torso, or environmental shots with the subject clearly set in his or her surroundings. Which you choose depends on a number of factors, and one or other will be clearly suggested by the situation.

If the setting is attractive, interesting or relevant, then it may seem natural to include it. Such environmental shots can also be helpful when you have to work with an uninteresting face, or when the subject has a stiff, awkward expression that would look bad in close-up. A wide-angle lens (24mm to 35mm on a 35mm camera) is the most generally useful. Longer lenses can be used from further back, but the greater distance makes communication with the subject difficult.

Excluding the environment and concentrat-

Eye-contact portraits 1
Perhaps the most basic of all photographic portraits, even out of the studio, is one where the subject looks straight to the camera and therefore to the person viewing the photograph. The photographer and camera are intentionally a part of the setting. Most people soon begin to feel uncomfortable at holding a direct gaze, so shoot quickly. For a head shot like this, a moderately long focal length gives good proportions. If there is any doubt about the depth of field, focus on the eyes.

Eye-contact portraits 2
Alternatively, photograph subjects at a relevant activity, shooting as they pause to look up. This approach, used here in a welding shop in Athens, is particularly easy to manage. The activity can also be a stimulus for keeping up a flow of conversation, itself a way of putting people at ease.

ing on the person being photographed places more emphasis on his or her individual character. As this inevitably means moving closer to the subject, use a moderately long-focus lens for the correct perspective effect. A wide-angle or even standard lens will distort the face noticeably when used in close-up. With a 35mm camera, focal lengths of 85 to 200mm are most useful. Longer focal lengths still give good perspective, but have shallow depth of field and smaller maximum apertures. Where a restricted depth of field is a problem, focus on the eyes.

Lighting The control of lighting is very limited with outdoor photography, and you will often simply have to make the best of the existing conditions. Hazy sunlight is generally ideal for most portraiture, giving good modelling without harsh shadows. In duller weather, there may be insufficient contrast. This can be partly overcome by using a high contrast (that is high speed) film, push-processing (see pages 66–67 and pages 84–85) or placing the subject next to a dark area such as the open doorway to an unlit room or dark vegetation.

In bright sunshine, the contrast range on a face is usually too high, with dense, sharp edged shadows. With the sun overhead, the eye sockets are normally shadowed. A low sun is better but, as frontal illumination may cause the subject to squint, one solution is to fill-in shadows by holding a white card or crumpled foil reflector close to the face. A more elaborate answer is to set up a screen of translucent material over the subject. In many cases, the only answer is to move the subject into the shade, even though the light level may be much lower. If the shade is lit entirely by reflection from a blue sky, a noticeable blue cast will result on colour film. If this seems likely, move the location next to a sunlit white wall, or use a reflector.

A pocket flash unit can be used to fill in shadows (see pages 50–51) and can also be effective with backlighting. Often, however, it introduces an artificial appearance.

Filters For flattering portraiture, a diffusing filter softens edges and conceals wrinkles. With black-and-white film, a reddish filter reduces spots and blemishes, whereas to enhance a ruddy appearance, use a yellow-green filter (see pages 60–63 and 82–83).

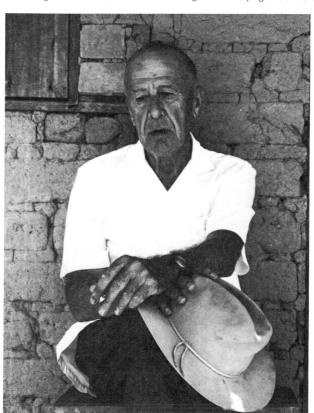

Shaded lighting On bright clear days, and particularly when the sun is high (as in summer or in the tropics), direct sunlight will not suit many portrait subjects. To avoid high contrast and deep shadows, one solution is to place your subject just a foot or two into the shade – under the overhang of a roof, for example. Reflected light from the sky and ground is gentle and usually flattering. The colour balance, however, may be difficult to judge, and this approach is generally more successful in black-and-white. Always shade the lens very carefully to avoid flare from surrounding bright areas.

Skin tones: exposure control

This page represents average Caucasian or oriental skin tones – that is, one stop lighter than average 18 per cent grey (see pages 14–15). Virtually all light meters, including those built into cameras, give an 'average' reading, which means that, when taking a direct reading of a face, you should increase the exposure by one stop, either widening the aperture or using a slower shutter speed. In situations where it is difficult to take a direct reading, hold this page in similar lighting and take a substitute reading from it.

Black skin is particularly difficult to meter correctly, being several stops darker than an average tone, and covering a wide range from person to person. This page represents an average black skin tone. Use it to make a substitute reading in the same way as the left-hand page but, in order to maintain visually the same dark appearance, decrease the indicated exposure by two stops.

Special events

The key to covering public events, whether parades, festivals or demonstrations, is advance planning. Most events are organized, at least to some extent, and it is usually possible to prepare viewpoints and timing in advance.

If possible, obtain a schedule ahead of time. Then explore the site to discover the best vantage points and the lenses that will be required. A high viewpoint, such as a balcony or the roof of a building, gives good overall coverage, with the possibilities of wide-angle shots to establish the setting and selective close-ups with a long-focus lens. Movement will be restricted, however, which may be a problem if the event follows a predetermined route. Press boxes or other special areas may be better, although these are generally placed to suit the specific needs of news photographers, which may not necessarily coincide with your own. Some form of pass is usually necessary, and this is best applied for as early as possible, particularly with popular events.

Normal photographic coverage of an event hinges on one or two key moments, with establishing and supplementary shots to give variety and continuity. If a number of photographs are to be used or displayed together, it is important that they should not be similar to each other, either in content or graphic technique. Because of this, it is usual to make a deliberate effort to cover different aspects of the event, such as the key moments, reactions of spectators, close-up details of behind the scenes preparations, and to inject variety into the photography by varying lenses, viewpoint, lighting and the scale of the subject.

If you have to work from one fixed position, take more rather than less equipment – a tripod with a loosened head is useful with long lenses. On the other hand, if you aim to cover different viewpoints quickly, take only what will fit into a shoulder bag. When events are likely to move rapidly, two loaded camera bodies can help save opportunities missed while reloading film.

The main event For a basic establishing shot of a procession, use a camera position in front of the column, either at ground level or on a balcony. This means anticipating the route and being ahead of the crowds. A long lens is normally useful to compress perspective. ASA 64: 1/125 sec at f5.6.

Details To complement overall views, look for details, such as close-ups of the participants. This elaborate gilt coach and its helmeted escort make a rich, ornate shot that characterizes the pomp of the Lord Mayor's show in London. Moderate long-focus (here 180mm on a 35mm camera) or standard lenses are appropriate.
ASA 64: 1/60 sec at f3.5.

Impromptu moments With a careful choice of subject, a detail can convey as much information as a wider view. This tightly cropped photograph of a boy with his famous friend was taken with a 400mm lens on a 35mm camera.
ASA 64: 1/125 sec at f6.3.

Behind the scenes Unguarded moments behind the scenes can be every bit as interesting as the main event, giving a different perspective, and showing things that are usually ignored or unseen. A wide-angle lens (20mm on a 35mm camera) was used.
ASA 64: 1/60 sec at f3.5.

173

Children

Children are among the most accessible and easiest of subjects – more active and imaginative than adults and far less self-conscious. They may become difficult, however, when the photographer has a set view of how a portrait session should proceed and tries to fit the child into a preconceived role. Children are not easily managed when they have lost interest.

Two different approaches are candid photography and camera-conscious portraiture. Candid work is, on the whole, easier with children than with adults, as they quickly become absorbed and preoccupied with activities, frequently oblivious to the camera. As with all candid photography, a long-focus lens allows you to shoot at some distance unobserved. Keep the camera close at hand to seize opportunities, and try to capture expressions and activities that are revealing rather than just cute. Look not just for single shots, but for sequences of pictures, such as the progress of a child exploring a new attraction.

If you set out to take portrait where the child is aware of the camera, try to avoid any rigid procedure or ideas, following instead the child's own interests:
- Keep the proceedings relaxed and informal.
- Do not force the child into any activity or pose that it obviously resists.
- Keep the technical aspects as simple as possible. If you can do without extra lighting, so much the better. Any complexities may bore the child.
- Involve the child in the picture-taking. Keep up a constant stream of conversation, make it fun, and get the child to help decide on the pictures. If you have an instant film camera, this becomes even easier.
- Have facilities at hand that you can use to distract the child's attention – a toy, some activity, music. You can either use this from the start for a seemingly unposed photograph, or to regain the child's attention if boredom sets in.

Preoccupied portraits To bring informality to a portrait shot, make sure that there is something more immediately interesting than the camera to distract the child. It could be a toy, something happening out of the picture frame, or even, as here, food. This approach relates child portraiture to candid photography.

Games Sports and games, apart from being so thoroughly absorbing that the camera is often not noticed, present great opportunities for capturing variety of expression, action and intense interest.

Favourite things One portrait technique is to ask a child to show you something of special interest. If there is any danger of shyness, and you particularly want an eye-contact photograph, pride of achievement or ownership will usually, as here, overcome it. Keep close and use a moderately wide-angle lens.

With parents A child's intimate but varying relationship with its mother or father can be a rich subject in itself. There is no need always to show the parent's face. The hands alone, for instance, may be expressive, yet leave the child as the centre of visual interest.

Camera involvement For a change, try involving yourself in children's play. You will almost certainly lose control over the situation but a close, subjective view can be fresh and different. A wide-angle lens is normally the most useful.

Action and sports 1

Most action, from football through to motor racing, consists of periods of low activity followed by bursts of rapid movement. As a result, timing the shot is of vital importance. Few sports contain sustained periods of maximum effort, so that it is particularly valuable to be able to anticipate the peaks of action. Here, familiarity helps, and try to spend time at first just observing the flow of movement before using the camera – if conditions allow. Capturing the peak of action frequently demands an accuracy of

timing measured in fractions of a second. While knowledge of the sport or activity will help you anticipate the dramatic moment, fast reactions and good camera handling are necessary to capture it (see pages 100–107 for techniques). A motor drive on fast continuous operation can be useful, and at least guarantees the maximum number of shots around a particular action sequence. Standard motor drives do not operate faster than six frames per second, however, which means that at a shutter speed of

1/500 sec they can cover no more than slightly over one per cent of the action indiscriminately. It may be better to rely on manual operation, or at least a motor drive or power winder used for single shots. A possible compromise is to supplement manual shooting with a remote control motor drive camera on a tripod. An ordinary extension cable fitted to a simple foot switch is sufficient.

The peak of the action is not the only moment worth photographing. Look also for other moments of tension – runners on starting blocks, exhaustion after the action and moments behind the scenes, for example.

For most sports, the preparations described on pages 172–173 apply. Effort spent arriving at a good shooting position is never wasted, and can simplify camera technique greatly. In many situations, the viewpoint is fixed, so that selecting the right focal length to frame the subject is important. Here a zoom lens can be valuable, particularly when the action ranges over a distance, such as football matches and track events. The two disadvantages are that zoom lenses have smaller maximum apertures at each focal length than the corresponding fixed lenses, and the additional lens control may be distracting when following fast action.

◀ **The peak of the action** The precise timing needed to capture this split-second moment in a soccer game made even a rapid firing motor drive unreliable. Using the camera's normal shutter release allowed only one shot, but gave greater accuracy of timing.

Long-focus lenses Although close enough to be mistaken for an air to air shot, this photograph of the Red Arrows aerobatic team was taken from the ground at an air display – underlining the value of a long-focus lens (here 400mm on a 35mm camera) in situations where it may not be possible to get close to the subject. The very high speed of the aircraft and their diagonal approach prevented follow-focusing (see pages 122–123) and the lens focus was set in advance, the shutter being released when the approaching aircraft appeared sharp. ASA 64: 1/500 sec at f5.6.

There are several methods of dealing with movement in action or sports events. Using a fast shutter speed to capture a sharp image is only a limited solution, and is not necessarily suitable in all situations. It is important to convey a sense of action, which a crisp motionless image may lack. The camera handling techniques involved in the following methods are described on pages 122–123.

Frozen action Start by estimating the shutter speed necessary to stop all action in the frame (see pages 120–121 for a basic guide). As this depends on the movement across the picture area, it is determined not only by actual speeds, but by how large the moving subject appears in the frame. Fast limb movements, such as a football kick with the footballer filling about half the frame, generally need shutter speeds of 1/1,000 sec to record sharply. At speeds higher than 1/1,000 sec, many camera shutters, and in particular focal plane blinds, suffer inaccuracy, which will affect exposure. With the shutter speed selected, use a lens with as wide a maximum aperture as possible, and choose the film speed to suit the light level. It may be necessary to up-rate and push-process the film to allow a particular shutter speed to be used, although this will inevitably increase grain size (see pages 66–67 and 84–85). In colour, particularly with photographs intended for reproduction, better definition can sometimes be achieved by using a lens with a shorter focal length and wider maximum aperture with Kodachrome film than by using a fast film and a long-focus lens that fills the frame with the subject. The extremely fine grain compensates for the disadvantage of selectively enlarging the chosen part of the image later. One problem with frozen action is that it may be difficult to distinguish the subject from a complex background. Use shallow depth of field and position yourself so the background is plain.

Moments of least movement In every action, the amount of movement varies from moment to moment. An athlete jumping in the air, for example, is motionless at the highest point. Shooting at such moments allows slower shutter speeds to be used. They do not always coincide with the peak of the action, however, and may not produce the most representative

image. A viewpoint that captures the action coming towards the camera rather than across the field of view has a similar effect – the relative movement in the frame is less.

Panning Following a moving subject by swinging the camera is useful, not so much because it keeps the image sharp at slower shutter speeds, but because the background can thus be intentionally blurred to give better separation between the two, and therefore clearer definition. The streaking effect of a blurred background—a variety of tones and colours is usually better than a plain backdrop – also adds a strong sense of movement in the direction of

Motor drive sequence A rapid succession of shots arranged in a strip occasionally gives a better sense of the action than a single photograph. With motor drive sequences, try to find a camera position at 90° to the movement, so that no change in focus is necessary while shooting, for shutter flicker makes re-focusing difficult.
ASA 64: 1/500 sec at f5.6.

the pan. For most situations, choose a shutter speed just fast enough to hold the subject. This may be difficult to judge without experience, but experiment around 1/60 sec and 1/125 sec. The slower the speed, the more pronounced the streaking.

Deliberate blur The intentionally slower speeds used in panning can also be used for a deliberately unsharp, impressionistic effect of the whole subject. Speeds which allow the subject or part of it to move significantly across the frame during the exposure produce images where definition is sacrificed for streaking. As a rough guide, use speeds of 1/4 sec, 1/2 sec and

1 sec with fast action. The effect is clearest when the subject is light and the background plain and dark.

Sequences A rapidly taken sequence of one action, arranged in a strip, is another, quite different way of displaying movement. A motor drive set for continuous operation is essential. Anticipating bursts of action is especially important with this technique, as it works best when the early, slower stages are included. Visual focusing with a 35mm SLR camera is extremely difficult during motor-drive shooting because of the flickering effect of the mirror, and it is best to plan changes of focus in advance.

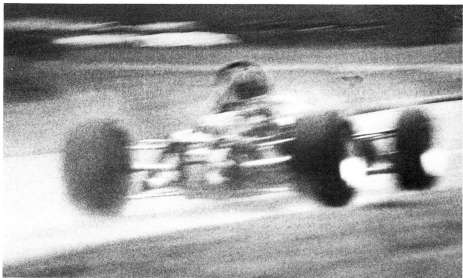

Before the action In many sporting events, the moments leading up to the action involve a build-up of tension and concentration. Photographically, they offer a change in the visual pace of the shooting, as here, where a young Thai boxer kneels to pray before a fight. A 180mm lens was used on a 35mm

camera. With the film rated at ASA 600, the exposure was 1/60 sec at f2.8.

Slow panning To enhance the feeling of movement, but at the expense of detail, use a slow shutter speed. This, particularly when combined with a grainy film, gives a streaked, impressionistic result, as in this shot of a racing car. ASA 400: 1/60 sec at f6.3.

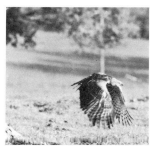
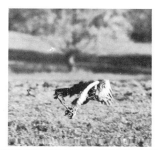
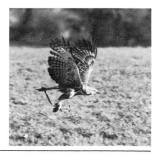

Wildlife 1

Wildlife photography relies heavily on fieldcraft – finding the animal and a suitable position to shoot, in most cases unobserved. As with candid photography of people, stealth and fast reactions are often needed, together with good camera handling technique. Whatever the subject, and however you intend to approach it, improve your chances of success by spending time in advance on research and planning a good location at the right time of year. Some national parks and wildlife reserves offer outstanding opportunities.

Photographing wildlife uses two basic techniques – stalking or constructing hides. In the first, less preparation is needed, but more fieldcraft. In the second, the initial effort is greater, and there may be long waits, but the rewards can be spectacular.

Stalking Stalking comprises both a knowledge of how to find animals and the ability to approach them unobtrusively. Be aware of the behaviour of the animals you are stalking. Many animals, for example, are at their most active around dawn and dusk, which means working in low light levels. Understanding their territorial habits will help you to find the right location. For all this, research is essential. Moving unobtrusively involves a number of techniques, many of them similar to the ways in which animals themselves hunt or avoid being hunted. The following are the most important:

- Dress inconspicuously or, better still, use camouflage. Wear drab clothing and avoid anything that might glint in sunlight. Face and hands normally appear bright and are easily visible at a distance so that, if you feel dedicated, apply streaks of dirt.
- Minimize your scent by being well clothed, moving around as little as possible, staying downwind of the animals you are tracking, and avoiding any deodorant or other scent
- Walk economically, with as little unnecessary movement of your torso and arms as possible. 'Roll' your feet when you walk, rather than slapping them down, and look where you put them, avoiding leaves or twigs that may crack
- If, by mistake, you make a loud noise, freeze instantly and stay motionless for a few minutes
- Try never to cross open ground, but instead use natural cover. Stay in the shade rather than sunlight, and never silhouette yourself against a skyline
- When making the final approach to an animal in full view, keep low and move only when it is busy with some activity. At the times when it pauses to check its surroundings, keep still. Move directly forward rather than obliquely, so that the animal has difficulty in telling whether you are moving at all. If the animal sees you look down at the ground – avoid eye contact

How animals and birds perceive

What seems good camouflage to human senses may not necessarily be effective for the animals you are trying to conceal yourself from.

Birds Most birds have better eyesight than humans, particularly in their ability to see detail at a distance. The eyes of a hawk, for example, can take in eight times more than human eyes. Most species also have a very wide field of view, up to 360° in the case of some ducks. On the whole, birds respond more to movement than to any other visual stimulus.

Hearing also tends to be good, although in flight is almost certainly less effective. On the other hand, few birds have a good sense of smell, except ground dwellers.

Mammals Because most mammals tend to be active at dawn, dusk, or night-time, eyesight is, on the whole, poor. Mammals that hunt or need to escape at speed, such as cats and deer, are an exception. Hearing is usually good – large ears are generally a sign of high sensitivity. The sense of smell can be so well developed that it is difficult for humans to imagine how important a part it plays. It is probably the chief sense for most mammals.

Establishing shots In concentrating on close approach, it is easy to forget the need for photographs that place the wildlife in its context. Known as establishing shots, such pictures relate the animal or bird to its natural setting. They function, at least in part, as landscape photographs. These Indian darters in a flooded acacia forest were treated as a scenic subject. Kodachrome 64, with a 180mm lens on a 35mm camera: 1/125sec at f2.8.

Starting with easy subjects Species that are known to be approachable in locations that are reasonably accessible give valuable opportunities to develop photographic techniques – by experimenting with, for example, lighting, camera angle, and focal length. This alligator, photographed from a bridge over the Myakka River in Florida exemplifies co-operative subjects. Kodachrome 64, with a 400mm lens on a 35mm camera: 1/250sec at f16.

Stalking wary subjects Deer, unless tame or used to regular feeding, will only tolerate approach to within a prescribed distance, establishing like many animals an invisible perimeter for their feeling of safety. In this case, 50 feet (14 metres) was the closest approach. The white-tailed deer's alertness shows that only a few moments remain before it will take flight. Kodachrome 64, with a 400mm lens on a 35mm camera: 1/125 sec at f5.6.

Hides The alternative to stalking is to use a hide – a concealed location usually sited within the animal's territory that permits close observation and photography over a period of time. For behavioural studies it is invaluable.

There are many different kinds of hide, depending on the animal, the habitat, and the facilities available. At established wildlife reserves there are often permanent hides, usually quite comfortable and so well established that for the animals or birds they have become an accepted part of the scenery. On the other hand, some wildlife photographers build their own hides, setting them up temporarily in view of a particular nest or feeding place. At a less elaborate level, it is also usually possible to put together a makeshift hide out of available natural materials.

When choosing a site for the hide, remember that it should have a clear, unobstructed view of a place that is visited regularly by the animal or bird you want to photograph. A nest or lair is one possibility. Others are feeding, drinking and bathing places. Avoid open spaces such as fields. Look instead for a background of vegetation, such as at the edge of a clearing. Do not let the hide appear in silhouette. Check in advance that the lens you will be using will give

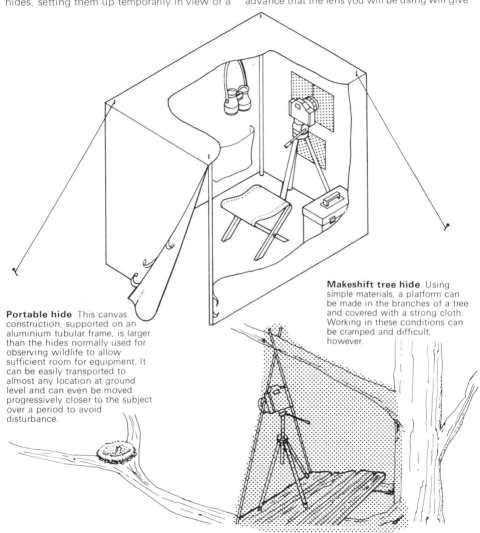

Portable hide This canvas construction, supported on an aluminium tubular frame, is larger than the hides normally used for observing wildlife to allow sufficient room for equipment. It can be easily transported to almost any location at ground level and can even be moved progressively closer to the subject over a period to avoid disturbance.

Makeshift tree hide Using simple materials, a platform can be made in the branches of a tree and covered with a strong cloth. Working in these conditions can be cramped and difficult, however.

a satisfactory coverage, and that foreground grass or bushes will not be in the way. Make sure also that the lighting will be right for the subject at the time of day you will be shooting – in other words, avoid having the sun shining directly into the lens and the subject in deep shade. Try and site the hide downwind.

With animals or birds that live permanently in a particular territory, you will need to introduce the hide carefully, in such a way that you do not cause disturbance. Moving the hide right up close on the first day will probably startle the animal so much that its pattern of activity will be disrupted or it may even abandon the site. The

normal method of introducing a hide is to set it up at a distance, moving it forward in stages over a period of time. Exactly how quickly it can be moved depends on the species and the particular situation, but it may take up to a week. When possible, move the hide at times when the animals or birds are elsewhere – if photographing a nest, wait until the bird is away feeding.

When the hide is finally in position, it may be necessary to clear away a few obstructions in front of it. This is known as 'gardening', and should be kept to an absolute minimum. If you open up a nest to clear view, it increases the risk of predators finding it.

Permanent hides Near feeding places or permanent nesting sites, permanent hides allow repeated presence at the same location. The animals are also likely to become accustomed to the hide and ignore it.

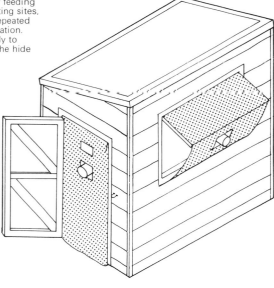

Boat hides As long as they cannot see any people, aquatic animals are likely to pay little attention to boats. Cover yourself with cloth and keep extremely still for as long as necessary for the shot – the only real difficulty with this approach.

Using a hide
Even with a well constructed hide, take the following precautions when using it, so as not to alarm the wildlife:
- Keep quiet
- Do not touch the walls of a canvas hide or allow any visible movement
- Move the camera and lens slowly and as little as possible
- Use a tripod and cable release to cut down vibrations with long lenses
- Do not wear artificial scents
- Do not place your eye too close to the viewing hole as it may be visible from outside
- When the hide is not in use, leave the base of a glass bottle poking through the lens opening as a dummy lens
- Enter the hide unobtrusively, either at night or when the animals or birds are not present, or by taking a friend with you who leaves after a short while to fool the subjects into thinking that the hide is empty once more

Permanent hide, baited location
With a hide that is permanent, or at least intended to last for a season, if may be possible to encourage some species to visit by regularly putting down food or water. In time, when the animals have become thoroughly accustomed to the hide, it may not even be necessary for observers to remain completely hidden. Baiting, however, can alter animal behaviour and should be undertaken with caution. The clearing opposite this hide in an Indian wildlife sanctuary was baited daily in the late afternoon and these chital were regular visitors.

Choosing the subject Some animals and birds are easier to approach than others, an important factor if you have little experience of hides yet want to ensure success. Many species that live and breed in colonies fall into this category. The security of large numbers often makes them less afraid of intruders who remain outside a certain minimum distance. This stork, in a large nesting colony, was relatively easy to photograph from a very unsophisticated hide.

Moving a hide In order to approach close to a subject, move the hide over a period towards a feeding or nesting site. Move the hide when the animals are distracted or away feeding, in a straight line if the terrain will allow.

Close-up and macro

Close-up photography and photomacrography do not have precise definitions, but in general terms they can be characterized as follows: *Close-up photography* covers work with a reproduction ratio of 1:7 to 1:1 (reproduction ratio compares the size of the image on the film with the actual size of the subject). Thus, close-up photography extends from the point at which the image is one seventh of the size of the object to when it is life-size. In practice, the reproduction ratio of 1:7 is the point at which the minimum significant exposure adjustment (1/3 stop) becomes necessary to compensate for the increasing distance between the lens and the film plane (see pages 188–189). *Photomacrography ('macro')* extends from a 1:1 reproduction ratio to about 20:1, at which point optical conditions demand the use of a microscope.

Camera images can be magnified in two ways: either by adding supplementary lenses or by increasing the distance between the lens and the film.

Supplementary close-up lenses These are simple meniscus lenses used for moderately close-up work. They are available in different strengths, measured in diopters. A +1 diopter lens has a focal length of 1 metre, and if placed in front of the camera's lens will shift the point of focus from infinity to 1 metre. A +2 diopter lens has a focal length of 0.5 metre, and shifts the point of focus from infinity to 0.5 metre and so on. Supplementary lenses can be combined, and the effect is additive (a +1 diopter and a +2 diopter act as a +3 diopter), although image quality begins to suffer noticeably when more than two are used together. When combining, put the stronger diopter next to the camera lens. Supplementary close-up lenses are useful because they are extremely simple to use, and need no additional exposure. They all, however, cause some loss of image quality – albeit very little with weak diopters used with a small aperture. Split-diopter lenses cover only half of the mount and can be used to bring a close foreground into focus at the same time as a distant background, without having to stop the aperture down.

Extension rings and tubes Close-up magnification can also be achieved by increasing the lens to film distance. The simplest and sturdiest method is to fit a ring or tube between the lens and the camera body.

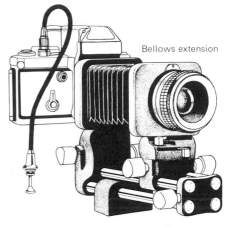

Bellows extension

Extension tubes

The focal length of a lens is the distance between the lens and the film when focused at infinity. Increasing this distance by half gives a reproduction ratio of 1:2. Doubling the distance gives 1:1, and so on (see table below).

Most good extension rings and tubes have linkages that connect the aperture diaphragm to the shutter and TTL meter, allowing the fully automatic diaphragm (FAD), where it exists, to remain in operation. Because they are fixed and robust, rings and tubes are well suited to outdoor work. Several can be combined to obtain the extension required.

Extension bellows Flexible bellows on a rack offer fine control over magnification, and are normally used for extreme close-ups. They are more delicate than extension tubes, and need more care in the field. To maintain FAD operation, some bellows use a double cable release to trigger both shutter and aperture diaphragm simultaneously.

Lens extension and reproduction ratio

Lens extension (percentage of focal length)	120	140	160	180	200	220	240	260	280	300
Reproduction ratio	1:5	1:2.5	1:1.7	1:1.2	1:1	1.2:1	1.4:1	1.6:1	1.8:1	2:1
Magnification	0.2×	0.4×	0.6×	0.8×	1×	1.2×	1.4×	1.6×	1.8×	2×

Lens extension: reproduction ratios and magnification

Extension (mm)	50mm Lens		100mm Lens		200mm Lens	
	Reproduction ratio	Magnification	Reproduction ratio	Magnification	Reproduction ratio	Magnification
5	1:10	0.1×	1:20	0.05×	1:40	0.025×
10	1:5	0.2×	1:10	0.1×	1:20	0.05×
15	1:3.3	0.3×	1:7	0.15×	1:13	0.075×
20	1:2.5	0.4×	1:5	0.2×	1:10	0.1×
25	1:2	0.5×	1:4	0.25×	1:8	0.125×
30	1:1.7	0.6×	1:3.3	0.3×	1:7	0.15×
35	1:1.4	0.7×	1:2.8	0.35×	1:6	0.175×
40	1:1.2	0.8×	1:2.5	0.4×	1:5	0.2×
45	1:1.1	0.9×	1:2.2	0.45×	1:4.4	0.225×
50	1:1	1×	1:2	0.5×	1:4	0.25×
55	1.1:1	1.1×	1:1.8	0.55×	1:3.6	0.275×
60	1.2:1	1.2×	1:1.7	0.6×	1:3.3	0.3×
70	1.4:1	1.4×	1:1.4	0.7×	1:2.8	0.35×
80	1.6:1	1.6×	1:1.2	0.8×	1:2.5	0.4×
90	1.8:1	1.8×	1:1.1	0.9×	1:2.2	0.45×
100	2:1	2×	1:1	1×	1:2	0.5×
110	2.2:1	2.2×	1.1:1	1.1×	1:1.8	0.55×
120	2.4:1	2.4×	1.2:1	1.2×	1:1.7	0.6×
130	2.6:1	2.6×	1.3:1	1.3×	1:1.5	0.65×
140	2.8:1	2.8×	1.4:1	1.4×	1:1.4	0.7×
150	3:1	3×	1.5:1	1.5×	1:1.3	0.75×

Some cameras, such as the Mamiya RB67, use bellows for normal focusing, and so automatically have a good close-focusing range. View cameras also use bellows normally – for close-up and macro work, they are simply extended fully, or a second set of bellows is added, which normally involves adding a rail extension and an additional standard.

As well as these three basic close-up systems, there are other techniques and equipment used to improve image quality or simplify procedures: **Reversing the lens** Most camera lenses are designed to perform well when the distance between the lens and film is smaller than the distance between the lens and subject. At magnifications greater than 1× (1:1) this is no longer true, and the image is better when the lens is reversed. Most lens manufacturers supply lens reversing mounts.

Macro lenses All lenses have optimum settings for best performance. With focus, this is normally at infinity. Macro lenses, however, are designed to give their best images at close distances, and are therefore better suited to this kind of work, at the same time giving good resolution at infinity. Some macro lenses are intended to be used with bellows and so lack independent focusing, but those with focusing mounts invariably have a long focusing range. **Close-focusing lenses** These normal lenses with an extended close-focusing range lack the great resolving power at close distances of true macro lenses.

Medical lens One special type of macro lens incorporates a built-in ringflash and predetermined exposure scale, making close-up work extremely simple and accurate, particularly in field conditions. Magnification is altered by a set of supplementary lenses. It is most effective at high magnifications, when the close flash to subject distance allows small apertures and therefore great depth of field.

Supplementary close-up lenses (diopters)

Reproduction ratio (magnification), 50 mm lens on 35 mm format

Diopter	$+\frac{1}{2}$	+1	+2	+3	+4
lens focused on infinity	1:40 (0.025×)	1:20 (0.05×)	1:10 (0.1×)	1:6 (0.17×)	1:5 (0.2×)
lens focused on 1 metre	1:20 (0.05×)	1:10 (0.1×)	1:6 (0.17×)	1:5 (0.2×)	1:4 (0.25×)

Close-up exposure

Any increase in the distance between lens and film reduces the quantity of light reaching the film. If the reproduction ratio is no greater than about 1 : 7 – the normal close-focusing limit for most lenses – the light loss is not significant. More than this, however, and either the exposure must be increased with a wider aperture or slower shutter speed or the lighting must be increased.

Using continuous light (that is, not flash) and TTL metering, there is no exposure calculation to be made – simply follow the indicated aperture and the shutter speed settings. Otherwise, use one of the formulae, tables or the specially prepared scale below.

Formulae There are two standard calculations for discovering the exposure increase:

1. exposure increase = $\left(\dfrac{\text{lens focal length}+\text{extension}}{\text{lens focal length}}\right)^2$

For example, if a 50mm lens is extended by another 25mm the exposure increase =

$$\left(\frac{50+25}{50}\right)^2 = 1.5^2 = 2.25 \times$$

Practically, this means opening the aperture by $1\frac{1}{3}$ f-stops (see the table opposite).

2. exposure increase = $(1 + \text{magnification})^2$

For example, if the image of a subject on film is half life-size, the magnification is $0.5\times$ (a reproduction ratio of 1 : 2). Thus, the exposure increase $= (1+0.5)^2 = 1.5^2 = 2.25\times$.

When calculating the lens extension, either refer to the scale marked on the bellows or extension rings, or measure the complete lens-to-film

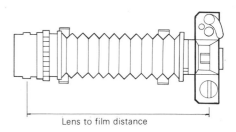

Lens to film distance

distance. The position of the film plane is marked on most cameras. With most lenses, measure from a point mid-way between the front and rear elements.

Tables The close-up tables on these pages give a simplified guide to exposure increase. Use whichever is the most relevant for the particular photographic situation.

Scales The specially prepared scale at the bottom of these two pages is the quickest of all three methods. Having extended the lens so that the image is at the magnification you want, aim the camera at the scale so that the arrow just touches the left-hand edge of the frame. The figure that appears at the right-hand edge indicates the number of extra f-stops required. For example, using a 35mm camera at a reproduction ratio of 1 : 2, the image of the scale through the viewfinder would look like this:

Exposure increase scale
Having composed the shot and corrected the focus, point the camera at the scales below, without re-focusing, so that the arrow touches the left hand edge of the frame. The right hand frame edge will then indicate the required exposure increase in f-stops.

6×6 format (for 6×7, use shorter side)

f-stop increase	4	3	2	1²∕₃	1¹∕₃
Exposure increase	16.0	8.0	4.0	3.2	2.5

35mm format

f-stop increase	4	3	2	1²∕₃	1¹∕₃		1		²∕₃
Exposure increase	16.0	8.0	4.0	3.2	2.5		2.0		1.6

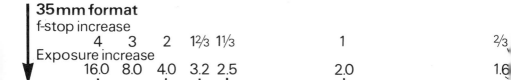

Close-up exposure increase

If you have worked out the reproduction ratio or magnification, increase exposure in accordance with this table. **R**=reproduction. **M**=magnification. **E**=exposure increase. **F**=exposure increase in f-stops and **X**=decrease in flash to subject distance (see pages 190–191). The latter is an alternative to **F**.

R	M	E	F	X	R	M	E	F	X
1:10	0.1×	1.2	$\frac{1}{3}$	1.1	1.2:1	1.2×	4.8	$2\frac{1}{3}$	2.2
1.5	0.2×	1.4	$\frac{1}{2}$	1.2	1.4:1	1.4×	5.8	$2\frac{1}{2}$	2.5
1:3.3	0.3×	1.7	$\frac{2}{3}$	1.3	1.6:1	1.6×	6.8	$2\frac{2}{3}$	2.7
1:2.5	0.4×	2	1	1.4	1.8:1	1.8×	7.8	3	2.8
1:2	0.5×	2.3	$1\frac{1}{3}$	1.5	2:1	2×	9	$3\frac{1}{3}$	3
1:1.7	0.6×	2.6	$1\frac{1}{3}$	1.6	2.2:1	2.2×	10.2	$3\frac{1}{3}$	3.2
1:1.4	0.7×	2.9	$1\frac{1}{2}$	1.7	2.4:1	2.4×	11.6	$3\frac{1}{2}$	3.5
1:1.2	0.8×	3.2	$1\frac{1}{2}$	1.8	2.6:1	2.6×	13	$3\frac{1}{2}$	3.7
1:1.1	0.9×	3.6	$1\frac{2}{3}$	1.9	2.8:1	2.8×	14.4	$3\frac{2}{3}$	3.8
1:1	1×	4	2	2	3:1	3×	16	4	4

Quick Exposure Guide

To correct the exposure in close-up or macro work, read off the lens to film distance against the lens focal length. Then open the lens by the number of f-stops indicated. For example, with a lens to film distance of 80mm and a focal length of 50mm, increase exposure by $1\frac{1}{3}$ f-stops.

Lens focal length (mm)	50	60	70	80	90	100	110	120	130	140	150	160	170	180	190	200	210	220
35	$1\frac{1}{3}$	$1\frac{1}{2}$	2	$2\frac{1}{3}$	$2\frac{2}{3}$	3	$3\frac{1}{3}$	$3\frac{1}{2}$	$3\frac{2}{3}$	4	$4\frac{1}{3}$	$4\frac{1}{2}$	$4\frac{2}{3}$	$4\frac{2}{3}$	5	5	$5\frac{1}{3}$	$5\frac{2}{3}$
50	—	$\frac{1}{2}$	1	$1\frac{1}{3}$	$1\frac{2}{3}$	2	2	$2\frac{1}{2}$	$2\frac{2}{3}$	3	$3\frac{1}{3}$	$3\frac{1}{3}$	$3\frac{1}{2}$	$3\frac{2}{3}$	4	4	4	$4\frac{1}{3}$
55	—	$\frac{1}{3}$	$\frac{2}{3}$	1	$1\frac{1}{3}$	$1\frac{2}{3}$	2	$2\frac{1}{3}$	$2\frac{1}{2}$	$2\frac{2}{3}$	3	3	$3\frac{1}{3}$	$3\frac{1}{2}$	$3\frac{2}{3}$	$3\frac{3}{4}$	4	4
60	—	—	$\frac{1}{2}$	$\frac{2}{3}$	$1\frac{1}{3}$	$1\frac{1}{2}$	$1\frac{2}{3}$	2	$2\frac{1}{3}$	$2\frac{1}{2}$	$2\frac{2}{3}$	3	3	$3\frac{1}{3}$	$3\frac{1}{3}$	$3\frac{1}{2}$	$3\frac{2}{3}$	4
80	—	—	—	—	$\frac{1}{3}$	$\frac{1}{2}$	$\frac{2}{3}$	$1\frac{1}{3}$	$1\frac{1}{2}$	$1\frac{2}{3}$	$1\frac{2}{3}$	2	$2\frac{1}{3}$	$2\frac{1}{3}$	$2\frac{1}{2}$	$2\frac{2}{3}$	3	3
90	—	—	—	—	—	$\frac{1}{3}$	$\frac{1}{2}$	$\frac{2}{3}$	$1\frac{1}{3}$	$1\frac{1}{3}$	$1\frac{1}{2}$	$1\frac{2}{3}$	$1\frac{2}{3}$	2	2	$2\frac{1}{3}$	$2\frac{1}{2}$	$2\frac{1}{2}$
105	—	—	—	—	—	—	—	$\frac{1}{3}$	$\frac{1}{2}$	$\frac{2}{3}$	1	$1\frac{1}{3}$	$1\frac{1}{3}$	$1\frac{1}{2}$	$1\frac{2}{3}$	2	2	2
120	—	—	—	—	—	—	—	—	$\frac{1}{3}$	$\frac{1}{3}$	$\frac{1}{2}$	$\frac{2}{3}$	1	$1\frac{1}{3}$	$1\frac{1}{3}$	$1\frac{1}{2}$	$1\frac{1}{2}$	$1\frac{2}{3}$
135	—	—	—	—	—	—	—	—	—	—	$\frac{1}{3}$	$\frac{1}{3}$	$\frac{1}{2}$	$\frac{2}{3}$	1	1	$1\frac{1}{3}$	$1\frac{1}{3}$
150	—	—	—	—	—	—	—	—	—	—	—	—	$\frac{1}{3}$	$\frac{1}{2}$	$\frac{1}{2}$	$\frac{2}{3}$	$\frac{2}{3}$	1
180	—	—	—	—	—	—	—	—	—	—	—	—	—	—	—	$\frac{1}{3}$	$\frac{1}{3}$	$\frac{1}{2}$
200	—	—	—	—	—	—	—	—	—	—	—	—	—	—	—	—	—	$\frac{1}{3}$

1

2/3

2.0

1.6

$\frac{1}{3}$

1.3

Close-up with flash

Particularly for active subjects, such as insects and small animals, flash illumination is useful for outdoor close-ups. Extending the lens demands greater exposure, while the small apertures needed to compensate for limited depth of field restrict the photographer to slow shutter speeds if daylight is the only illumination.

Because the precise lighting effect of a portable flash unit is difficult to estimate, and because small differences in the position of the flash create substantial exposure differences, it is essential to use a standard arrangement, with the bracket and flash heads in known positions.

Construct a set-up similar to the ones illustrated right, calculating the flash setting and aperture for a number of predetermined extensions. As maximum depth of field is usually desirable with this kind of close-up, it is better in most cases to decide first on the aperture and then adjust the flash output or distance. Automatic flash units generally produce too little illumination for small aperture settings, and are better used in the manual mode.

The easiest method of calculating flash intensity is with a flash meter, making allowance for lens extension (see the tables on the previous pages). Alternatively, use this formula:

$$\text{flash to subject distance} = \frac{\text{guide number}}{\text{aperture} \times (\text{magnification} + 1)}$$

The answer will be given in feet or metres, depending on which guide number you use. For example, with a guide number of 60 (in feet) and a 50mm lens extended by 75mm (a magnification of 1.5×), then to use an aperture of f22 the flash distance will be:

$$\frac{60}{22 \times (1.5+1)} = \frac{60}{22 \times 2.5} = 1.1 \text{ feet, or } 13 \text{ inches}$$

Whatever method you use to calculate the settings, run a test, bracketing apertures and flash distances.

Close-ups with ring flash Although a ring-flash gives shadowless, frontal lighting which can be monotonous if used frequently, it gives extremely consistent results, and is particularly useful in crevices and other cramped spaces. Because the flash is in a fixed position in relation to the lens, the only exposure adjustments possible are aperture setting and power output. At high magnifications, the flash is so close to the subject that a small aperture and great depth of field are possible, but at small magnifications the flash distance is normally too great for a satisfactory depth of field.

Alternative flash fittings for close-up fieldwork

1 Single flash This is the most basic setting – a single head aimed at the subject from about 45°. The lighting is more natural if the head is elevated slightly, as well. Keep the flash close to the lens to minimize shadow areas.

2 Single flash with reflector A small white or silvered card, on the opposite side of the subject from the flash, fills in the shadows.

3 Two flash heads A second, smaller flash unit, aimed from the other side of the lens, is a more effective fill-in than a reflector. The fitting shown here is an alternative to the lens-mounted bracket – two flash extension arms screwed to the base of the camera body or bellows track.

1/60 sec at f4

1/8 sec at f11

Depth of field control By
altering shutter speed and
aperture, three different depths of
field were obtained in this shot of
a small wild flower. The shallow
depth of field given by a wide
aperture (f4) isolated the subject
too sharply, but a narrow
aperture (f32) brought too much
distracting background into the
shot. The best result was the
compromise setting of f11, with a
greater portion of the subject in
focus but the background a blur.

1 sec at f32

Depth of field In close-up work, depth of field
is very shallow, even at small apertures. As a
result, accurate focusing is essential. The best
indication of depth of field is to stop the lens
down (use the preview button with an FAD
system), although the view may be too dark to
see the whole image clearly. The depth of field
table below gives the extent of sharpness at
different apertures and magnifications,
measured in millimetres.

Subjects such as insects generally look best
with great depth of field. Flowers, on the other
hand, often need an intermediate depth of field
to separate them from fussy backgrounds.

Depth of field table (mm)

Reproduction ratio	Magnification	f5.6	f8	f11	f16	f22	f32
1:10	0.1×	41	59	81	117	160	232
1:5	0.2×	14	16	22	32	45	64
1:3	0.33×	4.5	6.4	8.8	12.8	17.6	26
1:2	0.5×	2.2	3.2	4.4	6.4	8.8	12.8
1:1.5	0.66×	1.7	2	3.3	4	6.6	8
1:1	1×	0.8	1.1	1.5	2.1	3	4.2
1.5:1	1.5×	0.41	0.6	0.8	1.2	1.6	2.4
2:1	2×	0.28	0.4	0.55	0.8	1.1	1.6
3:1	3×	0.16	0.75	0.32	0.47	0.64	0.94

Aerial shots 1

Light aircraft, helicopters and balloons can all be made suitable for aerial photography. They have different features when used as camera platforms, and the necessary techniques differ in each case.

Light aircraft The most generally useful aircraft for photography is a single-engined, high-

winged plane, such as a Cessna. Relatively inexpensive to hire, it combines manoeuvrability with a fairly unrestricted view, and is commonly available. From either door, the angle of view from wing tip to wheel is just sufficient for a 35mm camera with a 20mm lens to be used horizontally without parts of the aircraft appear-

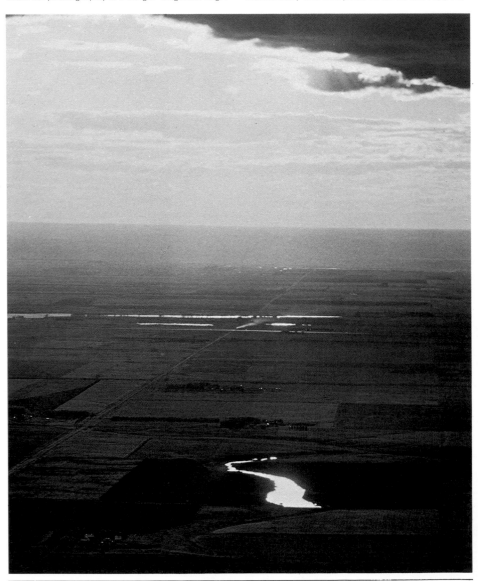

ing in the shot. Models with retractable wheels are even more useful. Aircraft with wings below the fuselage, such as the Beechcraft, can only be used satisfactorily if the luggage hatch in the tail is opened.

Engine vibration and air buffeting can cause camera shake. As a precaution, use a high shutter speed – 1/500 sec is ideal ·with a standard lens – and support the camera against your body rather than the aircraft. The longer the focal length of lens you use, the faster the shutter speed needs to be. For specific shots, the aircraft can be slipped sideways towards the subject at low throttle to reduce vibration.

For high quality work, never shoot through aircraft windows. In most situations, opening or removing a hatch or window does little to the handling of the aircraft, and improves the photography immeasurably. When photographing from a Cessna, unscrew one end of the port window's retaining bar and either shoot from the passenger seat behind the pilot or ask the pilot to use the starboard controls. The pressure of the airflow under the wing will keep the window firmly open in flight. With some aircraft, a complete door can be unscrewed at the hinges or, as a last resort, the rear luggage hatch can be removed, although in this case the shooting position will be cramped.

When shooting through windows is unavoidable (at high altitudes or on a commerical flight), keep the camera close to the window and use a piece of cloth or your hands to eliminate reflections. Avoid shooting when sunlight strikes the window, causing flare and showing up cracks or scratches in the plastic.

For near vertical photography, the aircraft must usually be banked quite steeply. As this alters the direction of the flight, there is only a short time available for shooting. A better solution is to have the aircraft bank continuously in a tight circle over the target. This also facilitates coverage from different angles.

Helicopters With greater manoeuvrability and a wider field of view than a fixed-wing aircraft, helicopters are almost ideal, but set against these advantages are the much greater hourly cost and greater vibration, particularly when hovering. As with fixed-wing aircraft, use a high shutter speed, dampen vibration by not resting your arms against the fuselage, and shoot through an open window if possible. An elaborate answer to reducing vibration is a gyroscopically-stabilized camera mount. Models such as the Kenyon use a rapidly spinning gyroscope to create a stable platform, and can be hand-held or bolted to the helicopter's fuselage. Although essential for movie cameras they are really only justified for use with still cameras when low light levels and slow shutter speeds cannot be avoided. Although the main rotor blades may be an unnoticeable blur to the eye, at high shutter speeds they will appear in the photograph. Be careful to keep them out of the frame.

Balloons Hot air or gas balloons and airships offer the most stable, vibration-free aerial platforms of all, allowing unrestricted shooting even at slow shutter speeds and with long-focus lenses. Their disadvantage is lack of control – manoeuvring to a desired position for photography is virtually out of the question.

Equipment All cameras with line-of-sight viewfinders can be used more or less successfully in aerial photography. Right angled viewing systems are much too difficult to use because of the restricted view and often cramped shooting positions. A 4×5in (9×12cm) technical camera gives excellent detail, but 6×6cm/6×7cm and 35mm cameras are also effective. With the window open, air buffeting can be severe, and it is important to wrap the camera strap tightly around the wrist. A pistol grip can also be useful. Engine noise often drowns the sound of the shutter tripping, so that it is important to check visually that the camera

Increasing contrast Lack of contrast is the most common problem to be overcome in aerial photography. Low elevation and shooting towards the sun are the solutions used here, with a 180mm lens on a 35mm camera. The low sun in the early morning and late afternoon can also help by giving more pronounced shadows. Bright reflections from rivers and lakes are another useful aid. ASA 64: 1/500 sec at f 2.8.

Shooting position A high-winged, single engined light aircraft, such as this Cessna Skywagon, is the best general camera platform for most aerial photography. The port window can be opened and by unscrewing the retaining bar will hold up against the underside of the wing in flight. For take-off and landing, keep it closed for stability.

is operating smoothly – otherwise, with a motor drive, it is possible to continue firing the camera after the film has been used up.

Except in the tropics, cabin temperatures can be low with the window open. Wear warm clothing and use silk gloves. Warm the camera against your body between shots.

Resolution of detail is important in most aerial photography, so that fine grain film is normally best, provided that its ASA rating allows a sufficiently fast shutter speed. False colour infrared film can also be successful in aerial photography for special effects. It was originally designed for camouflage detection and forestry surveying from the air.

Film Use high contrast film, or up-rate the film by a half stop or one stop to increase contrast (that is, use the procedure for under-exposure and over-development described on pages 66–67 and 84–85). Infrared film, both black-and-white and colour, has good haze reducing properties.

Filters Use an ultraviolet filter, and where the light levels permit, a polarizing filter.

The greatest difficulty with aerial photography is lack of contrast. This is due partly to atmospheric haze and ultraviolet scattering, and partly to scale. With the exception of rugged mountain terrain, most of the large elements of a landscape that figure prominently in ground-level photography, such as hills, tall buildings and trees, appear quite small through a standard lens at normal flying altitudes. With local detail reduced in size, there are fewer large areas of shadow or tonal differences, and so less contrast is recorded from the image.

To bring life and variety to aerial photography, there are a number of techniques for increasing contrast.

Lighting This is the single most important factor. Direct sunlight is nearly always preferable to an overcast day – the contrast is higher, and the overall light level allows high shutter speeds. A high sun, however, particularly with near vertical shots, gives flat lighting, and the long shadows cast by a low sun in the early morning and late afternoon give a stronger, more defined image. Also, shooting at an oblique angle rather than vertically, a greater variety of lighting directions can be covered by altering the camera position in relation to the sun. A good possibility is offered by shooting into sunlight reflected in water as this gives a very high contrast.

Altitude The less the thickness of the atmosphere to shoot through, the less haze and scattering will result. Flying at a low altitude – say 1,000 feet above ground level – and using a wide-angle lens gives greater contrast. An additional problem experienced when using long-focus lenses is heat shimmer. Pockets of rising warm air distort the image in the same way as heat rising from a road on a hot day.

Subjects Choose, where possible, subjects

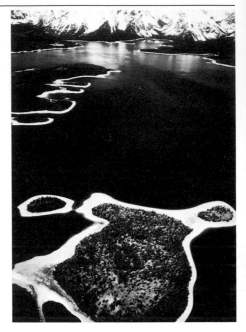

that are strong in contrast – either in colour, as with fields planted with different crops or trees against rock, or in tone, as with water against a shoreline or snow against rocks or trees. Patterns, such as complicated road intersections, field boundaries or housing estates, also make definite, strong images.

Flight preparation
Planning saves time and money – both important in aerial photography. Follow this sequence:
1. Plan the route and flight time on a map. If there is some uncertainty about subjects and you intend to select them on the way, make up a list of the types of subject.
2. Choose the time of day for flying, after finding out the general and specific weather conditions for the area by enquiring at the airfield.
3. Brief the pilot on your needs. Engine noise in flight may make communication difficult, so it is best to establish procedures for banking and changing altitude in advance, on the ground.
4. Prepare the aircraft by opening windows, removing hatches or adjusting seating, and install the camera equipment so that it is easily accessible. Check the field of view available.

Using subject contrast The shorelines of these small islands have such good inherent contrast that they would give a clear, definite image whatever the lighting conditions. Here, a vertical composition and wide-angle lens make the strongest use of the slopes.
Kodachrome 64, with a 20mm lens on a 35mm camera: 1/500 sec at f4.

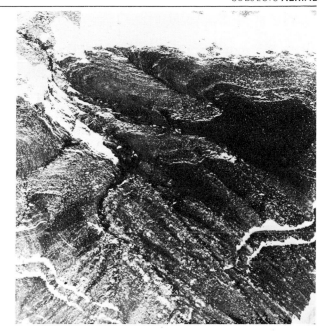

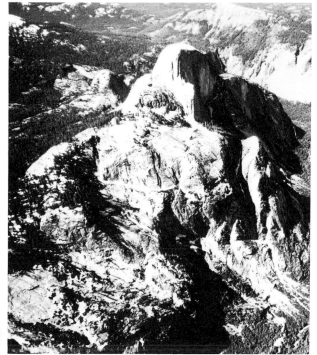

A sense of scale In aerial photographs of wild landscapes, the absence of familiar objects, such as roads, field boundaries or houses, can make it difficult to appreciate the scale of the scene. This shot of the barren escarpments of the Grand Canyon was taken with a 20mm lens on a 35mm camera. Kodachrome 64, 1/500 sec at f5.6.

Wide-angle lens at low altitude One of the basic techniques for maintaining contrast and colour saturation, particularly useful when you have no choice of lighting conditions, is to use a wide-angle lens and fly low. Being closer to the subject – in this case El Capitan in the Yosemite national park at midday – the effects of haze are reduced.
Kodachrome 64, with a 20mm lens on a 35mm camera: 1/500 sec at f5.6.

Underwater 1

There is now a wide range of underwater camera and lighting equipment available, to suit all levels of diving proficiency. The simplest is a compact 110 plastic camera for use down to 15 feet (5 metres). The most elaborate a rugged cast aluminum housing that will take a motor-driven camera, interchangeable lenses, and powerful flash heads. Most underwater cameras or housings are in 35mm format, but a few larger format cameras, notably Hasselblad, can be used in specially designed housings.

The basic choice of equipment is between an

Minolta Weathermatic The simplest amphibious camera is a sealed 110 model suitable for sub-surface use. It is designed to be taken to a depth of five metres.

Nikonos With interchangeable lenses, some for use exclusively underwater, the 35mm Nikonos is the standard amphibious camera built to professional standards.

Moulded plastic housing Available for most makes and models of camera, these transparent housings are widely used.

35mm cast aluminium The most rugged housings for 35mm cameras are made from cast aluminium. These allow work at greater depths and frequently will take a motor drive. Dome correction ports are a standard feature.

6×6cm cast aluminium housing Custom housings for medium format cameras, such as this motor driven Hasselblad with a 70mm back, are invariably bulky. Interchangeable front and rear dome correction ports make the best use of the available camera lenses.

amphibious camera and a housing that will accept your existing camera system. Under-water optical problems (see pages 198–199) are such that purpose built, water-contact lenses, on an amphibious body, would be ideal, but as this involves the expense of a completely new camera system, housings are a popular and economical alternative. The major amphibious camera currently available – the Nikonos – is very good but carries the disadvantage of not having reflex viewing. The Minolta Weather-matic, in 110 format, has built in flash.

Soft vinyl housing For depths to about 30 feet (9 metres), a transparent bag with an inset glove is adequate for occasional use.

Light meter housing Moulded plastic housings are available for both continuous light meters and flash meters.

Flash unit For ease of handling, electronic or bulb flash units can be mounted on adjustable arms attached to the camera housing or bracket.

Waterproofing

The basic solution used in practically all underwater cameras and housings is the O ring. This is a thin rubber ring, circular in cross-section, that fits into a groove at the point where the camera or housing can be opened. Being squeezed slightly under the pressure of the catches, it acts as a seal. A tight accurate fit is essential. Any damage to the O ring or bad fitting can quickly and permanently ruin equipment.

Camera care

Because salt water can be so damaging – a flooded camera is frequently irreparable – never skip cleaning and maintenance. Follow these checks and procedures:
1. With a new housing, submerge it to a depth of at least 20 feet, or whatever is the recommended safe maximum depth, without the camera inside. If there are any defects, you will not have ruined a camera
2. After diving, submerge the equipment in a pail of fresh warm water for at least half an hour and then hose down to dissolve completely any dried and crystallized salt. Rinsing is insufficient
3. Dry equipment thoroughly after washing and never open a housing or amphibious camera, even to change film, with wet hands or hair
4. When the equipment is dry, check the O rings and grooves for grit, sand and crystallized salt. Coat the rings, screws and threads with special O ring grease
5. On land, keep equipment out of the sun
6. Protect ports, which are usually made of acrylic, by keeping them covered with a rubber cap or cloth when not in use ·
7. Do not subject the equipment to rapid temperature changes as condensation will form inside.

Several special problems are encountered with underwater photography, generally connected with the behaviour of light. Firstly, because of refraction, light will be distorted as it passes through water to air or water to lens surfaces. And secondly, the level of illumination falls off greatly as depth underwater increases.

Refraction The greater refraction in water than in air has three effects on uncorrected lenses:
1. Objects appear to be 25 per cent nearer than they really are
2. They appear to be one third larger than they really are
3. The lens angle of view is narrowed by 25 per cent
The water, in fact, acts as an additional positive lens in front of the camera. All three optical effects are interrelated.

Change in angle of view underwater
Note: the focal length does not change

(35mm format) Focal length	Normal angle (diagonal)	Underwater angle
16mm	170°	127.5°
20mm	94°	70.5
24mm	84°	63°
28mm	74°	55.5°
35mm	62°	45.5°
50mm	46°	34.5°
55mm	43°	32°

Amphibious, water-contact lenses, such as on the Nikonos, are designed for underwater use, and are therefore corrected. An ordinary lens in a housing, however, will suffer these problems if it is behind a flat port, and there will also be chromatic aberration and poor resolution at the edges, and pincushion distortion. To correct for refraction effects, it is normal to fit a dome port, which acts as a negative lens. This solves two of the problems – angle of coverage and apparent size of objects – but alters the focusing so much that a supplementary close-up lens (see pages 186–187) is needed in order to focus on infinity.

Natural light underwater Natural light photography underwater is adequate with fast film and colour correcting filters, down to about 30 feet (9 metres). Some light of all wavelengths is lost by reflection from the surface of the water, and more is lost by attenuation with increasing depth. In addition, suspended particles scatter light at all depths. More importantly for colour photography, water absorbs wavelenghts selectively, so that even at only a few feet below the surface, much of the red is lost from the sunlight filtering through. At greater depths shorter wavelengths are absorbed, until at about 100 feet (30 metres) only a dim blue remains. Use the filter table for depths to 30 feet (9 metres).

Natural light photography is normally re-

stricted to general views. Use a very wide-angle lens as refraction will reduce its covering power, and to enhance contrast shoot from below to make use of the silhouetted shapes of coral and rock formations wherever possible.

Weather conditions are an important consideration – bright sunlight between mid-morning and mid-afternoon is virtually essential for contrast and colour saturation, and a calm sea will have better visibility than a rough one. If you cannot see details at 30 feet (10 metres), conditions are not satisfactory.

Filter corrections for sunlight underwater

Depth	Filter
5–15ft (1.5–4.5m)	CC20Red
15–20 (4.5–6m)	CC30Red
20–25 (6m–7.5m)	CC40Red
25–30 (7.5–9m)	CC50Red

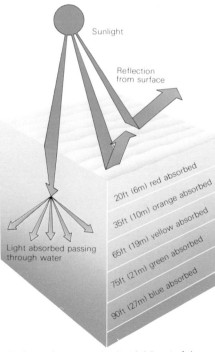

Light underwater A substantial part of the sunlight striking the surface of water is immediately reflected. Still more is scattered and absorbed as the light passes through the water itself. The result is a great fall off in the level of illumination as the depth increases. Different colours are extinguished at different depths. Red is the first to go (at about 20 feet) and red filters may have to be used to correct the colour balance. Blue is the last colour to disappear, at 90 feet. Below 100 feet, no colour is visible underwater.

Artificial light underwater With the exception of underwater landscapes, and certainly below 30 feet (9 metres), artificial lighting is essential. Tungsten ciné lights can be used, but flash is weight-for-weight more powerful. Whether you use flash bulbs or electronic flash, make a preliminary series of tests, using the quoted guide number as a starting point. Absorption and lack of reflective surroundings reduce the flash intensity. Automatic sensors are unreliable underwater because of particles reflecting the light back.

Absorption also eliminates some red light unless the flash is used in close-up, and a CC20Red filter is best kept over the lens for most situations. Try never to aim the light from close to the camera position – this causes 'back-scattering' – in effect, the illumination of suspended particles in front of the subject. The best general lighting position is from above the subject, in imitation of sunlight. You can achieve this by attaching the flash to a jointed boom arm on the housing, by hand-holding with an extension cable, or by having your diving partner aim it. A second flash can be used to fill in shadows.

Flash For fish and all underwater close-ups, only artificial light is practical. Flash not only prevents movement blur but restores the colour and contrast lacking at distances over a few feet. Here, a single flash unit was fired from slightly above the camera position – the most basic method, with the virtue of simplicity.

Daylight For overall views – underwater landscapes, for example – artificial lighting is useless except to provide fill-in light for foreground detail. Lack of contrast is a problem for both colour and black-and-white film, but can be overcome to some extent by shooting from below, silhouetting subjects against the light at the water's surface. A wide-angle lens gives greater depth of field, important because the light levels are usually low, requiring the widest apertures. When using colour film, use the filter correction table opposite for the depth you expect to be working at.

5. PREPARATIONS
Packing 1

Careful packing is one of the most important ways of preventing camera damage and prolonging the life of equipment. Ideally, all equipment should be packed so that each item is held securely, protected from physical damage by padding and a hard case, and kept clean. In practice, however, cameras need to be accessible on location and a degree of compromise has to be made.

The best general solution is to use two types of case: a rigid, shock-proof container for transporting cameras from one location to another,

and a soft shoulder bag that the day's film and equipment can be loaded into. Rigid cases are difficult to work from on the move, and soft bags cannot give maximum protection in transit.

Rigid cases and shoulder bags need different approaches to packing. The former need to carry as much equipment as possible securely and safely, while accessiblity and portability are the priorities for a shoulder bag. Hard camera cases should always have reflective surfaces – bright metal or white paint – to reduce heating in sunlight. Black is completely inappropriate.

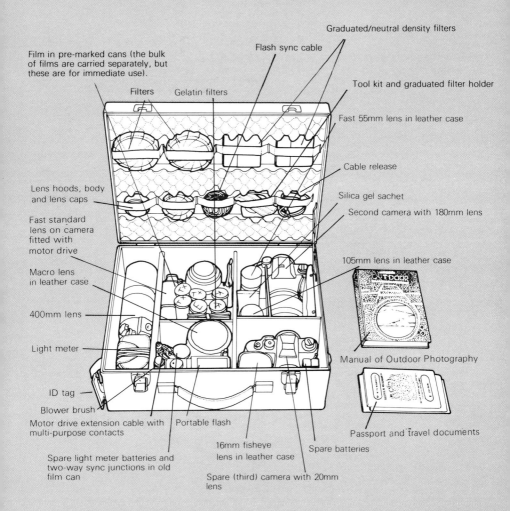

Graduated/neutral density filters

Flash sync cable

Film in pre-marked cans (the bulk of films are carried separately, but these are for immediate use).

Tool kit and graduated filter holder

Filters Gelatin filters

Fast 55mm lens in leather case

Cable release

Lens hoods, body and lens caps

Silica gel sachet

Second camera with 180mm lens

Fast standard lens on camera fitted with motor drive

105mm lens in leather case

Macro lens in leather case

400mm lens

Light meter

Manual of Outdoor Photography

ID tag

Blower brush

Motor drive extension cable with multi-purpose contacts

Portable flash

Passport and travel documents

Spare light meter batteries and two-way sync junctions in old film can

16mm fisheye lens in leather case

Spare batteries

Spare (third) camera with 20mm lens

Rigid case: 35mm camera This type of case, often in beaten aluminium (aluminum), should be sealed so that it is waterproof and dust-proof, capable of being locked, and as rugged as possible. The standard forms of padding are either felt-lined compartment divisions held in place by grooves or Velcro tabs or both, or blocks of foam (soft or hard, with a closed-cell construction being the most shock-proof). When packing like this for transport, it matters less that equipment can be pulled out in a hurry than that everything is held firmly in place, unable to scratch or knock against edges.

Individual lens cases are used here because, although not necessary in the hard metal case,

they will be transferred to a shoulder bag on location. The interior of this case measures $16\frac{3}{4} \times 13 \times 5\frac{1}{2}$ins ($43 \times 33 \times 14$cm).

Rigid case: 4×5in view camera Large format cameras generally pack less compactly than others. Closed-cell foam, cut to shape with a saw-toothed knife, is the safest padding. By disassembling and laying flat, the bulk of a view camera can be reduced. The interior dimensions of the moulded aluminium case illustrated here are $20 \times 16\frac{1}{2} \times 6\frac{3}{4}$ins ($46 \times 42 \times 17$cm).

4×5in (9×12cm) rear standard,
150mm lens fitted underneath for packing

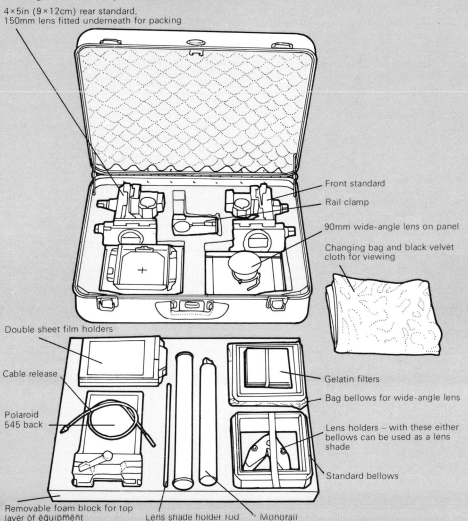

Front standard

Rail clamp

90mm wide-angle lens on panel

Changing bag and black velvet cloth for viewing

Double sheet film holders

Cable release

Polaroid 545 back

Gelatin filters

Bag bellows for wide-angle lens

Lens holders – with these either bellows can be used as a lens shade

Standard bellows

Removable foam block for top layer of equipment

Lens shade holder rod

Monorail

Soft shoulder bag: 35mm

Shoulder bags are available in a wide variety of designs, sizes and materials. Accessibility is the main need, and a combination of internal compartments and many separate pockets is ideal. A tough, waterproof outer covering is important, and some form of internal padding. Individual leather lens cases are useful for protection. If a large quantity of equipment is likely to be carried, the carrying strap should be strong, and run continuously round the bottom of the bag. A separate carrying grip is also an advantage.

Some designs *look* like camera bags, and while there are occasions where this does not matter, in candid photography conspicuousness is a disadvantage. An ordinary-looking bag in a drab colour is nearly always better than one which advertises the photographer.

This shoulder bag, in hard-wearing canvas and leather, is relatively large, but it is better to have one with a generous allocation of space than be unable to add an extra lens or two.

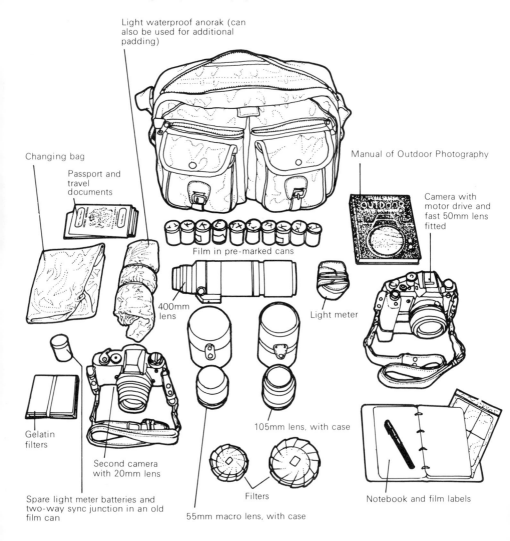

Light waterproof anorak (can also be used for additional padding)

Changing bag

Passport and travel documents

Manual of Outdoor Photography

Camera with motor drive and fast 50mm lens fitted

Film in pre-marked cans

400mm lens

Light meter

Gelatin filters

105mm lens, with case

Second camera with 20mm lens

Filters

Spare light meter batteries and two-way sync junction in an old film can

55mm macro lens, with case

Notebook and film labels

The amount of equipment that photographers take when travelling varies greatly according to personal preferences, format and the type of photography anticipated. Use this comprehensive checklist to tick off the items you may need on any trip.

Camera bodies
Main body/bodies
Spare
Motor drive/power winder
Remote control
 leads/triggering
 mechanisms
Fresh batteries
Special cameras: underwater,
 panoramic
Instant film camera

Camera accessories
Neck straps
Body caps
Soft release button
Cable release
Cable extension for motor
 drive
Rubber eye cups
Spirit level
Spare batteries: TTL, motor
 drive
Spare focusing screens
Extra viewfinder
Battery pack
Polaroid back

Lenses
Fish-eye
Extreme wide-angle
Wide-angle
Normal
Moderate long-focus
Extreme long-focus
Fast, wide-aperture lens
Macro lens
Zoom lens
Perspective control lens
Tele-converter

Lens accessories
Lens hoods
Front and back lens caps
Filters: UV, colour
 conversion, colour
 compensating, polarizing,
 graduated, soft focus,
 effects
Filter holder

Close-up accessories
Supplementary lenses
Extension rings/tubes
Bellows extension
Double cable release
Reversing ring

Supports
Tripod
Tripod head
Thread adapters
Monopod
Pocket tripod
Ground-plate
Rifle stock
Clamps
Bean bag

Exposure meters
TTL heads
Hand-held meter
Spot meter
Flash meter
Colour temperature meter
Spare batteries

Lighting
Portable flash
Diffusing head
Umbrella and clamp
Light stand(s)
Hot shoe
Extension lead
Photoelectric slave cell
Mains adapter
Spare batteries
Sync junction
Reflectors: card, foil, mirrors
Mains (line power) lighting:
 power packs
 heads
 power leads
 sync leads
 spare flash tubes
 spare lamps
 spare modelling lamps
 umbrellas
 diffusing heads
 reflector heads
 barn doors
 snoot
 large reflectors: card, foil,
 flats
 spare fuses
 cables
 generator

General equipment
Tape
Changing bag
Clamps: spring, G, C
Knife with retractable blade
Screwdrivers: regular and
 cross-head

Hacksaw
Scissors
Stapler
Allen keys
Tape measure
Rubber bands
Plastic bags
Plug adaptors
Blu-tack
Glue
Markers and pens
Notebook
Adhesive labels

Film
Basic colour transparency
Fine-grained colour
 transparency
High-speed colour
 transparency
Tungsten-balanced colour
 transparency
Special purpose colour
 transparency
Basic colour negative
High-speed colour negative
Tungsten-balanced colour
 negative
Basic black-and-white
Fine-grained black-and-
 white
High speed black-and-white
Special purpose black-and-
 white
Instant film
Instant film holder
Instant negative portable tank

Cases
Shoulder bag
Rigid case
Film case/bags
Individual lens cases
Stuff sacks
Padding
Tripod case
Lighting cases
General accessory case/bag

Personal baggage
Basic clothing
Waterproof jacket
Down jacket
Extra footwear
Gloves
First-aid kit
Water purification tablets
Salt tablets
Sunglasses
Sunburn cream
Travel documents, including
 passport and tickets
Camera invoices or carnet
 (see page 204)

Travel: preparations and precautions

When travelling with photographic equipment, make sure not only that everything is safely packed and protected, but also that you have anticipated customs and security checks at international frontiers. On aircraft in particular, try to carry the most valuable equipment and film with you as personal baggage. Check that your insurance policy covers the areas you will be travelling to.

Packing A good system to follow is to reserve one or two rugged cases for transporting camera equipment, and then transfer the items you are likely to need on a day-to-day basis into a soft shoulder bag when you arrive at your destination. Ideally, cases for transporting equipment should be strong (moulded aluminium is excellent), waterproof, sealed, padded and lockable. Two very good commercially available systems are Rox (West Germany) and Haliburton (USA). Some motion picture hire companies, such as Samcine, will also make customized cases for specific equipment. The dimensions of hand baggage in commerical aircraft are restricted by the space under seats. These vary slightly, but a case measuring $17\frac{1}{2} \times 14 \times 6$ in ($45 \times 36 \times 15$cm) will just fit under most.

Make sure that the interior is well padded so that metal and glass parts do not scratch against each other. Push extra pieces of foam rubber or cloth into any remaining gaps. Uncock all camera shutters and open lens diaphragms to reduce strain.

Customs Camera equipment is not only valuable but is frequently subject to heavy import duty. As a result, most countries restrict the quantity that can be brought in for personal use. Check in advance the limits on camera bodies, lenses and film imposed by the country you are visiting by asking the embassy or consulate. These official limits are rarely enforced but be prepared. As a general rule, two camera bodies, a few lenses and a small bag of film will cause no problems.

Most customs require assurances that equipment and film will not be sold inside their country. Even if you are over the official limit, it is often possible to make an arrangement with the customs whereby a list is prepared for later inspection when you leave. Because of this, it is a good idea to have a few copies of such a list already prepared. As a last resort, suggest that the list be entered into your passport.

The internationally recognized system for moving valuable goods temporarily between countries is to use an ATA Carnet. Chambers of commerce in many countries issue these, and they are officially acceptable international customs documents. They guarantee that duty will not be avoided. As a result, the conditions for issuing them are stringent and inflexible, as well as expensive. The amount of the full duty has to be deposited with your local chamber of commerce, and a complete, precise itinerary made out. Because of these conditions, the Carnet system is not commonly used by photographers.

To avoid problems on your return, carry with you either the camera invoices or photocopies of them. The serial numbers will identify where the equipment has been bought, but an invoice removes any doubt.

X-Rays Despite the reassurances posted on airport X-ray machines, they frequently do ruin unprocessed film. X-rays fog film in the same way as visible light – how much depends on the strength of the machine and the amount of time that the film is exposed to it. The effect is cumulative, so that while one pass through a low dose machine may have no noticeable effect, several may take the film over the point at which damage is caused. Lead-lined envelopes are not guaranteed to be safe, as the X-ray machine operator may simply increase the intensity until the rays penetrate the contents. It is also risky to pack film in checked baggage, as this is occasionally subjected to high dose spot checks at some airports.

The only safe answer is to carry film in your hand luggage and ask for a manual inspection, which is available at most airports, despite protests by security staff. Unfortunately, if this is refused, there is little you can do, although a few rolls can usually be carried in your pockets as personal effects. As a last resort, show this page to the security personnel:

Professional, highly sensitive photographic film
Do not X-ray

French

Film ultra-sensitif pour usage professionel.
Ne pas soumettre aux rayons X.

German

Hochempfindlicher, photographischer Film für professionellen
Gebrauch.
Nicht durchstrahlen

Spanish

Película ultra-sensitiva, para uso profesional.
No utilizar rayos X.

Portuguese

Película fotográfica profissional altamente sensivel.
Não passe em Raios X.

Chinese

敏感度極高職業攝影膠片
勿用×光檢查

Japanese

要注意!!
高感度学術用
未現像フィルム
Ⅹ線照射厳禁!

Arabic

فلم تصوير مهني شديد الحساسية لا يتأثر بالاشعة السينية 。

Adverse conditions

In some extreme conditions, the general camera care and maintenance described on pages 146 to 151 is not sufficient by itself to protect equipment. In unusually high or low temperatures and humidity, it is important to take special precautions.

Humid tropics Heat and humidity are both damaging to film and equipment – combined, their effect is multiplied. Firstly they accelerate the deterioration of film, particularly if it has already been exposed. In these conditions, process film as soon as possible after use. For protection from high humidity, do not open sealed film cans until you are ready to use them. Having exposed the film, pack tightly in sealed containers with a desiccant, leaving as little air space as possible. Silica gel is the most convenient desiccant. Keep it in porous bags or cans, drying it out frequently in an oven or over a fire. In the absence of silica gel, use uncooked rice, which although ten times less effective is usually readily available.

To protect film from heat, keep it cool rather than refrigerated – unless you have large quantities of desiccant as bringing film out from very low temperatures causes condensation. A cool picnic box is useful. Keep it in the shade.

Give the same protection to camera equipment, inspecting it regularly for signs of internal condensation, corrosion, and fungus on the lens surfaces. Use a camera case with a reflective surface and a waterproof seal (pages 200–201), keeping the cameras inside between shots. Never leave equipment or cases in direct sunlight.

Dry tropics The chief problem with deserts and other dry areas is airborne dust, sand and grit. These penetrate equipment, causing abrasive damage to mechanical parts and to film as it moves through the camera. Always keep the equipment packed when not in use, and then seal all joints and gaps with tape. Always use a clear filter to avoid exposing the front element of the lens to the etching action of sand, and in dust-storms place the camera in a plastic bag, as described below for rain. When temperatures are high, take the same precautions as under humid tropical conditions. Keep cases and equipment ventilated by raising them off the ground.

Arctic The contrast in temperature between outdoor conditions and heated interiors or body warmth in the Arctic causes serious condensation problems. When a camera is brought into a warm room from sub-zero temperatures, moisture condenses inside the mechanism. To protect equipment, either avoid taking it into warm interiors or seal it in plastic bags that are well packed with desiccant before coming inside. When moving to low temperatures from the warmth, condensed breath and wind blown snow tend to enter joints, thaw and then freeze. Here, the answer is either to keep the equipment fairly cold all the time, or to seal it as much as possible with special camera tape.

Low temperatures thicken some lubricants – silicates less than others – and thus slow down or even jam some mechanical operations. Check in advance whether this is likely to be a problem for your equipment by placing it, in sealed bags with desiccant, in a refrigerator or freezer set to the temperatures you are likely to encounter. If there are signs of jamming, have the cameras 'winterized' professionally. This involves replacing the lubricants with thinner ones, and the equipment should not then be used in warm conditions.

Batteries release less power at low temperatures. Carry spares, and keep a separate battery pack under your clothing if possible. Selenium cell light meters are unaffected and are therefore more reliable than battery powered meters.

Film suffers from the same condensation problems as equipment. In addition, it becomes brittle at low temperatures, snapping easily. It can also generate electrostatic discharge, causing the appearance of 'lightning' sparks on the emulsion. Always wind film on gently, listening for the sound of sprocket holes tearing. Operate the camera manually rather than with a motor drive.

Rain and salt spray Penetrating wet conditions can have the same effect, over a period of time, as dropping the camera in water. Amphibious cameras, such as the Nikonos or the Minolta Weathermatic, are best in heavy rain, cloud, or wind driven salt spray, but regular equipment can be used if sealed in a clear plastic bag that is waterproof. Use a large bag to ease camera movements, and cut a hole just large enough for the lens, sealing it around the filter with a rubber band.

Wipe off any accidental moisture immediately. When salt water, which is particularly corrosive, is likely to collect on the equipment, carry with you a small bottle of fresh water or alcohol and swabs.

Mountains Mountain conditions are frequently cold and wet (see above), but the chief damage to equipment is physical – knocks and scrapes to inadequately protected cameras and lenses. Either strap a rigid camera case onto a pack frame or, if you need rapid access to the camera, use a well padded soft case, preferably one that can be carried on your back. Climbing with a bag held only by a shoulder strap is dangerous because it is unbalancing and puts the equipment at risk.

Tropical damp The warm rain and humidity of tropical regions can be just as debilitating as cold. Army-surplus equipment cannot be bettered. Try jungle boots – these have solid waterproof soles but lighter upper parts so you will not become uncomfortably warm. A light waterproof jacket which opens down the front is best, especially with a hood. The camera can be worn around your neck under the jacket and kept dry. It can then be brought out quickly when you want to shoot.

Cold conditions It is impossible to work well when you are cold, so invest in a good quality down-filled jacket. This will be light and allow free movement. A hood is an advantage. Good climbing boots are important, especially in rough country. Woollen socks and long underwear are essential in very low temperatures. Heavy gloves will keep you warm but will have to be removed when shooting begins. Silk under-gloves then come into their own.

Temporary waterproofing In exceptionally wet conditions, particularly when salt-water spray is present, it can be a wise precaution to enclose the camera in a clear plastic bag. Leave

sufficient play in the bag to allow you to use the camera controls such as the aperture ring. Seal the bag around the front of the lens with a rubber band. You can also fix the bag around the

viewfinder in the same way – attaching the camera's rubber eye-cup may make this easier – although if necessary you will be able to see tolerably well through the plastic bag.

Insurance and legal

There are four important legal areas that can affect photographers: restrictions on the taking of photographs, copyright, restrictions on their use, and loss or damage. The law on these matters varies from country to country, from state to state, and even occasionally between cities with local ordinances or bylaws that may be relevant. As a result, the guidelines given here are rather general and err on the side of caution. Always, if you have a specific problem, seek professional legal advice.

Restrictions on taking photographs In most public places there are few restrictions facing the photographer. If, however, you have fairly elaborate equipment – say, tripods, lights and models in a busy street – the police may consider you to be a public nuisance. If in doubt, check local ordinances. Military and security-classified installations are almost always restricted. In some politically sensitive countries, this category may even extend to such seemingly innocuous subjects as bridges and railway stations. Most international airports also forbid photography for security reasons. Places open to the public but under private control, such as some parks, can impose their own regulations. If you do not follow them, you may be guilty of trespass.

When photographing people in a public place you will not normally face legal problems in taking candid shots of strangers. Not everyone likes being photographed, however, and if you are being intrusive you should expect a reaction. In these circumstances, the law is unlikely to protect you. In a few countries, there are legal restrictions against photographing certain people – women in some Muslim countries, for example.

Copyright Copyright disputes in photography are quite frequent and rarely simple. The law differs considerably between countries, as do interpretations of the existing laws in individual cases.

In Great Britain, for example, the relevant legislation is the Copyright Act 1956, which states that the owner of the copyright is the person who owns the photograph itself, and not necessarily the photographer. If you take a photograph for your own use at your own expense, then you own the copyright. If, however, someone commissions you, then the copyright will normally be considered to belong to them, unless you have a written agreement to the contrary. This may seem unfair to the photographer, particularly in comparison with recent legislation in the United States, and the best way of making sure that you can continue to enjoy the benefits of your own photography – if you want to have continued use of it – is to have the client agree in writing that the copyright will be yours, even though he may retain certain agreed rights to use the photographs.

In the United States, the new copyright law (US Copyright Act) applying to all photographs taken after 1 January 1978 establishes that, in almost all cases, the photographer owns the copyright. The main exception is the case of full-time staff photographers. So, even if you have been commissioned to take the photographs, the copyright will still remain yours unless you assign it to someone else in writing. As always, it is important to read contracts carefully and seek advice if you are in doubt.

Protect the copyright in your work by putting a copyright notice on all your photographs. The words 'Copyright © (your name) (year)' are sufficient. For cast-iron protection, register the copyright of important photographs with the Register of Copyrights, Library of Congress, Washington DC 20540.

Use of photographs Having blamelessly taken a photograph, and acquired the copyright, you do not automatically have the right to use it as you wish. With a photograph of a person, depending on how you use it, you may find yourself liable to legal action for invasion of

privacy or even libel. As far as invasion of privacy is concerned, as a general rule you can publish a person's photograph without his or her permission if it is for news or educational purposes, but cannot if it is for advertising or purposes of trade. To do the latter, you need a signed release, such as the one reproduced on pages 210–211. In any case, whenever possible it is a good idea to have your photographic subjects sign a release. You do not necessarily know at the time how you might want to use the photograph at some time in the future.

To avoid libel actions, which in this area arise chiefly because of the text accompanying published photographs, simply make sure that all the caption information you supply with a photograph is accurate. Then, if anything libellous is published, it can be shown not to have originated from you.

Loss or damage If someone to whom you have supplied a photograph loses or damages it, (probably a publisher or advertising agency considering it for use), then the possibility of compensation rests entirely on whether you have a written agreement. With an original transparency or negative, future earnings will be permanently lost, so it is essential that every time you send out photographs for possible use a delivery note accompanies them. The terms on this form should clearly state the amount of financial compensation in the event of loss, damage or theft, and the recipient should sign and return it. This is a straightforward form of insurance, because anyone accepting both the photographs and the delivery note is assumed to have agreed to the terms.

In the case of loss or damage to film by virtue of a defect in the film or an error in the processing, practically all film manufacturers and processing laboratories protect themselves by a limitation of liability. Replacement with an equivalent quantity of fresh film is the maximum compensation you can expect.

Insurance
The following types of insurance may be useful:

Equipment Normal insurance policies cover accidental loss or damage but exclude mechanical failure and regular wear and tear. Insure each item at its replacement value rather than its original cost, revising the policy each year to allow for inflation. A 'worldwide' policy is useful if you travel a great deal, but the premium can be reduced by placing restrictions on the less portable items – insuring studio lighting for one location, for example. Every time you buy a new piece of equipment, remember to add it to the insurance schedule.

Public liability Professional photographers should insure themselves against third party injury or damage caused during an assignment.

Professional indemnity Also for professional photographers, this form of insurance is a protection against libel and other legal claims, particularly important in advertising photography.

Weather Although costly in proportion to the risk, bad weather that results in cancellation or postponement of photography can be insured against.

Car If you use your own car for commerical photographic assignments, make sure that the policy allows business use.

Travel Apart from your equipment, insure yourself for personal accident and medical expenses, and your baggage and personal effects when travelling abroad.

Release form

If you take an identifiable photograph of a person without his or her written consent and it is published, you run the risk, however slight, of a lawsuit based on invasion of privacy or libel. The law in this respect differs between countries and states, but if you feel that the photograph may well be used later in a publication, the best insurance against such problems is to have the person sign a model release form. There are no standard forms, but the one reproduced here covers most possibilities. Photocopy it and ask the 'model' to sign it. You should ask the parent or guardian if the model is a minor – the age differs between countries.

Model Release

Name of photographer

Number or description of photograph(s)

Date of photograph

For consideration received, I give ..* and all licensees and assignees the absolute right to copyright and use the photograph(s) described above and any other reproduction or adaptations thereof, in whole or in part, alone or in composite or altered form, or in conjunction with any wording or other photographs or drawings, for advertising, publicity, editorial or any other purpose.

I understand that I do not own the copyright in the photograph(s), and I waive any right to inspect or approve the finished use of the photograph(s).

I hereby release and discharge ..* and all licensees and assignees from any liability whatsoever, by reason of any distortion or alteration or use in composite or other form, whether intentional or not, which may occur in the making or use of the photograph(s).

I have read this release and am fully familiar with and understand its contents.

**I am over the age of majority and have the right to enter into this contract.
**I am not over the age of majority, but my parent/guardian agrees to these conditions.

Name

Signature _____ Date _____

Address

Name of parent/guardian

Signature

Witness

Address

*insert photographer's name **delete as applicable

Metric measurements

Most measurements in connection with photography are given in metric units — focal length, for example. Some readers will find metric measurements convenient for all dimensions and calculations, but for those who prefer feet and inches metric measurements can be converted with the tables on these pages.

Ounces to grams oz	gms
1	28.3
2	56.7
3	85.0
4	113.4
5	141.7
6	170.1
7	198.4
8	226.8
9	255.1
10	283.5

Grams to ounces gms	oz
1	0.04
2	0.07
3	0.11
4	0.14
5	0.18
6	0.21
7	0.25
8	0.28
9	0.32
10	0.35

Pounds to kilograms lbs	kg
1	0.45
2	0.91
3	1.36
4	1.81
5	2.27
6	2.72
7	3.18
8	3.63
9	4.08
10	4.54

Kilograms to pounds kg	lbs
1	2.20
2	4.41
3	6.61
4	8.82
5	11.02
6	13.23
7	15.43
8	17.64
9	19.84
10	22.05

Pints to litres pts	l
1	0.47
2	0.94
3	1.41
4	1.88
5	2.35
6	2.82
7	3.29
8	3.76
9	4.23
10	4.70

Litres to pints l	pts
1	2.08
2	4.16
3	6.24
4	8.32
5	10.40
6	12.48
7	14.56
8	16.64
9	18.72
10	20.80

Fluid ounces to millilitres fl oz	ml	Millilitres to fluid oz ml	fl oz
1	30	10	0.3
2	59	20	0.7
3	89	30	1.0
4	118	40	1.3
5	148	50	1.7
6	177	60	2.0
7	207	70	2.4
8	237	80	2.7
9	266	90	3.0
10	296	100	3.4

Inches to millimetres		Millimetres to inches		Yards to metres	
ins	mm	mm	ins	yds	m
$\frac{1}{2}$	13	10	0.4	10	10
1	25	20	0.8	20	18
2	51	30	1.2	30	27
3	76	40	1.5	40	37
4	102	50	2.0	50	46
5	127	100	3.9	60	55
6	152	150	5.9	70	64
7	177	200	7.9	80	73
8	203	250	9.8	90	82
9	229	300	11.8	100	91
10	254	350	13.8	200	183
11	279	400	15.8	300	274
12	305	450	17.8	400	366
		500	19.7	500	475
		600	23.6	600	549
		700	27.6	700	640
		800	31.5	800	732
		900	35.5	900	823
		1,000	39.4	1,000	951

Feet to metres		Metres to yards	
ft	m	m	yds
1	0.30	10	11
2	0.61	20	22
3	0.91	30	33
4	1.22	40	44
5	1.52	50	55
6	1.83	60	66
7	2.13	70	76
8	2.44	80	87
9	2.74	90	98
10	3.05	100	109
20	6.10	200	219
30	9.15	300	328
40	12.20	400	437
50	15.25	500	547
100	30.50	600	656
200	61.00	700	765
300	91.50	800	875
400	122.00	900	984
500	152.50	1,000	1,094

Distances and scale

These pages include some guides to subject distance that the photographer may find useful. They are approximate but will provide some aid when focusing without the aid of a reflex viewer or rangefinder. The metric rule on the right hand edge will be useful with close-up and macro work (see pages 186-191) — when measuring lens extension, for example.

Subject distance To calculate the approximate distance away of a person of average height (5 feet 8 inches or 1.72 metres), hold the book out in front of you with your arm straight and see which of these figures is nearest in apparent size. An indication of the distance is given in each case.

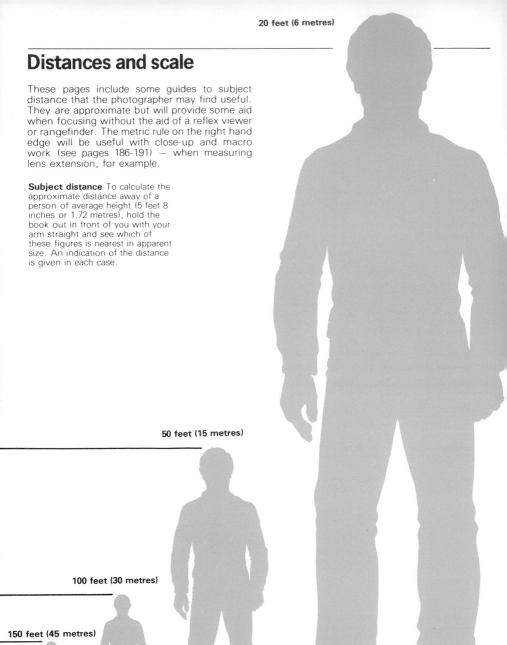

50 feet (15 metres)

100 feet (30 metres)

150 feet (45 metres)

Visual rangefinding Another means of estimating the distance of a subject is to use its size in the viewfinder as a guide. With a person of average height (5 feet 8 inches or 1.72 metres) filling the frame except for a small clearance top and bottom, read off the distance for the type of lens and camera you are using. For example, a person filling the frame of a 35mm camera with a 50mm lens attached will be 14 feet (4.25 metres) away.

35mm camera

Lens	Distance
20mm	5½ feet (1.65 metres)
35mm	10 feet (3 metres)
50mm	14 feet (4.25 metres)
100mm	28 feet (8.5 metres)
200mm	55 feet (16.5 metres)
400mm	110 feet (33 metres)

6 x 6cm camera

Lens	Distance
38mm	5½ feet (1.65 metres)
50mm	7½ feet (2.25 metres)
80mm	12 feet (3.6 metres)
150mm	23 feet (7 metres)
250mm	38 feet (12 metres)
500mm	76 feet (23 metres)

Lens angles of view

90 °

60° 45° 30° 20° 15° 10° 5°

5° 10° 15° 20° 30° 45° 60°

90°

Estimating angles When choosing the lens for the angle of view you require, hold these pages up to your eye and point them at the subject. The angles of view can then be read off the top edge of the page. Check the angle chosen against the table on page 125 for the correct focal length.

217

Shooting check

Before starting a photographic session, go through the checklist below to avoid basic mistakes. Although obvious, each of these steps is surprisingly easy to miss, and the results can be disastrous.

35mm cameras 1. Check whether the camera contains film by gently turning the rewind knob clockwise. If there is tension, it is loaded.

4. Set the film speed dial correctly, and if the camera back has a slot for the film carton end, slip it in as an extra reminder.

5. Check that the right filters, if any, are fitted, and that the lens cap is removed.

8. When using flash, check that the shutter speed is correctly set if the camera has a focal plane shutter.

9. Set the aperture and shutter speed.

View cameras 1. Having set up the camera and composed the shot, shade the lens as close as possible to the picture area.

2. With the lens stopped down, check that there are no obstructions in front of the lens.

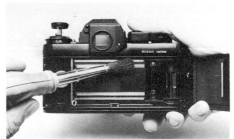

2. If the camera is empty, open the back and clean away particles of dust or film chips.

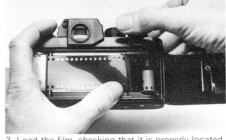

3. Load the film, checking that it is properly located on the take-up spool and sprockets, shut the back and wind on to the first frame.

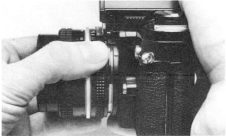

6. Check that the TTL meter coupling to the lens is working, and is accurate (see pages 16–17).

7. Operate the battery check, if there is one.

3.Check that the aperture is set and closed before loading film.

4. Load the film holder and withdraw the dark slide.

Index

Acknowledgements

The photographs in this book are
by the author except those on the
following pages:

Gerry Cranham Photos: 176.
Neyla Freeman: 8-9, 12, 17
(centre), 61 (above), 71-2, 76, 85,
Seaphot: 199.
Tony Weller: 67.